THE PROFESSIONAL PHOTOGRAPHER'S LEGAL HANDBOOK

NANCY E. WOLFF

ALLWORTH PRESS
NEW YORK

P A C A

PICTURE ARCHIVE COUNCIL *of* AMERICA

11 10 09 08 07 5 4 3 2 1

Published by Allworth Press
An imprint of Allworth Communications, Inc.
10 East 23rd Street, New York, NY 10010

Cover design by Chris Werner
Interior design by Mary Belibasakis
Page composition/typography by Integra Software Services, Pvt., Ltd., Pondicherry, India
Cover photo by Mark Harwood/Getty Images

ISBN-13: 978-1-58115-477-1
ISBN-10: 1-58115-477-1

Library of Congress Cataloging-in-Publication Data

Wolff, Nancy (Nancy E.).
 The professional photographers legal handbook / Nancy Wolff.
 p. cm.
 ISBN-13: 978-1-58115-477-1 (pbk.)
 ISBN-10: 1-58115-477-1 (pbk.)
1. Photography–Law and legislation–United States. 2. Photographers–United States–Handbooks, manuals, etc. I. Title.

 KF2042.P45W65 2007
 346.7304'82–dc22

 2007002012

CONTENTS

PART I
COPYRIGHT LAW

Introduction

As legal counsel to the trade association Picture Archive Council of America (PACA) for the past number of years, I have written a regular column in the association's newsletter. PACA was initially founded in 1951 and its purpose is to engage in advocacy, education, and communication to foster and protect the interests of those individuals and entities that are in the business of worldwide licensing of "imagery"—still, motion, and illustration. The legal column in each newsletter was to fulfill this mission. My first challenge in writing the column has always been to find a case, a change in the law, or a legal term that the members will find useful and most importantly, interesting. My second challenge has been to explain the law in plain English (to the extent any lawyer can do that) and to show why it might be relevant. This handbook is the result of the articles I published in the PACA newsletter over the past seven years. The issues discussed touch on all aspects of licensing images: copyright in the imagery, rights relating to the subject matter (people, buildings and art objects), contractual issues involved in licensing. As it is a compilation of writings, this book is not intended to replace legal advice or serve as a complete legal research tool for the photo community. There are many other cases that relate to copyright, trademark, right of publicity, and contracts that were not included in the newsletter or are beyond the scope of this book.

I would like to thank the PACA board for supporting me in this effort, the many legal interns who have worked with me over the years and in particular, Robert Cooper Young, who worked with me while I was compiling this book, and Matthew Hintz, who was instrumental in helping me meet my deadline. Thank you to all those at Allworth Press, including my editor, Nicole Potter-Talling, for her creative thinking on how to combine articles in a way that makes a readable book, and to Allison Caplin and Tad Crawford for making me finish it almost on time. Finally, thank you to my husband, Jack Gernsheimer, for his never ending support and for the great design work by his company, Partners Design, on the book's cover.

PART I

Copyright Law

1 COPYRIGHT LAW FOR THE
PHOTO PROFESSIONAL

As the cases and discussion below illustrate, copyright law (more than any other legal area save, perhaps, contracts) has a significant impact on the field of photography. No one would dispute the assertion that photo professionals, be they photographers or stock photo libraries, are best armed with a sound understanding of their craft and commercial environment as part of their professional bag of tricks. It just so happens that copyright is the legal groundwork that ensures the basic *economic return* for these industry players as much as any technical skill and business savvy. With this important (arguably primary) consideration in mind, copyright law is entwined with and ultimately becomes part of the photographer's livelihood.

WHAT IS COPYRIGHT LAW?

A common misconception of this subject envisions copyright as a legal basis for "they took my idea!" or "I thought of that first!" claims. In fact, this really misses the mark of the theoretical and constitutional motivation behind copyright law as it exists today in the United States. Historically, copyright law *did* once exist as a way of controlling who could disseminate what information by granting only specific individuals the literal right to copy that information. However, these early days when kings exerted control over knowledge were on their way out when the American Framers drafted the constitutional roots of today's Copyright Act. At Philadelphia's Constitutional Convention of 1787, *encouraging* the creation and dissemination of information, as opposed to stifling it, was

a primary goal of the new, enlightened Republic. A product of that convention, Article I, Section 8, Clause 8 of our Constitution grants Congress the power:

> to promote the Progress of Science and the useful Arts, by securing for limited Times, to Authors and Inventors, the exclusive Right to their respective Writings and Discoveries.

Indeed, as with most constitutional language, this sentence raises more than a few questions. How does this language encourage sharing and creating information? And why does this call for a copyright law regime?

While the answers to these questions might not be wholly satisfactory for everyone, we can say there are widely accepted explanations. Here, the primary idea is to urge Americans to action, which plainly promotes the common good—to wit, sharing information. Our forefathers imagined, in step with their capitalist leanings, that the best incentive for individual participation in the common good was an economic one. By granting "exclusive rights," such as the right to copy and distribute the work, authors gain a sort of limited monopoly in their works. As such, their economic incentive is protected against the freeloading copycat who hopes to profit without putting anything at risk, a result that at least increases the likelihood of compensation. Compensation justifies production, which in turn benefits the public in the form of music, art, and literature.

It's an interesting and complicated theory (and this is the simple version), resulting in a congressional act which is doubly so. For starters, once we've recognized that copyright law operates as a monopoly, we're faced with a cosmos of subtle qualifications and limitations on that monopoly. This raises more complications, but ultimately appropriate ones. Since the primary justification behind the monopoly is to encourage creativity, there has to be a give and take. Copyright's monopoly cannot go so far as to stifle other works, which may promote the general welfare themselves. As a result, we'll find that copyright law only protects works falling into certain categories, and among these protected works, certain elements of them remain unprotected.

Accordingly, we will begin with a short explanation of why photographs fit within one of copyright law's protected categories. We'll then examine the more complicated issues, which comprise the bulk of the copyright discussion—namely,

understanding the legal limits of copyright protection. Afterwards, the reader will understand copyright as both a sword and a shield that indeed is a necessary tool of the profession.

COPYRIGHT AND PHOTOGRAPHS

The Copyright Act (which is Title 17 of the United States Code) protects "original works of authorship" that are "fixed in a tangible medium." We get these basic requirements from statutory language of Title 17 of the United States Code Section 102, which acts as "square one" for our progression through copyright law:

> Copyright protection subsists, in accordance with this title, in original works of authorship fixed in any tangible medium of expression, now known or later developed, from which they can be perceived, reproduced, or otherwise communicated, either directly or with the aid of a machine or device.

As the book's title suggests, we'll mostly be concerned with how copyright and photography interact. Photographs and other forms of visual images are protected under Section 102(5) of the Act, which refers to "pictorial, graphic, and sculptural works." As such, the copyright holder in a photograph is afforded a package of rights divided into several classes commonly known as: reproduction rights, adaptation rights, distribution rights, and performance and display rights. Yet in order to enjoy these rights, the would-be copyright holder has to first satisfy the "original work of authorship" and "fixed in a tangible medium" requirements.

Fixation in a tangible medium requires the author to simply create something permanent and dispensable. Recall that the original Constitutional provision mentions "writings." Our fixation requirement recognizes that a work could only enhance public welfare if the public can share in hearing, reading, or seeing it. "Writings" has been given a very broad definition that has come to include negatives, photographic prints, and CD-ROM disks and DVDs. Fixation doesn't usually pose many questions in the photography industry.

ORIGINALITY REQUIREMENT

Our originality requirement is a bit more slippery, even though courts have reiterated that it only calls for independent creation and a *minimal* degree of originality. Described by courts as the "sine qua non" and "cornerstone of copyright protection," the originality analysis determines not only what works are protected but also the extent of protection. While the invention of photography was still young, there were serious doubts as to whether the products of a technique that allowed "nature to create her image" and was widely promoted as an incontestable illustration of truth were truly original works of the photographer at all. Indeed, some photography was lovingly referred to as "mere mechanical reproduction of some object" with "no originality of thought or any novelty in the intellectual operation connected with its visible reproduction in shape of a picture" by the very same court that first upheld the applicability of copyright to photography in the landmark case *Burrow-Giles Lithographic Co. v. Sarony*.

In 1884, the Supreme Court decision *Burrow-Giles Lithographic Co. v. Sarony* held that photographs fit within the scope of copyright as writings that could exhibit the requisite originality to be entitled to protection. *Burrow-Giles v. Sarony* involved Sarony's photo *Oscar Wilde No. 18*. Ultimately, and without much explanation or guidance, the *Burrow-Giles* court found this photo capable of protection as a "useful, new, harmonious, characteristic, and graceful picture" as exhibited by "posing, selecting, arranging, lighting, and shading." Following this decision, it has been generally presumed that any photograph exhibits originality due to the author's choices regarding composition. But that's an issue still being sorted out in the courts. The following case demonstrates the lingering thought of courts that some photographs may not exhibit originality.

The Bridgeman Art Library, a British company, brought a copyright infringement action against Corel Corporation based on the inclusion of approximately 120 images of fine art in a series of Corel CD-ROM titles of well-known paintings of European Masters. Bridgeman has exclusive rights in many well-known works of public domain art from museums located around the world. It maintains a library of large format transparencies created by professional photographers of such works as well as a digital library. Bridgeman licenses these transparencies to clients for a fee. Since Bridgeman has exclusive access to many of the works and the only authorized transparencies, it was inferred that the reproductions included in the Corel CD-ROMs were unauthorized copies. Corel claimed that it obtained the images as 35-mm slides from a California company, Off the Wall, Inc. The trial court dismissed the

action upon a motion by Corel for summary judgment, meaning that the court found that, as a matter of law, Corel was entitled to judgment without the need for a trial to determine the facts.

The district court held that the large-format transparencies, taken by professional photographers, were not protected by the act since they were not original. Because the transparencies strove to accurately reproduce the underlying works of art without any modification, they could not, in the court's eye, be original. The court analogized the photographs taken by professionals to that of a photocopy and distinguished from photographs of people, places, and events that were creative and deserving of copyright. The court determined that a photograph that was merely a copy of someone else's work could not be original despite the change of medium or talent used in taking the image. Although the court relied on UK law, Judge Kaplan of the Southern District of New York concluded that it would reach the same result under U.S. law.

Bridgeman requested that the district court reconsider its decision and provided the court with briefs from leading UK copyright lawyers, which suggested that the court misinterpreted UK law. Under UK law, they argued, the photographs of public domain works would be protected. Further, the court did not recognize that the U.S. Copyright Office had accepted one of the transparencies for registration, indicating that it was sufficiently original to meet their requirements. Having a second opportunity to review the case, the court reaffirmed its prior decision.

The court elaborated on the issue of whether a transparency of a public domain work of art was subject to copyright under U.S. law. The court examined the history of photography as an art form protected by copyright dating back to the 1884 case of *Burrows-Giles Lithographic Co. v. Sarony* finding photographs fitting into "writings" under U.S. copyright law. Citing Nimmer's work (a body of treatises that have become the leading authority on copyright law), the court noted two situations in which a photograph should be denied copyright for lack of originality. The situation that the court found persuasive in this case was "where a photograph of a photograph or other printed matter is made that amounts to nothing more than slavish copying."

Judge Kaplan noted that in order for a photograph of other printed work to be protected by copyright, the case law requires a "distinguishable variation, something beyond technical skill to render the reproduction as original." Further, the court concluded that a change in medium (such as from a painting to a photograph) is insufficient to find the requisite "distinguishable variation."

While the court concluded that the overwhelming majority of photographs would have at least a modest amount of originality required for copyright

protection, "slavish copying" that only required technical skill would have no spark of originality and would not be protected. Apparently the court did not recognize any creative input regarding the art reproduction transparencies. Holdings like these are mired in the outdated idea of the photographer as merely a technician, akin to someone pressing a button on the photocopy machine. What has been understood as being part of a photographer's creative process, the selection of lighting, angle, choice of film and camera, were equated with "sweat of the brow"; mere technical skills not amounting to "original."

Here, the term "original" appears to be misunderstood as requiring originality in the subject matter. This conception is distinguished from one that envisions originality as the "creative eye" of the photographer including choices involving lighting, angle composition, mood, camera, and film as part of the creative endeavor. Even in photography involving art reproduction, the photograph will never look like the painting itself. We could imagine many differences in the way different photographers would light and approach the subject in order to depict it—surely enough difference to distinguish each photographer from someone who simply pushes a button.

While some could argue that the *Bridgeman* court was way off the mark, decisions like this do raise difficult nuances in copyright law. Since a "better" art reproduction photograph will more closely reflect the colors of a painting, the argument that this style of photography is only a "slavish copy" was clearly easy for the court to accept. Characterizing a photographer's creative choices behind an image as mere technical skill, no more than a photocopy machine, doesn't bode well for the art form. If the term "original" had begun to stand for original as to subject rather than original choices of the photographer, many types of photography would have fallen under scrutiny. Taken to an extreme, any photograph of an existing object—an old sneaker, the Sears Tower, the Grand Canyon, or your Aunt Tilly might not be considered original, since another "author" created the underlying work. Equating the experience and skills of a photographer to a photocopy machine that merely records natural objects poses an obvious threat to photography as a protected subject matter. Fortunately, while the *Bridgeman* holding is often cited to illustrate the need for originality, most courts have implicitly beat a slight retreat from its extreme implications. The trend of courts to regard photography as outside of copyright protection hasn't taken serious root, and it appears the holding would be very isolated to the facts in *Bridgeman*.

The *Bridgeman* case gives us an opportunity to also discuss how the federal court system works. *Bridgeman* as it exists today, is a "lower court" decision by

one federal judge in the Southern District of New York. Federal Courts in the United States are divided into geographic divisions throughout the country. Cases tried at the lowest level, the district court, can be appealed to the Circuit Court. At the Circuit Court level, a three-judge panel will review the lower court decision, ultimately agreeing or disagreeing in a written opinion. The higher court decision is then binding if the same issue is raised again in a district court (the trial level) *within that circuit.* Only a decision of the Supreme Court of the United States is controlling (or a "precedent") within all the Federal Circuits. The courts that hear the most copyright cases are the Second Circuit (which includes New York) and the Ninth Circuit (which includes California and Washington State). As such, a decision like *Bridgeman* isn't controlling in California, and a Ninth Circuit decision isn't binding in the Second Circuit. Even in New York, a lower court decision like Bridgeman is not considered precedent and is not required to be followed by another district court. As we look at a decision like this, it's important (and comforting) to know that its legacy and its attendant shortcomings won't follow us throughout the country.

Returning to originality, in *Ets-Hokin v. Skyy Vodka* a Ninth Circuit Court in San Francisco ruled that a photographer's product shots of stylized vodka bottles merit copyright protection as original works, contrary to a lower court decision. The photographer was hired to photograph the Skyy Vodka bottle with its characteristic blue color and rectangular label. The photographer retained all rights to the photographs and granted a limited license to Skyy. A dispute arose (it happens), and the photographer sued for copyright infringement. In dismissing the photographer's case, the lower court found that the photographer did not have a valid copyright in the photographs because the photographs were "derivative works" based on the vodka bottle, insufficiently original to warrant copyright. The appeals court disagreed—finding that the photographs met the minimal standard of originality under the Copyright Act.

This case, quoting W. Eugene Smith, Edward Weston, and opinions following *Burrow-Giles v. Sarony,* revisited the history of photography's copyright protection. In so doing, the *Ets-Hokin* court reiterated that the threshold for originality is very low, and that "the idea that photography is art deserving protection reflects a longstanding view of Anglo-American law." Here, as in many photography cases since 1884, Judge McKeown pointed out that "Courts today continue to hold that decisions by the photographer—or, more precisely, the elements of photographs that *result* from these decisions—are worthy of copyright protection." The decisions Judge McKeown mentions are the ones set forth in *Burrow-Giles v. Sarony.* Namely courts have recognized selection of

subject, posture, background, lighting, and even perspective alone as elements that exhibit the photographer's "authorship" and hence, originality warranting copyright protection.

Around the same time *Ets-Hokin* was decided in the Ninth Circuit, the District Court for the Southern District of New York ruled in favor of a photographer in another copyright infringement action. In *SHL Imaging Inc. v. Artisan House, Inc*, a manufacturer of mirrored picture frames hired the photographer to create colored slides for sales literature. In addition to this use, the manufacturer used the photographs in a catalog, reproduced them in 5,000 brochures, and offered them as magazine "comps" or publicity releases. Further, the photos ended up in the hands of Photo-2-Art, Ltd., for scanning. Here, the plaintiff sued for infringement as some of these uses went beyond the scope of his license.

In response, the manufacturer alleged that the photographer's copyright in the photographs of the frames was invalid, claiming they are not original. On the issue of originality, the manufacturer argued that such photographs were simply not original and that in any case they were derivative works based on the frames and must satisfy a higher standard of substantial originality. (Derivative works will be discussed more fully in a later section.) The court concluded that the photographs were sufficiently original to warrant copyright protection. Following the principle set into motion in 1884, the plaintiff explained to the court the considerable creativity in his choice of, among other things, lighting and artistic judgment in determining the amount of shadow and use of lighting to minimize any reflection in the mirrors. Here, copyright protection would be limited to exact reproduction of the photos, indeed exactly what defendants had done. As a result, the extent of the protection was sufficient to warrant a copyright infringement claim.

About a year after *SHL Imaging Inc*, the District Court for the Southern District of New York in *Oriental Art Printing, Inc. v. Goldstar Printing Corp.* was faced with the question of originality regarding some favorite Chinese dishes, holding that pictures of common Chinese food dishes do not secure copyright protection when the pictures were taken and are used to illustrate items on a Chinese restaurant's menu. The photographs at issue were of several "common" dishes: sweet and sour chicken, General Tso's chicken, roast pork egg foo yung, Singapore mei fun, seafood delight, barbeque spare ribs combo, pepper steak with onion, pu pu platter, Peking duck, and bean curd home-style. These images were arranged on a white background in various patterns such as full circles, semi-circles, and open circles, ovals, zigzags, and parallel rows, among other patterns.

While the plaintiffs in this case had copyright in layouts of the several dishes, the court noted that just because the overall image was copyrighted did not mean that its constituent parts would invariably secure copyright protection, as copyright protection extends only to those components of a work that are original to the creator. This court correctly pointed out that, as what is commonly referred to as the "cornerstone of protection," originality requires independent creation by the author and at least some minimal degree of creativity, however small it may be. This Judge, however, felt that these pictures of Chinese food did not meet those requirements. Finding that the pictures were of the "most common Chinese dishes used in take-out menus," that the photos lacked any artistic quality, and that no "creative spark" spawned these images, the court noted that even the pattern on the plates that held the food was common and that the lighting did not change from picture to picture, which further implied a lack of artistic quality.

The Court feared that allowing these photos to obtain copyright protection would give the plaintiffs an exclusive right to use the photographs to establish a monopoly for printing menus that depict certain commonly served Chinese dishes. Certainly, the originality requirement is in place to prevent just such an outcome, as it would ultimately prevent future works that would add to the general welfare. Indeed, imagine a monopoly on seafood delight, pu pu platter, and Peking duck! In time, the entire island of Manhattan would be under the thumb of a single copyright holder and surely rioting and havoc would ensue. However, the Court found that the overall design did contain the requisite originality to render it a copyrightable work. Hence, this "graphic design" of the menu deserved protection, while the individual photos that make up the design lacked the requisite originality to qualify.

Such an analysis is arguably flawed as it confuses "common subjects" with a lack of originality. Even photographs of common subject matter, from Peking duck to cousin Marty, can enjoy copyright protection. The caveat is that the less original your subject matter, the narrower the protection, since only the copyrightable, original elements should be protected. In legal terms this is called a "thin" copyright. The bottom line is that photographs depicting common objects may have less copyright protection compared to other "unique" or "highly creative" images. Still, copyright law generally affords these photographs *some* protection. For those of you in the food photography game who may be getting a little nervous about your chosen subject matter, I doubt this decision should have far-reaching effects in your field, as most images will exhibit a sufficient degree of originality and possess more identifiable copyrightable elements in choices regarding lighting, composition, arrangement, mood, and other indicia of creativity.

On the subject of "thin" versus more robust protection, a recent opinion by Judge Kaplan of the District Court for the Southern District of New York recognized that the idea needed some fleshing out in order to make the originality assessment more rigorous than a mere list of decisions that go into lighting, shading, angle, arranging and posing subject, and overall mood. For years, a court hearing a copyright infringement case involving photography would invoke the *Burrow-Giles v. Sarony* magic list to find the requisite originality—a method that bore little by way of guidance as to exactly how deeply a photo's originality, and hence its protection, ran. Enter *Mannion v. Coors Brewing*, which involved what's referred to as a "copycat" case.

Jonathan Mannion, a freelance photographer specializing in portraits of celebrity athletes and musicians, was hired by *SLAM*, a basketball magazine, to photograph Kevin Garnett in connection with an article. Mannion's picture was a three-quarter-length portrait of Garnett against a backdrop of clouds wearing casual street clothes and a heap of (in Judge Kaplan's words) "bling-bling."

In early 2001 Carol H. Williams Advertising began developing ideas for outdoor billboards that would advertise Coors Light beer. One of CHWA's comp boards used a manipulated version of the Garnett photograph and superimposed on it the words "Iced Out." Long story short—Coors eventually put up billboards with art that was quite similar to that in the Garnett photograph—down to the bling-bling. Mannion saw the billboard and brought an infringement action in early 2004 claiming that the photograph used in the billboard infringed his Garnett photograph.

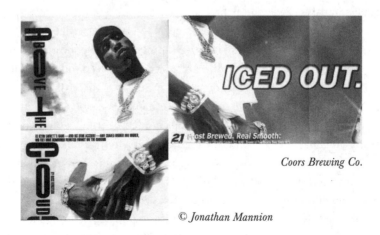

Coors Brewing Co.

© *Jonathan Mannion*

Judge Kaplan pointed out that while a photographer has no right to prevent others from photographing pre-existing objects, a photographer who arranges or otherwise creates the subject that his camera captures may have the right to prevent others from producing works that depict that subject. Looking across the pond to the leading thoughts on UK copyright law, Judge Kaplan set forth some new principles and determined that a photograph may be original in three respects: rendition, timing, and creation of the subject.

Originality in rendition is that which does not depend on creation of the scene or object to be photographed. Here the originality resides instead in the effect of such elements as angle of shot, lighting, shade, exposure, effects achieved by filters, developing techniques, etc. This is in line with the settled doctrine that if the image exhibits originality, it will qualify for protection, while the underlying subject is left up for grabs. Historically, judges agree that unless a photograph is an exact copy of another work, it will exhibit at least some level of originality in the rendition. This is simple enough. We've all seen thousands of pictures of the Grand Canyon. Each one of them may very well qualify for copyright protection, but the protection would not extend so far as to bar future photographs of the same subject.

Kaplan continued to explain that a photographer "may create a worthwhile photograph by being in the right place at the right time." For example, the photographer "Weegee" was known (and also named) for arriving at crime scenes well before the authorities to document the carnage. His impeccable timing contributes to the protectability of his images. However, his copyright will not extend to prohibit others from photographing the same subject in general.

Judge Kaplan recognized that "a photograph may be original to the extent that the photographer created the scene or subject to be photographed." Keep in mind that while a photograph may be original in the rendition or timing, copyright protects the image but does not prevent others from photographing the same object or scene. As a departure from that general principle, Kaplan held "the extent that a photograph is original in the creation of the subject, copyright extends also to that subject." This holding means plainly that "an artist who arranges and then photographs a scene often will have the right to prevent others from duplicating that scene in a photograph or other medium."

The court then moved on to apply these principles to the case at hand. At the outset, Kaplan found the Garnett photograph to be original in that Mannion in fact orchestrated the scene. Even if he did not plan every detail before he met Garnett, the facts showed that he was in charge of the shoot

and blocked it out to achieve a desired effect. Kaplan pointed out that the originality of the photograph extends beyond the individual clothing, jewelry, and pose viewed in isolation. He reminds us that "it is the entire image–depicting man, sky, clothing, and jewelry in a particular arrangement–that is at issue here, not its individual components." The originality inquiry turned out in favor of the plaintiff and ran deep once the court found that the photographer had orchestrated the scene sufficient to support a finding of creation of the subject.

We've yet to see whether or not Judge Kaplan's assessment of originality stands the test of time; the point of these cases is to illustrate that our originality requirement provides a hurdle to entry as well as defines the extent of protection, in whatever shape the discussion takes. In addition to this limit, the idea/expression doctrine has historically drawn another boundary of protection. As the originality requirement recognizes that the monopoly granted by copyright cannot be so broad as to stifle new works, so, too, in its own way does the idea/expression doctrine.

IDEA OR EXPRESSION?

In order to protect works in such a way that doesn't preempt future works, copyright protects the expression of an idea, yet not the idea itself. If copyright extended to the underlying idea, and if copyright granted exclusive rights in an idea to one author, it would ultimately discourage thousands of original works of authorship. Such a result would make the world a very boring place. Notice there are hundreds of vampire movies, several biographies of Dwight D. Eisenhower, and somewhere in the neighborhood of several million country songs about lost dogs, wives, and pickup trucks. Under our copyright regime, if someone were to express any of the core ideas mentioned above in an original way, they would not infringe on other works. Each original work could be eligible for protection.

Like the originality concept, the idea/expression dichotomy is not as simple as it sounds, and one should be prepared for that unpleasant surprise at every turn in copyright law. One recurring debate is whether the idea can even be expressed in more than one way. Copyright law has historically held that some ideas can only be expressed in certain ways, and in such cases we say that the idea and the expression have merged. The "merger doctrine" dictates that when the idea can only be expressed in one way, neither the idea nor the expression will enjoy copyright protection. Indeed, we can challenge the underlying assumption that certain ideas can only be expressed some ways. While the

merger doctrine is widely supported by case law and the Copyright Office, very recent developments in the courts indicate that the doctrine might not be useful in copyright cases dealing with visual arts.

Gentieu v. Tony Stone Images, a 2003 case out of Chicago, Illinois, provides an example of the majority position concerning the merger doctrine. Gentieu is a photographer specializing in images of babies. She typically shoots them against a white lit background, eliminating any shadow so they appear to be floating. In 1993 Gentieu signed an exclusive agency agreement with Tony Stone Images (TSI), granting TSI the right to be her exclusive stock-photography agent. She was assigned an editor who would send what TSI called "shoot briefs," essentially a list of potential subjects that clients were interested in licensing. One particular shoot brief suggested that the photographer submit baby photographs such as a "baby shot straight on silhouetteable clean white background." Without reference to any Gentieu images, the art directors at TSI sent a similar shoot brief to other photographers. As a result, other contributors submitted baby pictures to TSI that were shot against a white background. In *Gentieu*, the plaintiff claimed that TSI violated her copyrights by reproducing and making derivatives of her baby pictures and by commissioning others to do so. With respect to the allegations of unauthorized copying and the creation of derivatives, the court was required to determine whether the alleged "infringing" baby pictures materially used Gentieu's protected expression. Since copyright does not protect an idea, the protected expression comprises the elements of a photographer's composition such as lighting, shading, camera angle, background, and perspective. Here, the court took the line that "ordinary poses that follow from the choice of the subject matter are not protectible." Consequently, the court concluded, Gentieu could not claim copyright in the idea of photographing naked or diapered babies or in the poses that are the natural movement and facial expressions of babies.

In carefully comparing fifteen sets of photographs, the court concluded that in each case there was no copying of protected elements. The court described Gentieu's copyright in her baby pictures as "thin." Since she limited the photographs in some cases to a head shot against a white background, adding nothing else that was protected in terms of copyright, a court would only make a finding of infringement in the case of near exact copying. Here, the court recognized the risk of granting a monopoly on all naked babies against a white background to one photographer.

The court also noted that a photographer does not control the "pose" of a baby and that there was nothing original added by the photographer. The natural "poses" a baby makes could not be attributed to one photographer exclusively.

As a further complication, the *scenes a faire* doctrine also informs the idea/expression and merger analysis. In *Kaplan v. The Stock Market Photo Agency*, a New York Federal District Judge dismissed photographer Peter B. Kaplan's (Kaplan) claim for copyright infringement against the Stock Market Photo Agency, Inc. (Stock Market) and the Fox News Network (Fox). The complaint alleged that the Stock Market licensed an "imitation" photograph created by Bruno Benvenuto to Fox for advertising purposes. Both images depicted a sort of first-person perspective of a man in a business suit (including those snazzy wing tip shoes) standing on the ledge of a high building, as if contemplating a leap. The court found that the similarities between the two images arose from "non-copyrightable" elements—the photographer's central concept or idea of a businessman contemplating a leap. Again, a fundamental principle of copyright law is that the Copyright Act protects expression and not ideas. Where the line lies in the work between the idea and the expression of the idea is often a difficult determination. Courts rely on a doctrine known as "*scenes a faire*" which roughly translates "scenes that must be done" to analyze these slippery infringement cases with the result that certain choices in incidents, characters, and scenes that are standard in the treatment of a given topic are not protected under copyright law. The *Kaplan* court, in comparing the two photographs, determined that the topic of an exasperated businessman contemplating a leap from a tall building is standard in today's fast-paced business climate, especially in New York. In addition to this grim outlook, the subject matter of such a photograph is unprotected along with the choices that "necessarily flow" from that standard setting. These choices include the pose of the man standing on a roof or a ledge of a building with shoes partially extended. The court found that it would be impossible to portray the subject matter without using that pose. Further, the court found the choice of wardrobe (a pinstriped business suit and wing tip shoes) to be characteristic of a businessman's dress. In addition, the high angle from the perspective of the businessman looking down at the street was essential to expressing the "jumper's own viewpoint" and was considered to be the most common viewpoint in this scenario. Accordingly, the choice of camera angle was also unprotected. As a result, the court found the only similarity between the two photographs to be based on unprotected elements associated with the underlying subject matter. Stating that Benvenuto added his own originality in expressing the underlying idea of a businessperson contemplating a leap from a tall building to the street below, the court dismissed the infringement action.

This case demonstrates the difficulties inherent in any copyright infringement action involving photos of similar subjects. Following Kaplan and the classic *scenes a faire* doctrine, courts using this majority approach will have to determine if copied elements flow from the idea or if the photo comprises the protected choices made by the photographer. Since these are case-specific determinations, there are no hard-and-fast rules to follow. Considering the fact that there are many universal ideas and concepts expressed in photography, confusion in this area can be disheartening to would-be defendants, as no professional in the industry wants to be embroiled in a lengthy legal battle over whether one work copied another of a similar subject matter. On the other side of the coin, the *Kaplan* court's treatment of elements that "necessarily flow" from an idea might make one wonder if the idea/expression doctrine could swallow the photography industry whole! Several of the cases employing the majority approach to *scenes a faire* and the idea/expression doctrine have certainly exhibited this tendency, resulting in a dismissal for the plaintiff. In a very recent case, another federal judge sitting in New York tried to make some sense of it all.

The case belongs to the class of disputes similar to the one in *Kaplan v. Stock Market.* It's an all-too-frequent scenario. A photographer sees an ad that looks suspiciously familiar. Sure enough, an ad agency comped the original photograph and then had another photographer create a similar image with different models. The question arises, "Is it inspiration or infringement?" Because of the vast body of cases following *Kaplan*esque doctrine, the ad agency or other "copycat" artist could claim that it only took the idea of the photograph and not any "protected elements." One can imagine the ad agency's response: "Copyright only protects expression and not the idea of the expression." If the dispute were to go to court, the accused copier would likely describe the subject of the photograph in such broad terms that it of course sounds like an "idea." How convenient. In some cases, this catchphrase approached the proverbial license to steal–that is, until Judge Kaplan (not to be confused to the plaintiff in the *Kaplan* case!) of the Southern District of New York weighed in on the issue. In one fell swoop Judge Kaplan tried to revoke the license. As his opinion attempted to remove entirely the idea/expression inquiry from the analysis, he may have opened up the door to more successful copycat photography actions. To be sure, the approach could at least give the plaintiff some leverage when looking to a copycat for a settlement.

In our discussion of originality, we mentioned the very "out of the box" thinking of the *Mannion v. Coors* court. It should be no surprise that the court

that shook up the originality debate also weighed in on the idea/expression discussion. (For the background facts of the *Mannion* decision, see above.) Once the *Mannion* court deemed the plaintiff's work sufficiently original, the analysis moved on to the infringement inquiry. Coors argues that the billboard does not infringe because the two shared only "the generalized idea and concept of a young African American man wearing a white T-shirt and a large amount of jewelry." Here the defendants were relying on the axiom of copyright law which holds that copyright does not protect "ideas"; only their expression. The doctrine urges "when a given idea is inseparably tied to a particular expression, courts may deny protection to the expression in order to avoid conferring a monopoly on the idea to which it is inseparably tied." Historically, this merger doctrine in its various forms has stymied many a copycat photography plaintiff. Some of our previous examples demonstrated that courts were perfectly comfortable saying there was only one way to depict a cat chasing a mouse or a person contemplating a leap from a tall building.

Yet in his *Mannion v. Coors* decision, Kaplan moved away from this type of reasoning. He began by pointing out that the idea put forth by defendants "does not even come close to accounting for the similarities between the two works, which extend at least to angle, pose, background, composition, and lighting." Employing a little imagination, Kaplan points out that it is quite possible to imagine any number of depictions of the subject in question. Further, one could imagine that most of them might possibly look nothing like either of the photographs at hand. Clearly, with a universe of possible ways to express an idea through a visual work, it may very well be that no individual copycat photography plaintiff merely seeks to protect an idea rather than its expression. Judge Kaplan delved further into the notion of "idea/expression" distinction and in a surprising twist, called it "useless" when dealing with works of visual arts.

Kaplan seemed to want to push a concept that has been kicking around for some time. Namely, that it is probably impossible in most cases to speak of the particular "idea" captured, embodied, or conveyed by a work of art because every observer will have a different interpretation. He goes on to state that it is not clear that there is any real distinction between the idea in a work of art and its expression. An artist's idea, among other things, is to depict a particular subject in a particular way. A number of cases from the Second Circuit have observed that a photographer's conception of his subject is copyrightable. By "conception" the courts mean originality in rendition, timing, and creation of

the subject. Anyone with access to a thesaurus knows that "conception" is akin to "idea." The court concludes by saying that in the context of photography, the idea/expression distinction is not useful or relevant. Judge Kaplan went so far as to state that he specifically found the *Kaplan v. Stock Market* assessment of *scenes a faire* to be totally unconvincing.

This is no small move for the field of copyright, and considering the law's relative distaste for big changes, one wonders if it will stick. Even after Judge Kaplan decreed that the "idea" versus the "expression of the idea" was a poor test for copyright infringement in cases involving two works of visual art, Judge Chin of the *Diodato v. Kate Spade* court (also in the Southern District of New York) dismissed a copyright action brought by a photographer against the alleged imitator, finding that the similarities "flowed" from the idea of the photograph and were not protected. How *Mannion* and *Diodato* can be reconciled is unclear other than the judges were different and reacted very differently to the subject matter depicted in two images before them. This illustrates how photography cases are difficult. Courts are hesitant to grant copyright, a form of monopoly, to one artist over what the judge perceives to be a common "*idea.*" In both *Mannion* and *Diodato*, the court was asked to dismiss the copyright action before a trial, on a motion for summary judgment. This is a common way lawyers handle copyright infringement actions. If a decision can be decided early on that there is or is not a copyright violation, substantial money can be saved in avoiding a trial. In *Mannion*, Judge Kaplan decided that there were enough similarities to go to a jury; in *Diodato*, Judge Chin decided that as a matter of law there was no infringement and dismissed the case before trial.

At first blush, it appears that the facts in *Diodato* favor the plaintiff. In 2001, Bill Diodato took a photograph of the bottom of a bathroom stall. Through the opening underneath the door, one can see a woman's feet astride a toilet in stylish, colorful shoes, her underwear hanging above her ankles, and a handbag resting on the floor. Diodato submitted the photograph to defendant Kate Spade LLC ("Kate Spade") in January 2003. Although representatives of Kate Spade deny they copied the photograph, Kate Spade's November 2003 advertising campaign included a photograph of a woman's feet astride a toilet, in stylish, colorful shoes, with a handbag on the floor. The photographer sued Kate Spade.

The court admitted that the plaintiff's idea to use a woman sitting on the toilet to showcase fashionable shoes and accessories was clever but was not uncommon and was used elsewhere in popular culture. Consequently, the

judge found that most of the elements in Diodato's photograph were not protected by copyright and dismissed his case. But how did the court reach its decision? To begin, the court described Diodato's photograph:

[Diodato's] Photograph was taken from the floor outside a bathroom stall. It depicts the bottom portion of the stall and a woman's feet in pink shoes decorated with green, yellow, and purple leaves, with thin pink straps crisscrossing up her legs. The woman's lime green underpants are taut just above her ankles. A light brown handbag rests on the floor next to the woman's left foot, and a white toilet is visible in the background. The woman's feet are on the floor, her heels raised at a stiff angle by the heels of her shoes. The woman's ankles are turned in, with her toes painted red [. . .] The Photograph is taken from a distance, with the bathroom stall and door separating the subject and the camera. Almost the entire bottom half of the photograph consists of the light grey lines of the floor tiles, with virtually all of the floor out-of-focus. The floor comes into focus halfway up the photograph, where the woman's feet touch the ground and the handbag sits. The photograph is framed at the top and on the left by the darker grey of the bathroom stall and door. A light seems to shine on the legs, toilet, and handbag, in contrast to the shadows in the foreground and background. The overall tone of the photograph is whimsical, fun, and bright.

After Diodato took his photo, his rep, Marge Casey & Associates (MCA), received a request from Kate Spade, the accessory company, for portfolios to review and delivered Diodato's portfolio that contained this very same photograph. The portfolio was well received and MCA was requested to redeliver it in a few weeks. It was redelivered and ultimately returned. When MCA asked Kate Spade if the company was interested in Diodato, MCA was informed that Kate Spade only worked with important or well-known photographers.

Kate Spade eventually hired a photographer, Jessica Craig Martin ("Martin"), to conceptualize and shoot photographs for its advertising campaign. She was requested in early June 2003, to photograph Kate Spade's anniversary party at the Explorers' Club in New York City, in a paparazzi style. One of the photographs taken that night was the allegedly infringing

photograph, taken in the bathroom of the Explorers' Club; It was one of the approximately fourteen photographs used in Kate Spade's fall 2003 advertising campaign.

The court described this photograph as follows:

. .

> The Kate Spade Photograph is taken from the tiled floor in front of a toilet. A woman's legs are visible from just below the knees; she wears purple-tinted fishnet stockings and satin pink shoes with straps crisscrossing once around her ankle, and her light tulle petticoats fall to the side of the toilet. A shiny, silver square handbag sits next to her left foot. The Kate Spade Photograph is cropped close to the woman, the toilet between her legs, and the handbag, so that little of the surrounding area is visible, aside from square tiles on the wall. The bottom portion of the Kate Spade Photograph consists of smaller floor tiles, mottled in color and texture. . . . With the exception of the extreme foreground, the floor and other images are in focus, grounding the photograph. In addition, there seems to be a spotlight shining on the center of the frame, creating sharp contrasts in light. The entire photograph is detail-rich and textured. The purse has a metallic shine and creases; light reflects off the bows on the satin shoes; and the distinct patterns of the wide-net stockings and the tile floor add energy to the photograph. The woman's feet are pointed toward each other, her left foot is slightly raised and leaning on its side. The image seems to be of an evening event, as the woman is dressed in party attire and the shadows are dark.

. .

Photographer Martin describes her signature style as strong artificial light and flash in a paparazzi style. She said she was given no direction or sketches from Kate Spade other than what accessories to include. She claims to have never seen the Diodato portfolio.

The attorneys for Kate Spade needed to establish that the idea of a woman sitting on a toilet to showcase shoes and a handbag was a common theme. To do so, they submitted a number of stock photographs. A scene from the film "Charlie's Angels: Full Throttle" was described involving actress Cameron Diaz, a toilet stall, and Spiderman underpants. Lastly, Martin had previously photographed the feet of two women, in shiny gold shoes and side-by-side bathroom stalls, in a widely circulated photograph.

Kate Spade moved to have Diodato's complaint thrown out on a number of grounds, most of which constitute the ordinary defenses. For purposes of this part of the chapter, we'll stick to the idea/expression language. The *Diodato* court held that most of the aspects of the plaintiff's photograph are derived from the idea of the photograph, or naturally flow from that idea, and are not protected. As a result, the vast majority of elements in the Diodato photograph that are similar to those in the Kate Spade photograph are not protected. This included the elements of the woman's feet, the handbag, and the base of the toilet; all *scenes a faire.* The court even described the fact that both images were out of focus in the front of the photograph to flow from the scene. "Likewise, it is standard for the photographer to take such a photograph from or near the floor, and it follows that a portion of the floor closest to the camera might be out of focus." The pose of the feet pointed inward was also not protected, according to the court, because it would be natural to show more of the shoe in a fashion photo and the pose of the feet was not original. Even the placement of the handbag was considered standard. Judge Chin then commented on the different style of the two photographers in how they lit the photographs. Finally, he referenced Judge Kaplan and his recent decision where he discussed the "difficulty of distinguishing between idea and expression" in copyright infringement cases, finding that "in the context of photography, the idea/expression distinction is not useful or relevant."

However, Judge Chin distinguished the case by stating that in *Mannion* there was no question that plaintiff's photograph was original where the subject of Diodato's photograph, while clever, was not original. Only Diodato's rendition was determined to be original. As a matter of law, the court held that a jury could not reasonably find that any substantial similarities between the photographs relate to protected elements of the copyrighted work. The court dismissed the plaintiff's case.

"What now?" you may ask. Before commencing an action for copyright infringement based on what you believe is a knock-off photograph, I would consider how a court may react to the image. How original are the elements in the photograph? If the photographer has creatively placed the models and objects in a way that is uncommon, you could succeed. If you search a few stock Web sites and see photographs of very similar themes, you may not want to go forward with a copyright claim. These cases are always more difficult than cases where the actual photograph is used outright. Sadly, differences in outcomes may be entirely attributable to the difference in judges, but the choice of judge is not within your control. If a case looks like it may run into

an idea/expression analysis after you have reviewed the claim with a copyright lawyer, the best solution might be to settle a case after a claim letter is sent.

OTHER LIMITS ON PROTECTION

Aside from the limits on protection commanded by the originality requirement and the idea/expression doctrine, there are some other contours to copyright protection's borders. You will recall that the original Constitutional provision for copyright law refers to "writings," a phrase that has come to mean anything from computer programs to action figures. You will also remember that Section 102 of the Copyright Act includes "pictorial works," which is broad enough to include photographs as well as maps and diagrams. Indeed, statutory categories of copyrightable subject matter are rightly very broad and vague in order to best adapt to economic, technological, and aesthetic changes. However, broad general categories don't necessarily mean that each specific work of art is granted absolute coverage. As a result, most cases actually devote considerable time to describing what isn't covered under the law.

The "smiley face" is an example of something not covered under the Act. Anyone who wasn't raised on the moon is familiar with the smiley face associated with the "Have a nice day" slogan. Would the smiley face be covered under copyright law? Seems original. Seems like an expression of an idea. In 1998 a Frenchman, Frank Loufrani, did try to claim that he was the originator of the famous yellow smiley face that has been on buttons, T-shirts, posters, and about everything else since the 1960s. However, the "true" originator Harvey Ball asserts that he originated the smiley face in 1963, well before Mr. Loufrani claimed that he spun out the yellow face. As much as either Mr. Loufrani or Mr. Ball have added to popular culture, the smiley face would not be protected by copyright. Aside from the fact that–like so many things in the sixties–it was freely distributed and therefore entered the public domain (to be discussed in another chapter), the chances are slim that it would have been subject to protection had the proper procedures been followed.

While copyright protects the broad subject matter of graphic works, it does not protect mere symbols. Nor does it cover short slogans such as "Have a nice day!" or "Take my wife, please!" or signatures (should Mr. Ball include his beneath the beaming face) since the Act expressly excludes the protection of short words and phrases. Specifically, Section 106(b) of the Copyright Act excludes short terms and phrases. Trademark law *may* protect some slogans and short phrases but Copyright won't.

2 THE KEYS TO THE COURTHOUSE:
REGISTERING THE WORK

So you've got a photograph, negative, or digital image on a disk. You've satisfied the fixation element. You didn't merely copy someone else's image on the office copy machine, nor did you cut and paste the image from a stock photo library, so it's probably an original work. You're most likely holding an image that's protected under copyright, even if the idea/expression and *scenes a faire* doctrine tell you that maybe it won't receive corner-to-corner protection. Yet as an author of an image with nothing more, you're probably pretty satisfied with yourself but really only halfway in the game. If you tried to enforce that copyright against any infringer, you'd soon find that *registration* is almost as important as the work itself.

Registration is not required for copyright protection. Theoretically, your work falls under copyright protection as soon as the original work is fixed in a tangible medium. But registration *is* a prerequisite before United States authors can bring an action for infringement in federal court. Because of certain treaties, foreign authors may bring an action in federal court without securing a registration certificate. Very importantly, registration of the work before an infringement occurs will affect the type of damages available to the author.

If registration is made within three months after publication of the work or prior to an infringement, statutory damages and attorney's fees will be available to the copyright owner in court actions. Statutory damages are the amount of damages a court can award in its own discretion against an infringer, without the owner of a work having to prove that he or she was damaged. Statutory damages can be awarded up to $30,000 per infringement and increased up to $150,000 in the event of willful infringement. Couple this with the possibility of attorney's fees, and registration becomes rather attractive. Without registering a work prior to infringement, only an award of actual damages or profits will be available to the copyright owner. When the infringement is a use of an

unregistered photograph, the measurement of actual damages is a license fee or a multiple thereof. Certainly an award of fees will not offset the time and money spent on litigating a copyright claim. Believe it: the benefits of registration really make your copyright an asset.

USING FORM VA

That being said, registration is a bit complicated. However, the Copyright Office has been open to suggestions from various trade associations and has over time made efforts to encourage registration and simplify the process, such that photographers could and should incorporate the process into their routine business tasks. For instance, the Copyright Office Web site now offers "fill-in" forms that you can download with Adobe Acrobat and fill in before printing. At this writing, you still need to mail in the completed form to the Copyright Office with the fee and deposit requirement. The Copyright Office anticipates offering online registration in late 2007. If you elect online registration, the fee will be reduced and there will be one form for all works. Check the Copyright Office Web site for further instructions. Registration of all works must be made with the U.S. Copyright Office (*www.loc.gov/copyright*). The specific steps to take when registering a photograph depend on whether the work is published or unpublished, but the following three steps apply to all registrations of visual works (photographs).

First, the registrant will need to complete what's known as a Form VA, which the Copyright Office makes available as a PDF file at *www.copyright.gov/forms/formvai.pdf.* Second, there's a filing fee (recently increased from thirty to forty-five dollars, but these fees can change from time to time, so check with the Copyright Office for the current fee when you register). Lastly, the Copyright Office needs to see just what it is you're registering. Hence, you'll have to give them a non-returnable deposit of the work. The form of deposit required depends on whether the work is published or unpublished. The Copyright Office is not required to retain deposits of published works for more than a reasonable time, which at present means they retain them for approximately ten years. For litigation purposes, it may be helpful if the Library of Congress retains the deposit in the event a question arises as to whether a particular image is included as part of a registration. For an additional fee, the Copyright Office will retain the deposit. Unpublished works are retained.

It cannot be stressed enough how important it is to promptly register work, and to send the application via an overnight carrier, with proof of delivery. The date of registration is the date the application is received by the Copyright Office. Remember, statutory damages and attorney's fees will be available to

the copyright owner in court actions if registration is made within three months after publication of the work or prior to an infringement of the work. That being said, the Copyright Office recommends that your completed application is received within three months of publication of the *earliest* published photograph within the a group of registered images.

An author can register works individually or as a group. Registering photographs individually involves the three steps mentioned above. These steps again require the following:

1) A completed Form VA (*www.copyright.gov/forms/formvai.pdf*)

2) The filing fee

3) A non-refundable deposit of the work to be registered

The form of deposit required depends on whether the work to be registered is published or unpublished. A deposit of "identifying material" is required to register unpublished works. Only *one* copy of the work to be registered is necessary for unpublished works. "Identifying material," or "I.D. material," generally consists of two-dimensional reproduction(s) of a work in the form of photographic prints, transparencies, or photocopies that show the complete copyrightable content of the work being registered. Deposits for published works should include *two* deposits of every photograph for which a copyright is sought. The deposit may be in the form of any of the following, listed in the Library of Congress's order of preference:

- Digital form on one or more CD-ROMs including CD-RWs and DVD-ROMs, in one of these formats: JPEG, GIF, TIFF, or PCD

- Unmounted prints at least 3" × 3" in size, but no larger than 20" × 24"

- Contact sheets

- Slides, each with a single image

- A format in which the photograph has been published, for example, clippings from newspapers or magazines

- A photocopy of each photograph, which must be either a photocopy of an unmounted print at least 3" × 3" in size, but no larger than 20" × 24", or a photocopy of the photograph in its published format. It must be a color photocopy if the photograph was published in color.

- Slides, each sleeve containing up to thirty-six images

- A videotape clearly depicting each photograph

Note: If registering works published before March 1, 1989, the deposit copy must show the work as first published. The copy must show the copyright notice that appeared in connection with the photograph. The law before that date required published works to include a copyright notice with the ©, name, and year of publication.

If you're confused as to whether your work is published or unpublished, a work is published when it is distributed and offered to the public by sale, rental, display, or other methods, making one or multiple copies available.

Individual registration is available, but might not be very efficient for photographers, since their medium allows them to create thousands of copyrightable works in any given year versus the playwright who may create only one or two works every year or so. Hence, group registration of published works is a boon to photographers, since it allows them to register a large (although limited) number of images all at once under one form and one fee where previously a separate registration was required for each published photograph unless all were published in the same publication. There are two basic methods of registering a group of published photos under the regulation—one is with the group photo continuation sheets (known as Form GR/PPh/CON) and the other is without those forms. Registration with the GR/PPh/CON is encouraged because the form will give complete information about each individual photo, thus ensuring a more complete public record. The alternative is to list the information on the same CD-ROM as the submitted images as part of the deposit. The information could be helpful if you find yourself on the wrong side of a copyright claim. While group registration allows an author to protect a pile of images all at once, there are modest limits. As a result of a photographer filing *twenty thousand* photographs in one registration, the Copyright Office of the Library of Congress amended its final regulations concerning group registration of published photographs to limit the number of photographs that may be identified on continuation sheets submitted with a single application form and filing fee to *750*. The regulation places no limit on the number of photographs that may be included in a single group registration when the applicant elects *not* to use continuation sheets if the author instead identifies the date of publication for each photograph on the deposited image *and* the applicant meets the other regulatory requirements for group registration of published photographs.

To register a group of published photos using the Form GR/PPh/CON, you'll need to complete a Form VA (or a Short Form VA) along with Form GR/PPh/CON. The following provides a walk-through for completing a Form VA (which has different numbering of spaces from *Short Form VA*, so if you use this guide, make sure you are filling in Form VA):

 # Form VA

Detach and read these instructions before completing this form.
Make sure all applicable spaces have been filled in before you return this form.

BASIC INFORMATION

When to Use This Form: Use Form VA for copyright registration of published or unpublished works of the visual arts. This category consists of "pictorial, graphic, or sculptural works," including two-dimensional and three-dimensional works of fine, graphic, and applied art, photographs, prints and art reproductions, maps, globes, charts, technical drawings, diagrams, and models.

What Does Copyright Protect? Copyright in a work of the visual arts protects those pictorial, graphic, or sculptural elements that, either alone or in combination, represent an "original work of authorship." The statute declares: "In no case does copyright protection for an original work of authorship extend to any idea, procedure, process, system, method of operation, concept, principle, or discovery, regardless of the form in which it is described, explained, illustrated, or embodied in such work."

Works of Artistic Craftsmanship and Designs: "Works of artistic craftsmanship" are registrable on Form VA, but the statute makes clear that protection extends to "their form" and not to "their mechanical or utilitarian aspects." The "design of a useful article" is considered copyrightable "only if, and only to the extent that, such design incorporates pictorial, graphic, or sculptural features that can be identified separately from, and are capable of existing independently of, the utilitarian aspects of the article."

Labels and Advertisements: Works prepared for use in connection with the sale or advertisement of goods and services are registrable if they contain "original work of authorship." Use Form VA if the copyrightable material in the work you are registering is mainly pictorial or graphic; use Form TX if it consists mainly of text. **NOTE:** Words and short phrases such as names, titles, and slogans cannot be protected by copyright, and the same is true of standard symbols, emblems, and other commonly used graphic designs that are in the public domain. When used commercially, material of that sort can sometimes be protected under state laws of unfair competition or under the federal trademark laws. For information about trademark registration, write to the Commissioner of Patents and Trademarks, Washington, D.C. 20231.

Architectural Works: Copyright protection extends to the design of buildings created for the use of human beings. Architectural works created on or after December 1, 1990, or that on December 1, 1990, were unconstructed and embodied only in unpublished plans or drawings are eligible. Request Circular 41 for more information. Architectural works and technical drawings cannot be registered on the same application.

Deposit to Accompany Application: An application for copyright registration must be accompanied by a deposit consisting of copies representing the entire work for which registration is to be made.

> **Unpublished Work:** Deposit one complete copy.

> **Published Work:** Deposit two complete copies of the best edition.

> **Work First Published Outside the United States:** Deposit one complete copy of the first foreign edition.

> **Contribution to a Collective Work:** Deposit one complete copy of the best edition of the collective work.

The Copyright Notice: Before March 1, 1989, the use of copyright notice was mandatory on all published works, and any work first published before that date should have carried a notice. For works first published on and after March 1, 1989, use of the copyright notice is optional. For more information about copyright notice, see Circular 3, "Copyright Notice."

For Further Information: To speak to an information specialist, call (202) 707-3000 (TTY: (202) 707-6737). Recorded information is available 24 hours a day. Order forms and other publications from the address in space 9 or call the Forms and Publications Hotline at (202) 707-9100. Most circulars (but not forms) are available via fax. Call (202) 707-2600 from a touchtone phone. Access and download circulars, forms, and other information from the Copyright Office website at *www.copyright.gov*.

LINE-BY-LINE INSTRUCTIONS
Please type or print using black ink. The form is used to produce the certificate.

1 SPACE 1: Title

Title of This Work: Every work submitted for copyright registration must be given a title to identify that particular work. If the copies of the work bear a title (or an identifying phrase that could serve as a title), transcribe that wording *completely* and *exactly* on the application. Indexing of the registration and future identification of the work will depend on the information you give here. For an architectural work that has been constructed, add the date of construction after the title; if unconstructed at this time, add "not yet constructed."

Publication as a Contribution: If the work being registered is a contribution to a periodical, serial, or collection, give the title of the contribution in the "Title of This Work" space. Then, in the line headed "Publication as a Contribution," give information about the collective work in which the contribution appeared.

Nature of This Work: Briefly describe the general nature or character of the pictorial, graphic, or sculptural work being registered for copyright. Examples: "Oil Painting"; "Charcoal Drawing"; "Etching"; "Sculpture"; "Map"; "Photograph"; "Scale Model"; "Lithographic Print"; "Jewelry Design"; "Fabric Design."

Previous or Alternative Titles: Complete this space if there are any additional titles for the work under which someone searching for the registration might be likely to look, or under which a document pertaining to the work might be recorded.

2 SPACE 2: Author(s)

General Instruction: After reading these instructions, decide who are the "authors" of this work for copyright purposes. Then, unless the work is a "collective work," give the requested information about every "author" who contributed any appreciable amount of copyrightable matter to this version of the work. If you need further space, request Continuation Sheets. In the case of a collective work, such as a catalog of paintings or collection of cartoons by various authors, give information about the author of the collective work as a whole.

Name of Author: The fullest form of the author's name should be given. Unless the work was "made for hire," the individual who actually created the work is its "author." In the case of a work made for hire, the statute provides that "the employer or other person for whom the work was prepared is considered the author."

What is a "Work Made for Hire"? A "work made for hire" is defined as: (1) "a work prepared by an employee within the scope of his or her employment"; or (2) "a work specially ordered or commissioned for use as a contribution to a collective work, as a part of a motion picture or other audiovisual work, as a translation, as a supplementary work, as a compilation, as an instructional text, as a test, as answer material for a test, or as an atlas, if the parties expressly agree in a written instrument signed by them that the work shall be considered a work made for hire." If you have checked "Yes" to indicate that the work was "made for hire," you must give the full legal name of the employer (or other person for whom the work was prepared). You may also include the name of the employee along with the name of the employer (for example: "Elster Publishing Co., employer for hire of John Ferguson").

"Anonymous" or "Pseudonymous" Work: An author's contribution to a work is "anonymous" if that author is not identified on the copies or phonorecords of the work. An author's contribution to a work is "pseudonymous" if that author is identified on the copies or phonorecords under a fictitious name. If the work is "anonymous" you may: (1) leave the line blank; or (2) state "anonymous" on the line; or (3) reveal the author's identity. If the work is "pseudonymous" you may: (1) leave the line blank; or (2) give the pseudonym and identify it as such (for example: "Huntley Haverstock, pseudonym"); or (3) reveal the author's name, making clear which is the real name and which is the pseudonym (for example: "Henry Leek, whose pseudonym is Priam Farrel"). However, the citizenship or domicile of the author **must** be given in all cases.

Dates of Birth and Death: If the author is dead, the statute requires that the year of death be included in the application unless the work is anonymous or pseudonymous. The author's birth date is optional but is useful as a form of identification. Leave this space blank if the author's contribution was a "work made for hire."

Author's Nationality or Domicile: Give the country of which the author is a citizen or the country in which the author is domiciled. Nationality or domicile **must** be given in all cases.

Nature of Authorship: Catagories of pictorial, graphic, and sculptural authorship are listed below. Check the box(es) that best describe(s) each author's contribution to the work.

3-Dimensional sculptures: fine art sculptures, toys, dolls, scale models, and sculptural designs applied to useful articles.

2-Dimensional artwork: watercolor and oil paintings; pen and ink drawings; logo illustrations; greeting cards; collages; stencils; patterns; computer graphics; graphics appearing in screen displays; artwork appearing on posters, calendars, games, commercial prints and labels, and packaging, as well as 2-dimensional artwork applied to useful articles, and designs reproduced on textiles, lace, and other fabrics; on wallpaper, carpeting, floor tile, wrapping paper, and clothing.

Reproductions of works of art: reproductions of preexisting artwork made by, for example, lithography, photoengraving, or etching.

Maps: cartographic representations of an area, such as state and county maps, atlases, marine charts, relief maps, and globes.

Photographs: pictorial photographic prints and slides and holograms.

Jewelry designs: 3-dimensional designs applied to rings, pendants, earrings, necklaces, and the like.

Technical drawings: diagrams illustrating scientific or technical information in linear form, such as architectural blueprints or mechanical drawings.

Text: textual material that accompanies pictorial, graphic, or sculptural works, such as comic strips, greeting cards, games rules, commercial prints or labels, and maps.

Architectural works: designs of buildings, including the overall form as well as the arrangement and composition of spaces and elements of the design.

NOTE: Any registration for the underlying architectural plans must be applied for on a separate Form VA, checking the box "Technical drawing."

SPACE 3: Creation and Publication

General Instructions: Do not confuse "creation" with "publication." Every application for copyright registration must state "the year in which creation of the work was completed." Give the date and nation of first publication only if the work has been published.

Creation: Under the statute, a work is "created" when it is fixed in a copy or phonorecord for the first time. Where a work has been prepared over a period of time, the part of the work existing in fixed form on a particular date constitutes the created work on that date. The date you give here should be the year in which the author completed the particular version for which registration is now being sought, even if other versions exist or if further changes or additions are planned.

Publication: The statute defines "publication" as "the distribution of copies or phonorecords of a work to the public by sale or other transfer of ownership, or by rental, lease, or lending"; a work is also "published" if there has been an "offering to distribute copies or phonorecords to a group of persons for purposes of further distribution, public performance, or public display." Give the full date (month, day, year) when, and the country where, publication first occurred. If first publication took place simultaneously in the United States and other countries, it is sufficient to state "U.S.A."

SPACE 4: Claimant(s)

Name(s) and Address(es) of Copyright Claimant(s): Give the name(s) and address(es) of the copyright claimant(s) in this work even if the claimant is the same as the author. Copyright in a work belongs initially to the author of the work (including, in the case of a work make for hire, the employer or other person for whom the work was prepared). The copyright claimant is either the author of the work or a person or organization to whom the copyright initially belonging to the author has been transferred.

Transfer: The statute provides that, if the copyright claimant is not the author, the application for registration must contain "a brief statement of how the claimant obtained ownership of the copyright." If any copyright claimant named in space 4 is not an author named in space 2, give a brief statement explaining how the claimant(s) obtained ownership of the copyright. Examples: "By written contract"; "Transfer of all rights by author"; "Assignment"; "By will." Do not attach transfer documents or other attachments or riders.

SPACE 5: Previous Registration

General Instructions: The questions in space 5 are intended to find out whether an earlier registration has been made for this work and, if so, whether there is any basis for a new registration. As a rule, only one basic copyright registration can be made for the same version of a particular work.

Same Version: If this version is substantially the same as the work covered by a previous registration, a second registration is not generally possible unless: (1) the work has been registered in unpublished form and a second registration is now being sought to cover this first published edition; or (2) someone other than the author is identified as a copyright claimant in the earlier registration, and the author is now seeking registration in his or her own name. If either of these two exceptions applies, check the appropriate box and give the earlier registration number and date. Otherwise, do not submit Form VA; instead, write the Copyright Office for information about supplementary registration or recordation of transfers of copyright ownership.

Changed Version: If the work has been changed and you are now seeking registration to cover the additions or revisions, check the last box in space 5, give the earlier registration number and date, and complete both parts of space 6 in accordance with the instruction below.

Previous Registration Number and Date: If more than one previous registration has been made for the work, give the number and date of the latest registration.

SPACE 6: Derivative Work or Compilation

General Instructions: Complete space 6 if this work is a "changed version," "compilation," or "derivative work," and if it incorporates one or more earlier works that have already been published or registered for copyright, or that have fallen into the public domain. A "compilation" is defined as "a work formed by the collection and assembling of preexisting materials or of data that are selected, coordinated, or arranged in such a way that the resulting work as a whole constitutes an original work of authorship." A "derivative work" is "a work based on one or more preexisting works." Examples of derivative works include reproductions of works of art, sculptures based on drawings, lithographs based on paintings, maps based on previously published sources, or "any other form in which a work may be recast, transformed, or adapted." Derivative works also include works "consisting of editorial revisions, annotations, or other modifications" if these changes, as a whole, represent an original work of authorship.

Preexisting Material (space 6a): Complete this space **and** space 6b for derivative works. In this space identify the preexisting work that has been recast, transformed, or adapted. Examples of preexisting material might be "Grunewald Altarpiece" or "19th century quilt design." Do not complete this space for compilations.

Material Added to This Work (space 6b): Give a brief, general statement of the **additional** new material covered by the copyright claim for which registration is sought. In the case of a derivative work, identify this new material. Examples: "Adaptation of design and additional artistic work"; "Reproduction of painting by photolithography"; "Additional cartographic material"; "Compilation of photographs." If the work is a compilation, give a brief, general statement describing both the material that has been compiled **and** the compilation itself. Example: "Compilation of 19th century political cartoons."

SPACE 7, 8, 9: Fee, Correspondence, Certification, Return Address

Deposit Account: If you maintain a Deposit Account in the Copyright Office, identify it in space 7a. Otherwise, leave the space blank and send the fee of $30 with your application and deposit.

Correspondence (space 7b): This space should contain the name, address, area code, telephone number, email address, and fax number (if available) of the person to be consulted if correspondence about this application becomes necessary.

Certification (space 8): The application cannot be accepted unless it bears the date and the **handwritten signature** of the author or other copyright claimant, or of the owner of exclusive right(s), or of the duly authorized agent of the author, claimant, or owner of exclusive right(s).

Address for Return of Certificate (space 9): The address box must be completed legibly since the certificate will be returned in a window envelope.

Copyright Office fees are subject to change. For current fees, check the Copyright Office website at *www.copyright.gov*, write the Copyright Office, or call (202) 707-3000.

Form VA
For a Work of the Visual Arts
UNITED STATES COPYRIGHT OFFICE

REGISTRATION NUMBER

VA VAU
EFFECTIVE DATE OF REGISTRATION

Month Day Year

DO NOT WRITE ABOVE THIS LINE. IF YOU NEED MORE SPACE, USE A SEPARATE CONTINUATION SHEET.

1

Title of This Work ▼
February-March 2003 Photographs

NATURE OF THIS WORK ▼ See instructions
Collection of Photographs

Previous or Alternative Titles ▼

Publication as a Contribution If this work was published as a contribution to a periodical, serial, or collection, give information about the collective work in which the contribution appeared. **Title of Collective Work ▼**

If published in a periodical or serial give: **Volume ▼** **Number ▼** **Issue Date ▼** **On Pages ▼**

2

a

NAME OF AUTHOR ▼
Jane Doe, Photographer

DATES OF BIRTH AND DEATH
Year Born ▼ Year Died ▼

NOTE

Under the law, the "author" of a "work made for hire" is generally the employer, not the employee (see instructions). For any part of this work that was "made for hire" check "Yes" in the space provided, give the employer (or other person for whom the work was prepared) as "Author" of that part, and leave the space for dates of birth and death blank.

Was this contribution to the work a "work made for hire"?
☐ Yes
☑ No

Author's Nationality or Domicile
Name of Country
OR { Citizen of United States
Domiciled in USA

Was This Author's Contribution to the Work
Anonymous? ☐ Yes ☑ No
Pseudonymous? ☐ Yes ☑ No
If the answer to either of these questions is "Yes," see detailed instructions.

Nature of Authorship Check appropriate box(es). **See instructions**
☐ 3-Dimensional sculpture ☐ Map ☐ Technical drawing
☐ 2-Dimensional artwork ☑ Photograph ☐ Text
☐ Reproduction of work of art ☐ Jewelry design ☐ Architectural work

b

Name of Author ▼

Dates of Birth and Death
Year Born ▼ Year Died ▼

Was this contribution to the work a "work made for hire"?
☐ Yes
☐ No

Author's Nationality or Domicile
Name of Country
OR { Citizen of _____
Domiciled in _____

Was This Author's Contribution to the Work
Anonymous? ☐ Yes ☐ No
Pseudonymous? ☐ Yes ☐ No
If the answer to either of these questions is "Yes," see detailed instructions.

Nature of Authorship Check appropriate box(es). **See instructions**
☐ 3-Dimensional sculpture ☐ Map ☐ Technical drawing
☐ 2-Dimensional artwork ☐ Photograph ☐ Text
☐ Reproduction of work of art ☐ Jewelry design ☐ Architectural work

3

a

Year in Which Creation of This Work Was Completed
2003
This information must be given in all cases.
Year

b

Date and Nation of First Publication of This Particular Work
Complete this information ONLY if this work has been published.
Month 2/6-3/6 Day _____ Year 2003 Nation

4

See instructions before completing this space.

COPYRIGHT CLAIMANT(S) Name and address must be given even if the claimant is the same as the author given in space 2. ▼
Jane Doe
123 Main Street
Anywhere, USA 12345

Transfer If the claimant(s) named here in space 4 is (are) different from the author(s) named in space 2, give a brief statement of how the claimant(s) obtained ownership of the copyright. ▼

APPLICATION RECEIVED

ONE DEPOSIT RECEIVED

TWO DEPOSITS RECEIVED

FUNDS RECEIVED

DO NOT WRITE HERE OFFICE USE ONLY

MORE ON BACK ▶
• Complete all applicable spaces (numbers 5-9) on the reverse side of this page.
• See detailed instructions. • Sign the form at line 8.

DO NOT WRITE HERE
Page 1 of _____ pages

EXAMINED BY	FORM VA
CHECKED BY	
☐ CORRESPONDENCE Yes	FOR COPYRIGHT OFFICE USE ONLY

DO NOT WRITE ABOVE THIS LINE. IF YOU NEED MORE SPACE, USE A SEPARATE CONTINUATION SHEET.

PREVIOUS REGISTRATION Has registration for this work, or for an earlier version of this work, already been made in the Copyright Office?

☐ Yes ☑ No If your answer is "Yes," why is another registration being sought? (Check appropriate box.) ▼

a. ☐ This is the first published edition of a work previously registered in unpublished form.

b. ☐ This is the first application submitted by this author as copyright claimant.

c. ☐ This is a changed version of the work, as shown by space 6 on this application.

If your answer is "Yes," give: **Previous Registration Number** ▼ **Year of Registration** ▼

5

DERIVATIVE WORK OR COMPILATION Complete both space 6a and 6b for a derivative work; complete only 6b for a compilation.

a. Preexisting Material Identify any preexisting work or works that this work is based on or incorporates. ▼

6
a
See instructions before completing this space.

b. Material Added to This Work Give a brief, general statement of the material that has been added to this work and in which copyright is claimed. ▼

b

DEPOSIT ACCOUNT If the registration fee is to be charged to a Deposit Account established in the Copyright Office, give name and number of Account.

Name ▼ **Account Number** ▼

7
a

CORRESPONDENCE Give name and address to which correspondence about this application should be sent. Name/Address/Apt/City/State/ZIP ▼

Jane Doe
123 Main Street
Anywhere, USA 12345

b
✚

Area code and daytime telephone number (212) 555-1234 Fax number (212) 555-6789

Email

CERTIFICATION* I, the undersigned, hereby certify that I am the

check only one ▶ {
☑ author
☐ other copyright claimant
☐ owner of exclusive right(s)
☐ authorized agent of _____
Name of author or other copyright claimant, or owner of exclusive right(s) ▲
}

of the work identified in this application and that the statements made by me in this application are correct to, the best of my knowledge.

8

Typed or printed name and date ▼ If this application gives a date of publication in space 3, do not sign and submit it before that date.

Jane Doe

Date April 15, 2003

Handwritten signature (X) ▼

X _____

Certificate will be mailed in window envelope to this address:	Name ▼ Jane Doe	**9**
	Number/Street/Apt ▼ 123 Main Street	
	City/State/ZIP ▼ Anywhere, NY 12345	

YOU MUST:
• Complete all necessary spaces
• Sign your application in space 8
SEND ALL 3 ELEMENTS IN THE SAME PACKAGE:
1. Application form
2. Nonrefundable filing fee in check or money order payable to *Register of Copyrights*
3. Deposit material
MAIL TO:
Library of Congress
Copyright Office
101 Independence Avenue, S.E.
Washington, D.C. 20559-6000

Fees are subject to change. For current fees, check the Copyright Office website at www.copyright.gov, write the Copyright Office, or call (202) 707-3000.

*17 U.S.C. § 506(e): Any person who knowingly makes a false representation of a material fact in the application for copyright registration provided for by section 409, or in any written statement filed in connection with the application, shall be fined not more than $2,500.

Rev: August 2003—30,000 Web Rev: June 2002 ♻ Printed on recycled paper U.S. Government Printing Office: 2003-496-605 / 60,029

- In space 1, give a collection title on the Title line *and* give "Group Registration/Photos" *and* the actual number of photos in the group on the Previous or Alternative Title line.

- In space 2, name the photographer. Sometimes the work may be what is known as a "work made for hire." If the work was made for hire, name the employer *and* the photographer employee, for example "XYZ Company, employer for hire of Jane Doe," and answer "Yes" to the "work made for hire" question. (Do not use a Short Form VA for a "work for hire" claim.)

- In space 3a, give the year of creation of the last photo in the group and in space 3b, give the complete date of publication for the group or, if published on separate dates, give the *actual* range of publication dates, consisting of the *specific* dates of first and last publication, for example, February 6–April 14, 2003. If the exact date(s) of publication cannot be determined, you may qualify the publication date(s) with "approximately," but the month, day, and year must be included. No dates in the future are allowed.

Next, you'll move on to Form GR/PPh/CON.

- A separate entry must be completed for each photo even if more than one photo was published on the same date and on the same page of a periodical or other work.

- Number each photo entry on the form and, if possible, key each number to the corresponding photo in the deposit. (Limit to 750 images on a continuation sheet!)

- Give a title (may be words or numbers) and a complete date of publication for each photo.

Now, you'll also have to satisfy the deposit requirements:

- Simply deposit a copy of each photograph in the group in one of the suggested formats listed in the Library of Congress's order of preference.

REGISTRATION WITHOUT FORM GR/PPH/CON

As another method, you may decide not to send a Form GR/PPh/CON. You must still send a completed Form VA (or a Short Form VA). For this process, you'd simply begin by completing a Form VA as instructed above.

CONTINUATION SHEET FOR FORM VA
Instructions for Group Registration of Published Photographs

Detach and read these instructions before completing this form.
Make sure all applicable spaces have been filled in before you return this form.

Basic Information

When does a group of photographs qualify for a single registration using Form GR/PPh/CON? For published photographs, a single group copyright registration can be made if all the following conditions are met:

1. All the photographs are by the same author, who may be an individual or an employer for hire
2. All the photographs are published in the same calendar year
3. All the photographs have the same copyright claimant(s)

When to use this form: You may use Form GR/PPh/CON to list title and publication date information to supplement Form VA for a group of published photographs that qualify for a single registration under Section 202.3 of the Copyright Office regulations. Use of Form GR/PPh/CON is optional.

The advantage of group registration: Any number of photographs published within a calendar year may be registered "on the basis of a single deposit, application, and registration fee."

Cautions about group registration: If infringement of a published work begins before the work has been registered, the copyright owner can obtain the ordinary remedies for copyright infringement (including injunctions, actual damages and profits, and impounding and disposition of infringing articles). However, the owner cannot obtain special remedies (statutory damages and attorney's fees) unless registration was made before the infringement commenced or within 3 months after first publication of the work. **To be certain that your application, deposit, and fee are received in the Copyright Office within 3 months of publication of the earliest published photograph within the group, you may wish to register fewer than 3 months of published photographs on a single application.**

This Form GR/PPh/CON:
- May only be submitted together with a Form VA.
- Must list a group of works that qualifies for a single copyright registration.

Procedures for Group Registration of Photographs

1. You **must** file a basic application on Form VA that contains information required for copyright registration.
2. Use of Form GR/PPh/CON together with Form VA is optional, but encouraged. Form GR/PPh/CON provides separate identification for each photograph and gives information about the first publication of each as required by the regulation.

What Copies Should Be Deposited for a Group Registration of Photographs?

You must deposit a copy of each photograph included in the group for which registration is sought. One copy of each photograph should be submitted in one of the following formats. The formats are listed in the Library of Congress's order of preference:

- Digital form on one or more CD-ROMS including CD-RWS and DVD-ROMS, in one of these formats: JPEG, GIF, TIFF, or PCD
- Unmounted prints at least 3 inches by 3 inches in size, but no larger than 20 inches by 24 inches
- Contact sheets
- Slides, each with a single image
- A format in which the photograph has been published, for example, clippings from newspapers or magazines
- A photocopy of each photograph, which must be either a photocopy of an unmounted print at least 3 inches by 3 inches in size, but no larger than 20 inches by 24 inches, or a photocopy of the photograph in its published format. It must be a color photocopy if the photograph was published in color.
- Slides, each containing up to 36 images
- A videotape clearly depicting each photograph

Note: For a photograph published before March 1, 1989, the copy of the photograph must be one that shows the photograph as it was first published. The copy of the photograph must show the copyright notice, if any, that appeared on, or in connection with, the photographic work. This is necessary because the copyright law in effect from January 1, 1978, through February 28, 1989, required that a work be published with a copyright notice identifying the owner of the copyright and the year date of first publication of the work. (For more information on copyright notice, consult Circular 3.) The deposit copy for a photograph published prior to March 1, 1989 may be any of the above-listed formats as long as the format deposited faithfully reproduces the photograph in its exact, first-publication appearance.

Line-by-Line Instructions *for Registering a Group of Published Photographs on Form VA (with or without a Form GR/PPh/CON [Continuation Sheet])*

Please type or print using black ink. The form is used to produce the certificate.

It is possible to register a group of published photographs using only Form VA. However, the Copyright Office encourages you also to use Form GR/PPh/CON so that the registration record in the Copyright Office is more complete.

1 Space 1: Title

You must give a title for the group (for example: John Smith's published photos 2001). In the "previous or alternative titles" space you must state "Group Registration/Photos" and give the approximate number of photographs in the group (for example: Group Registration/Photos; approx. 450 photographs).

If you complete Form GR/PPh/CON, list an identifying title, publication date, and nation of first publication in Space B. You are also encouraged, but not required, to provide a brief description of each photograph.

2 Space 2: Author

Give the name and other information about the single author of all the photographs in the group. If the photographs are works made for hire, you must include both the name of the employer for hire and the name of the photographer (for example: "XYZ Corporation, employer for hire of John Doe"). Under "nature of authorship," check only the box for "photograph." **To qualify for a group registration, all the photographs must be by the same individual photographer.**

3 Space 3a: Year of Creation

Give the calendar year in which you completed the most recent photograph you are registering at this time.

4 Space 3b: Publication

The statute defines "publication" as "the distribution of copies or phonorecords of a work to the public by sale or other transfer of ownership, or by rental, lease, or lending." A work is also "published" if there has been an "offering to distribute copies or phonorecords to a group of persons for purposes of further distribution, public performance, or public display."

All published on same date: If the photographs in a group were all published on the same date, give the date of publication (month, day, and year) and the nation where publication first took place. In this case, you may complete a Form GR/PPh/CON to list the individual titles in the group and to describe each photograph, but you do not have to give the publication date either on the continuation sheet or on the deposited images.

All published on different dates (within the calendar year): If the photographs in a group were published on different dates, you must give the range of dates of publication (for example: January 1 – December 31, 2001) in space 3B and give the individual publication date of each photo either as a separate entry on Form GR/PPh/CON or on each image deposited.

If you provide the individual publication dates on Form GR/PPh/CON, you should label the photographs in the deposit in such a way that, for each photograph included in the deposit, it will be possible to determine its publication date. For example, you should number each box for each of the entries on Form GR/PPh/CON, and you may elect to write the number of each entry on the back of the corresponding photograph (or, if you deposit photographs in digital formats, use the number in the box as the file name of the corresponding photograph).

All published within 3 months of registration: If each photograph in a group is first published within 3 months before the date on which an acceptable application, deposit, and fee are received in the Copyright Office, you may give the range of publication dates, (for example: February 15 – May 15, 2001) in space 3B of the application without giving publication dates on the deposited images or on a Form GR/PPh/CON. However, you are encouraged to provide individual publication dates to create a more complete record.

5 Space 4: Claimant(s)

Name(s) and Address(es) of Copyright Claimant(s): Give the name(s) and address(es) of the copyright claimant(s) in this work even if the claimant is the same as the author. Copyright in a work belongs initially to the author of the work, including, in the case of a work made for hire, the employer or other person for whom the work was prepared. The copyright claimant is either the author of the work or a person or organization to whom the copyright initially belonging to the author has been transferred.

Transfer: The statute provides that, if the copyright claimant is not the author, the application for registration must contain "a brief statement of how the claimant obtained ownership of the copyright." If any copyright claimant named in space 4 is not an author named in space 2, give a brief statement explaining how the claimant(s) obtained ownership of the copyright. Examples: "By written contract"; "Transfer of all rights by author"; "Assignment"; "By will." Do not attach transfer documents or other attachments or riders.

6 Spaces 5 and 6

Not applicable; leave blank.

7 Spaces 7, 8, and 9

Complete where applicable.

CONTINUATION SHEET FOR FORM VA
for Group Registration of Published Photographs

- This optional Continuation Sheet (Form GR/PPh/CON) is used only in conjunction with Form VA for group registration of published photographs.
- If at all possible, try to fit the information called for into the spaces provided on Form VA, which is available with detailed instructions.
- If you do not have enough space for all the information you need to give on Form VA or if you do not provide all necessary information on each photograph, use this Continuation Sheet and submit it with completed Form VA.
- If you submit this Continuation Sheet, clip (do not tape or staple) it to completed Form VA and fold the two together before submitting them.
- Space A of this sheet is intended to identify the author and claimant.
- Space B is intended to identify individual titles and dates of publication (and optional description) of individual photographs.
- Use the boxes to number each line in Part B consecutively. If you need more space, use additional Forms GR/PPh/CON.
- Copyright fees are subject to change. For current fees, check the Copyright Office website at *www.copyright.gov*, write the Copyright Office, or call (202) 707-3000.

FORM GR/PPh/CON
UNITED STATES COPYRIGHT OFFICE

REGISTRATION NUMBER

USE ONLY WITH FORM VA

EFFECTIVE DATE OF REGISTRATION

(Month) (Day) (Year)

CONTINUATION SHEET RECEIVED

Page _____ of _____ pages

DO NOT WRITE ABOVE THIS LINE. FOR COPYRIGHT OFFICE USE ONLY

A

Identification
of Application

IDENTIFICATION OF AUTHOR AND CLAIMANT: Give the name of the author and the name of the copyright claimant in all the contributions listed in Part B of this form. The names should be the same as the names given in spaces 2 and 4 of the basic application.

Name of Author _____ Jane Doe _____

Name of Copyright Claimant _____ Jane Doe _____

B

Registration
for Group of
Published
Photographs

COPYRIGHT REGISTRATION FOR A GROUP OF PUBLISHED PHOTOGRAPHS: To make a single registration for a group of works by the same individual author, all published within 1 calendar year (*see instructions*), give full information about each contribution. If more space is needed, use additional Forms GR/PPh/CON. Number the boxes.

Number 1

Title of Photograph Woman on Bicycle

Date of First Publication 02 (Month) 06 (Day) 2003 (Year) Nation of First Publication United States

Description of Photograph (Optional)

Number 2

Title of Photograph Man Climbing Tree

Date of First Publication 02 (Month) 12 (Day) 2003 (Year) Nation of First Publication United States

Description of Photograph (Optional)

Number 3

Title of Photograph Boy in Street

Date of First Publication 02 (Month) 15 (Day) 2003 (Year) Nation of First Publication United States

Description of Photograph (Optional)

Number 4

Title of Photograph Couple Dancing

Date of First Publication 02 (Month) 21 (Day) 2003 (Year) Nation of First Publication United States

Description of Photograph (Optional)

Number 5

Title of Photograph Vietnamese Child

Date of First Publication 03 (Month) 01 (Day) 2003 (Year) Nation of First Publication United States

Description of Photograph (Optional)

Number		
6	Title of Photograph Revolutionaries in the Street	

Date of First Publication 03 (Month) 02 (Day) 2003 (Year) Nation of First Publication United States

Description of Photograph (Optional)

B

Registration
for Group of
Published
Photographs
(continued)

Number		
7	Title of Photograph Girls at Lunch	

Date of First Publication 03 (Month) 03 (Day) 2003 (Year) Nation of First Publication United States

Description of Photograph (Optional)

Number		
8	Title of Photograph African Tribes	

Date of First Publication 03 (Month) 06 (Day) 2003 (Year) Nation of First Publication United States

Description of Photograph (Optional)

Number

Title of Photograph

Date of First Publication (Month) (Day) (Year) Nation of First Publication

Description of Photograph (Optional)

Number

Title of Photograph

Date of First Publication (Month) (Day) (Year) Nation of First Publication

Description of Photograph (Optional)

Number

Title of Photograph

Date of First Publication (Month) (Day) (Year) Nation of First Publication

Description of Photograph (Optional)

Number

Title of Photograph

Date of First Publication (Month) (Day) (Year) Nation of First Publication

Description of Photograph (Optional)

Number

Title of Photograph

Date of First Publication (Month) (Day) (Year) Nation of First Publication

Description of Photograph (Optional)

Number

Title of Photograph

Date of First Publication (Month) (Day) (Year) Nation of First Publication

Description of Photograph (Optional)

Number

Title of Photograph

Date of First Publication (Month) (Day) (Year) Nation of First Publication

Description of Photograph (Optional)

**Certificate
will be mailed
in window
envelope to
this address:**

Name ▼
Jane Doe (Photographer)

Number/Street/Apt ▼
123 Main Street

City/State/Zip ▼
Anywhere, USA 12345

YOU MUST:
· Complete all necessary spaces
· Sign your application

**SEND ALL 3 ELEMENTS
IN THE SAME PACKAGE:**
1 Application form
2 Nonrefundable fee in check or money order payable to *Register of Copyrights*
3 Deposit material

MAIL TO:
Library of Congress
Copyright Office
101 Independence Avenue, S.E.
Washington, D.C. 20559-6000

C

Fees are subject to change. For current ▼ fees, check the Copyright Office website at *www.copyright.gov* or call (202) 707-3000.

June 2002 — 20,000 Web: June 2002 ♻ Printed on recycled paper

(But remember, we recommend Registration with the GR/PPh/CON because the form will give complete information about each individual photo, which could be helpful should one find oneself defending a copyright claim.) Also, while you can register an unlimited number of photographs in one application using this procedure, discrepancies between the number of deposited photos and the number given on the application will delay registration. This form of registration has its own deposit requirements. You will need to follow directions above for registration with Form GR/PPh/CON. In addition, the deposit material must contain complete publication information for each deposited photograph. If a CD-ROM (or DVD-ROM) is deposited, the newest amendments to the regulations regarding Group Registration of Photographs state that the date of publication for each photograph may be identified in a text file on the CD-ROM or DVD that contains the photographic images or on a list that accompanies the deposit. If hard copies of photos are deposited, you must provide publication information on each photo.

REGISTERING A GROUP OF UNPUBLISHED PHOTOGRAPHS

The above should have you rolling on registering your published images, but what if you have a body of works that are unpublished? A copyright notice is not required to protect unpublished works. Remember, a work is published when it is distributed and offered to the public by sale, rental, display, or other methods, making one or multiple copies available. Registering two or more unpublished photographs as a collection for a single fee is very straightforward and only requires submitting a completed Form VA, a registration fee, and a deposit of the works to be registered in the collection. You won't file a Form GR/PPh/CON because that form is only used for group registration of *published* works. In group registration of unpublished photos, the deposit requirement is again only *one* copy of the work with accompanying "Identifying material," or "I.D. material." This again generally consists of two-dimensional reproduction(s) of a work in the form of photographic prints, transparencies, or photocopies that show the complete copyrightable content of the work being registered.

The Affect of Inadvertent Error in a Copyright Registration

But let's face it, registering large numbers of photographs as a collection can still be a difficult and complicated task. Published works need to be registered separately from unpublished works and often the copyright owner is not sure

what is considered published or unpublished. According to the Copyright Office, publication includes "the distribution of copies of a work to the public by sale or other transfer of ownership, or by rental, lease, or lending" by consent of the owner. In addition, "the offering to distribute copies to a group of persons for purposes of further distribution, public performance, or public display, constitutes publication. A public performance or display of work does not of itself constitute a publication." Understandably, artists often ask how to register collections and express concerns as to what happens if the photographer bumbles, accidentally including a published image with a collection of unpublished images. It is better to register works and do your best job than not to register any photographs in fear that you might make an inadvertent error and include a few published photographs with the unpublished. The worst that could happen is that the registration would be valid but that one image might not be covered. Recently a federal court in Massachusetts was asked this same question, and agreed that inadvertent errors would not invalidate a copyright registration in a collective work.

In *Cipes v. Mikasa Inc.*, the District Court for the District of Massachusetts saw an action by a photographer Joel Cipes against Mikasa Inc., for copyright infringement and breach of contract. Cipes alleged that Mikasa unlawfully used, for commercial purposes, without license or permission, photographs taken by Cipes and registered by him with the Copyright Registration Office and/or failed to pay Cipes the requisite licensing fees for use of the photographs.

Cipes is a professional photographer who took photographs of Mikasa products, such as tableware and glasses, at the request of Mikasa. He would then license the images to Mikasa for limited uses, such as in bridal magazine advertisements. Cipes claimed that Mikasa exceeded the scope of the license agreement by using the photographs in other manners and that it failed to compensate him for such use.

Mikasa fought back by attacking the validity of the photographer's copyright registrations. Cipes registered certain of the photographs as an unpublished collection and was granted a certificate of registration dated July 8, 2002 from the Copyright Office. Mikasa asserted that the registration was invalid because the company displayed many of the photographs included in the collection in bridal brochures and on its Web site prior to the date of registration.

In addition to the collection of unpublished photographs, the photographer registered and was granted copyright certificates for collections of published works dated the same date. Mikasa also asserted that those registrations were invalid because 1) within each collection there were photographs that were published during different calendar years in violation of federal

regulations, and 2) several of the photographs were registered multiple times because they were inadvertently contained in more than one collection.

Based on these "defects," Mikasa asked the court to send Mr. Cipes packing, arguing that the photographer's registrations were invalid and that the court was required to dismiss the copyright portion of the complaint for lack of jurisdiction. Cipes admitted that several registration errors occurred but argued that because none of the errors were fraudulent or material to the interests of Mikasa, summary judgment was not warranted.

The basis for the motion to dismiss for lack of jurisdiction is Section 411 of the Copyright Act that provides that "no action for infringement of the copyright in any United States work shall be instituted until registration of the copyright claim has been made in accordance with this title." This is the statutory language we've translated into "A valid copyright registration becomes the keys to the courthouse."

Group registration permits photographers to register groups of published photographs in a single calendar year. Mikasa challenged the validity of the Cipes registrations of published collections of photographs on the grounds that within each collection, there were photographs that were not published during the same calendar year as required by the regulations and several photographs in those collections were registered in more than one collection.

Cipes conceded that the above errors were present in his applications. He took many pictures of Mikasa's products over a period of years and occasionally licensed the use of certain photographs to Mikasa for use in bridal magazines. Those licensed photographs would be considered "published." In 2002 Cipes registered all the Mikasa photographs but since many of the photographs were similar in appearance and had been taken and published over a number of years, Cipes accidentally misstated the year of publication of some of them on his application for registration. Likewise, Cipes inadvertently included several of the photographs in more than one collection.

As you now know, Federal courts are required to follow appellate court decisions within their district. Massachusetts is in the "First Circuit." Following the First Circuit decision in *Data General Corp. v. Grumman Systems Support Corp.*, this court concluded that the inadvertent errors did not invalidate the registrations. In *Grumman*, the district court ruled that copyright registrations were valid despite some inadvertent errors contained in transcribing computer source code. The Court of Appeals affirmed that decision, recognizing that it is well established that immaterial, inadvertent errors in an application for copyright registration do not jeopardize the validity of the registration. The Court of Appeals further approved of the district court's instructions to the jury that

"discrepancies in dates, filing the wrong pages or partial pages and similar errors do not impeach the validity of the copyright."

Because the photographer committed the errors inadvertently, the issue before the court was limited to their materiality to Mikasa. The court concluded that none of the errors were considered material to Mikasa. First, the Copyright Office provides a procedure and a form for the correction of errors of the kinds at issue (errors in dates and duplicate registration). Second, there was no allegation that Mikasa was prejudiced by the errors. The court held that the registrations were not invalid and denied Mikasa's motion for summary judgment.

Mikasa also moved for summary judgment with respect to certain registrations and argued that Cipes mistakenly or fraudulently registered the subject photographs as part of the unpublished collection despite the fact that he knew Mikasa had distributed the photographs prior to registration. Mikasa argues that because the subject photographs had appeared on Mikasa's Web site and in its bridal magazines prior to when Cipes registered them, the photographs should have been registered as a published collection.

This argument failed because an unauthorized user cannot change the status of a work from unpublished to published by virtue of using it without permission. Because an unauthorized user of a work is incapable of publishing it within the meaning of the Copyright Act, the photographs were properly regarded as unpublished at the time of registration.

While one should always try to register works as carefully as possible, it is comforting to know that inadvertent errors in completing a copyright registration are not fatal. Photographers should continue to register collections of works, both published and unpublished.

WHAT ARE THE BENEFITS OF REGISTRATION?

In *Villa v. Brady Publishing*, the importance of registering a copyright was made apparent to a graffiti artist who began an action for infringement, only to be dismissed by the Federal Court. Although the plaintiff *had* applied for registration, he failed to provide confirmation of the registration in the form of either an acceptance or refusal by the Copyright Office.

Hiram Villa is a graffiti artist who works in large wall murals often consisting of stylized letters spelling his pseudonym, "UNONE." When Brady Publishing published a book entitled *Tony Hawk's Pro Skater 2 Official Strategy Guide* and included a reproduction of one of Villa's murals without obtaining permission, he was not flattered and commenced a claim for copyright

infringement. The publisher successfully attacked Villa's claim of copyright infringement by simply pointing out that his work was not registered. Under the Copyright Act, registration (except for foreign works) serves as "the key to the courthouse" and is a prerequisite to any infringement action. Although Villa claimed to have applied for registration, the court was not satisfied that registration was complete without any evidence of registration from the Copyright Office. The court emphasized that it is not enough to say that the application is in the mail. Villa's claim was dismissed.

The importance of registering a copyright goes beyond avoiding the headache of court filings and an extended judicial process. Although a work can be registered at any time (unless it is already in the public domain), there are many advantages of early registration. If you have not registered prior to an alleged infringement, not only will you be prevented from filing an infringement suit until you obtain a registration (unless you are a foreign author), but you will also be prevented from receiving attorney's fees and statutory damages and will be limited to proving actual damages. Normally, registration of a copyright can take several months without the expedited process. Although it's certainly possible to seek special handling and request an expedited registration, the cost for this service is $685 in fees to the Copyright Office in addition to the standard registration fee (now forty-five dollars). Certifications of Registration for works registered within five years of creation are automatically presumed to be valid.

WHEN IS A WORK CONSIDERED REGISTERED?

By now, the reader should realize that a U.S. author must register his or her work with the Library of Congress before filing an infringement action in court. While you can request registration on an "expedited basis" if you need it for litigation or other good reasons, this special treatment is costly. Unless you have a rich benefactor with $685 per application lying around to expedite the registration process, your application must wind its way through the examiner's office. These days, it can take upwards of three months or more to receive your official registration certificate, and if the examiner has any questions, there may be further delay. Whether you need to wait until you receive the certificate before filing a claim has been decided differently across the country, depending on your judicial district.

In *Iconbazaar v. AOL*, the plaintiff, a North Carolina company, alleged that America Online used one of its images without prior approval. Iconbazaar

owns intellectual property rights in various computer graphic images or icons. Specifically, Iconbazaar alleged that AOL used a dragonfly image in its AOL Instant Messenger program without Iconbazaar's knowledge or consent. Iconbazaar filed a complaint against AOL in 2002 alleging copyright infringement among other claims. As one of its defenses, AOL asserted that the dragonfly image was not registered with the Copyright Office prior to the filing of the infringement action. AOL moved to dismiss the complaint based on this defect.

AOL argued that the Court did not have subject matter jurisdiction over the copyright claim because Iconbazaar failed to timely register its dragonfly image. The dispute centered on the issue of when a work is considered "registered" for purposes of copyright law. Iconbazaar contended that registration was complete upon sending an application to the Copyright Office, which it alleged was done sometime prior to the institution of the action. In contrast, AOL contended that registration was not complete until a party has received or been denied a registration certificate.

Some district courts have found that a copyright is registered upon filing a completed application with the Copyright Office, while others require a plaintiff to show receipt or denial of a copyright registration certificate before bringing suit. The court pointed out the importance of looking to what's known as "Congressional intent" behind the statutory provisions of the Copyright Act, and noted that many provisions seemed to support an interpretation that "it's in the mail" amounted to registration. In addition to direct statutory support, the court saw an overall statutory theme supporting the position that Congress intended for registration to be complete on application. Imagine a time line. The statute of limitations for copyright infringement actions is three years, so your time line is three years long. Beyond those three years, the abbreviation for statute of limitations, S.O.L., takes on another meaning, which should be familiar to most readers. Now, an owner of the disputed work may not bring suit for infringement until his copyright has been registered. The task of processing and evaluating a copyright application could be a lengthy one during which time an infringing use may continue unchallenged if the owner is not allowed to begin suit. The court therefore adopted the view that filing the completed application was sufficient and they refused to dismiss for failure to register the copyright. In other words, the court didn't want to start taking bites out of that three-year statute of limitations just because it takes time to get these applications through the office.

The interpretation by this court is favorable to copyright holders who have filed applications for copyright infringement but have not received the

application. Some would argue that claims should be dismissed when at the time a complaint is filed, the plaintiff had applied for a copyright on its work but had not received certification from or had its application denied by the Copyright Office. Under this reasoning a copyright action should be allowed when the certificate has been received because there are times when an application may be denied. This is often termed the "registration approach." Conversely, plaintiffs like Iconbazaar have asserted that simply having applied for registration before the claim is entered is enough to get the car started. This position is referred to as the "application approach." The federal courts are as divided on whether the "application" or "registration" approach is correct. In the districts following the application approach, infringement claim will not have the forced delay of awaiting the certificate. Hence, paying huge fees for expedited registration may not be necessary in all instances and the risk of running into a statute of limitations problem will be reduced.

PRE-REGISTRATION?

The real importance of registration is to preserve the possibility of statutory damages, including those for willful infringement, and attorney's fees (not to mention the excitement of getting your first bona-fide certificate of registration!). In addition to those perks, the U.S. Copyright Office recently unveiled what it calls Pre-registration Service. Certain categories of works are vulnerable to a practice known as "prerelease" infringement. Pre-registration was initially urged by the movie and music industry based on an increase in piracy of works prior to publication, which prevented the copyright owner from seeking statutory damages and attorney's fees normally available to works once registered as published. The Advertising Photographers Association (APA) encouraged the Copyright Office to include "advertising or marketing photographs" to the classes of works, which it did.

Although pre-registering a photograph will not substitute for standard registration, pre-registration grants the future registrant the right to bring an infringement action before releasing and registering the work. Pre-registration is meant to be a mechanism that will grant a successful claimant the brass ring—statutory damages and attorney's fees. Those who wish to pre-register a work and thereby acquire these benefits must meet three conditions. To begin, the work must be unpublished and must be in actual production in some physical or digital format. In addition, the work must fall within one of the six statutorily delineated and defined categories. For our purposes, the work must be either an

advertising or marketing photograph. Pre-registrants must also submit an online application with a certification of a reasonable expectation that the work is for commercial distribution as well as a one hundred dollar filing fee.

Once a work is pre-registered, any claimant must register the work "within one month of becoming aware of infringement and no later than three months after first publication." Without proof of registration within this time frame, the court must dismiss any action for infringement occurring before or within the first two months after first publication.

As with most anything released from the U.S. Copyright office, each condition, requirement, and exception of pre-registration provides some confusion. Anyone hoping to benefit from this new service is beholden to follow it to the letter, which will require us to understand each point. To begin, the work must be unpublished to qualify for pre-registration. Again, the Copyright Office defines publication as "the distribution of copies of a work to the public by sale or other transfer of ownership, or by rental, lease, or lending." The Copyright Office further explains that "the offering to distribute copies to a group of persons for purposes of further distribution, public performance, or public display, constitutes publication. A public performance or display of a work does not of itself constitute publication."

Pre-registration requires the work must be in the process of being prepared. This requires a demonstration that the "creation and fixation of the photograph must have already commenced." The Copyright Office doesn't require the final cut, but does require some modicum of photographic composition. The applicant would have to present a fixed work exhibiting elements of an original photographic arrangement such as: time and light exposure, camera angle, lighting, and arrangement of subject. Again, the requirement is commencement of the work, with room for editing or further creative input.

Further, the work must be intended for commercial distribution. This requires the claimant to verify "he has a reasonable expectation that the photograph will be commercially distributed." This could raise a few questions, to be sure. If the claimant has never had any significant commercial photography experience heretofore but officiously pre-registers his work, would his expectation be unreasonable? There are several points in the creative process where the artist may develop an intent vis-à-vis his or her work. At what point in the production of the work does the Copyright Office require the applicant to determine that the work is intended for commercial distribution? There's no real answer to that one.

Another point of interpretation arises in the categorical definition of "advertising or marketing photographs." This requires that the photos in question be

created for advertising or marketing for a product or service. This may be fine for the larger commercial photography houses that create marketing photographs as a matter of course, but here the smaller independent artist is asked to make a determination they may not otherwise be asked to make. In this case, as with intent to commercially distribute, the applicant's intent to use for marketing purposes may not be clear in each stage of production.

What we do know for certain is that this pre-registration service is intended to protect those works that are truly at risk of piracy before release. With advertising photographs, this could be an important service if photographing a celebrity to promote a movie the celebrity was starring in before the release. These types of images may be pirated and circulated before publication. It would not however, protect a portrait of a celebrity taken for an editorial article, pirated before the article was published. These types of photographs should be registered as unpublished works as soon as possible after creation to obtain the benefits of statutory damages and attorney's fees.

Advertising photographs that are pre-registered must be subsequently registered to obtain the benefits of statutory damages or attorney's fees. Unless there is real risk of prepublication piracy, it is still more economical to register all the works from a shoot as unpublished works prior to publication or if published, take advantage of the Copyright Office's regulations permitting group registration of photographs.

3 RIGHTS UNDER COPYRIGHT LAW

Under section 201 of the Copyright Act, legal ownership of a work "vests initially in the author or authors of the work." Such an unqualified statement leads one to think that's the end of that story. However, if for some reason a reader should forget everything but one point about copyright law after digesting this book, let it be that things are never as simple as they seem.

OWNERSHIP OF COPYRIGHT

Usually, the author of a work is the person who translates an idea into a fixed, tangible expression entitled to copyright protection. Under normal circumstances, a photographer is the author of his or her photographs and owns the copyright in them, even if a client owns a copy of a certain photo. Indeed, there are situations in which the person who hits the shutter release may be the author, yet not the owner of the copyright, as in the case where an author transfers the copyright to another. Ownership is important because only the owner of a copyright or the owner of an exclusive right (a "grantee") can enforce the rights that the Act affords. For photographers, and most importantly free-lancers, ownership issues frequently arise in the context of what is known as "work for hire." Works made for hire are "authored" by the hiring party, and the initial owner of the copyright is not the creator of the work but the employer or the commissioning party. The Act defines a work made for hire as "a work prepared by an employee within the scope of his or her employment; or a work specially ordered or commissioned if the parties expressly agree in a written instrument signed by them that the work shall be considered a work made for hire." The following case provides a good example of how a work is determined a work for hire, as well as the consequences of that doctrine.

In a complex case brought in an Illinois federal court, two "live-event" photographers, including Paul Natkin, brought an action against Oprah Winfrey and her production company Harpo Productions for using their

images in a book about the famed host. The plaintiffs worked as staff photographers on the show where they originally created the images. Oprah and Harpo Productions claimed the images were works for hire, making copyright ownership their own. The photographers, on the other hand, claimed that they were not employees, but independent contractors. As putative independent contractors, they would retain copyright ownership with the power to control use of the images. In this case, the photographers wished to limit the use of the photographs to publicity purposes.

The court applied the factors set forth in the seminal case concerning works for hire *Community for Creative Nonviolence v. Reid.* In *Reid,* the United States Supreme Court distinguishes between employees and independent contractors by using several factors. First, we consider the hiring party's right to control the work. Second, the skill required to create the work. Courts also look to the source of the materials used in creating the work. In addition, the duration of the relationship between the parties can indicate whether the artist was an independent contractor versus an employee. Also, if the hiring party had the right to assign additional projects to the hired party, the relationship looks more like an employer/ employee dynamic. If the hired party exercises a great degree of discretion over how and when to work, she begins to look more like an independent contractor. The method of payment, the provision of employee benefits, and the tax treatment of the hired party can also shed light on the type of relationship.

Using the *Reid* analysis, this court determined that the photographers were professionals who used their own equipment and hired others to take their place when they were unavailable. Also, the photographers received payment for their work by issuing bills, and were not paid a salary by Harpo Productions. The most important considerations were that the photographers did not receive any regular employee benefits for their work on the show, nor did Harpo Productions withhold taxes from the photographers.

The court stated that Oprah and Harpo could not be allowed to obtain the benefits associated with hiring an independent contractor, and at the same time enjoy the advantages of treating that person as an employee (or more importantly, treating the work created as their own). Copyright ownership in the images means control over the images, which in turn translates into money for the owner. If Harpo Productions owned the copyrights, they could license or sell them and the plaintiffs wouldn't see a dime. As owners of the photographs, the artists retain a body of rights that enable them to continue to enjoy the financial returns through further licensing.

In order to avoid a conflict, artists must expressly establish the type of relationship that exists between themselves and their clients. Unless otherwise

agreed to, contracts should clearly state that the work being performed is not a work for hire and that copyright ownership belongs to and will remain with the photographer.

THE RIGHTS OF A COPYRIGHT OWNER

The copyright owner controls the rights to his or her work to the exclusion of others. Only the author can give these rights away. The rights applicable to the visual arts include the following:

To reproduce the work. The copyright owner controls the right of reproduction, which means he or she can determine who can make a copy of the whole or part of a work.

To modify the work (derivative works). The copyright owner holds the exclusive right to modify the original work. This includes the right to make a painting from a photograph, or a collage from several different photographs or images. Even if derivative work is extremely creative, permission must be obtained from the owner of the original work, unless the defense of fair use applies. Manipulating and combining images in Photoshop or similar computer programs without permission is an example of an unauthorized derivative use.

To distribute copies. The copyright owner (or the owner's authorized agent) is the only one permitted to distribute copies of the work to the public by sale or other transfer of ownership, such as a licensing agreement. For example, if a publisher wishes to use a photograph in a book, a license must be obtained and, in most cases, a fee negotiated.

DERIVATIVE WORKS

Section 101 of the Copyright Act states:

A "derivative work" is a work based upon one or more pre-existing works, such as a translation, musical arrangement, dramatization, fictionalization, motion picture version, sound recording, art

reproduction, abridgment, condensation, or any other form in which a work may be recast, transformed, or adapted. A work consisting of editorial revisions, annotations, elaborations, or other modifications, which, as a whole, represent an original work of authorship, is a "derivative work."

. .

An example of a derivative work would be a photograph digitally altered by a designer in Photoshop or other software that allows manipulation or merging of the photograph with other images or materials. Another example is changing the medium of art, such as adapting a photograph to create a painting or sculpture.

A derivative work, in certain circumstances, may have its own copyright distinct from the copyright in the original photograph if the newly added material is sufficiently original, but it is a limited copyright that does not impair the copyright to the original work. The derivative copyright only covers any original work added in making the second work. Further, if a license is granted to create a derivative work, any derivative work created can only be used for the purpose granted in the license. Any greater use would be considered an infringement of the copyright to the original work and an action can be brought against the infringer.

When digital technology first became readily accessible, making it easier to manipulate and combine images to create a new and derivative work, a question arose regarding the ownership of the resulting work. While created from individual copyrighted images, such works were often combined using the skills of a computer technician. Since case law in the area of copyright usually lags years after a new technology, the best guess was that the computer technician should not be able to own the copyright in the derivative work one commissioned, but it would be advisable to have a written agreement that the copyright to the derivative work remains with the owner of the original material.

A California federal court had an opportunity to review this question, and agreed that the copyright should remain with the original creator. To avoid litigation, it would still be advisable to carefully review any terms of any invoice or purchase order when working with a computer technician in digitally altering images, and add clear language that the resulting derivative work belongs to the copyright owner, and not the computer operator.

The world-renowned equine photographer, Robert Vavra, learned this lesson the hard way. He sought the assistance of a graphic designer, Patrick

Sagouspe, to combine three of his images previously reproduced in his book *Equus: The Creation of a Horse.* In 1997 Vavra was involved in photographing promotional material for the Robert Redford movie *The Horse Whisperer* and decided to create a digital photographic montage to coincide with the opening. He had first worked with a computer artist to create a montage with three of his copyrighted images. When he was not satisfied with the resolution of the montage, he turned to Patrick Sagouspe, who had assisted him in the past in digitizing images for prior books and had higher quality equipment at his disposal. The montage was entitled "The Whisperer's Horse." Sagouspe apparently registered the composite image as a derivative work under his own name and demanded that Vavra stop selling prints of "The Whisperer's Horse" on the Internet. When Vavra refused, Sagouspe sued Vavra for copyright infringement. In the alternative, he claimed that he was a co-author of "The Whisperer's Horse" and was entitled to 50 percent of all the profits.

A Federal Court of the Southern District of California dismissed both copyright related claims on a motion for summary judgment. The court found that the derivative work registered by Sagouspe did not satisfy the test of minimal original contribution necessary to create a copyrightable derivative work. The court found that he only modified the original composite image previously created by the first computer artist. Secondly, the court found that his copyright must fail because it threatened to affect Vavra's underlying copyright to his images. Although Vavra could use the individual images, he could not use the combined images without fear of infringement.

While this decision answers the question of copyright ownership in this instance, it is always better not to have to prove that you are right in court. Clear agreements are still the best protection so that you remain the copyright owner when having digitally enhanced or altered works created.

"FOR LIMITED TIMES"

Since the rights granted under the Copyright Act do amount to a monopoly, the term of that monopoly is limited in order to find a balance in guaranteeing an economic return for current works while not going so far as to limit the possibility of future works. The duration of copyright in various years has become complicated. The Copyright Revision of 1976, effective 1978, changed the duration of copyright from a twenty-eight year renewal scheme to life of the copyright holder plus fifty years, unless it was a work for hire, in which case the duration of copyright was for seventy-five years. The Sonny Bono Copyright

Term Extension Act of 1998 extended U.S. copyright protection to life of the author plus seventy years and it affects works retroactively. Works for hire are now protected for ninety-five years. In addition, several amendments to the Copyright Act over the years have extended the duration of copyrights for works created under the 1909 Act, making our system of copyright extremely complex.

The following is a summary of the duration of copyright:

1) A work published after January 1, 1923 and before 1964, and originally copyrighted within the past seventy-five years, may still be protected by copyright if a valid renewal registration was made during the twenty-eighth year of the first term of copyright. If renewed, protection is now for the full ninety-five years. Example: a work published on January 2, 1923, and renewed between January 2, 1950 and January 2, 1951, will not fall into the public domain until the end of 2018.

2) Copyrights originally secured between 1950 and December 31, 1963, still require renewal under strict time limits. If renewal was made at the proper time, the renewal was for sixty-seven years. If renewal was not made, the works fell into the public domain at the end of the first term (twenty-eight years).

3) Copyrights secured between January 1, 1964, and December 31, 1977, have an optional renewal, which automatically vests on December 31st of the twenty-eighth year. Certain benefits accrue with renewal but are not required. It is still a two-term copyright but the second term is sixty-seven years, creating a ninety-five year copyright. Works created on January 1, 1964, will fall into the public domain at the end of 2059.

4) Copyrights in their second term on January 1, 1978, have been automatically extended to a maximum of ninety-five years without the need for further renewal.

5) Works created since 1978 are now protected for the life of the author plus seventy years, and in the case of work for hire, ninety-five years.

6) Works in existence but unpublished and unregistered on January 1, 1978, were automatically given federal copyright protection. All works are guaranteed at least twenty-five years of protection, or until December 31, 2002, and if published before that date, the term will extend another forty-five years or through the end of 2047.

This means that works of art that have never been published (i.e., only exhibited in a gallery but never reproduced), even if created in a year that *if published* would place it in the public domain, are still protected by federal copyright protection. All terms of copyright now run through the end of the calendar year in which they would expire.

It is a common assumption that older works, particularly photographs and works of art, that were created under the pre-1978 Copyright Act, are now in the public domain for lack of compliance with formalities such as publication with proper copyright notice, or registering copyright renewals within the twenty-eighth year after publication. While this might be a valid assumption with U.S. works, it may not be accurate with works of foreign authors. Under the current Copyright Act, certain foreign works that were in the public domain can be restored and protected under copyright.

FORMAL REQUIREMENTS

In our discussion concerning copyright term, we mentioned that works made before 1978 must comply with formal requirements or fall into the public domain. The following cases illustrate that even today, the formal requirements of the 1909 Act play a significant role in determining the rights of authors in relation to their works created before 1978. The 1909 Copyright Act was rife with formalities that if left unattended, could thrust works into the public domain to the misfortune of the unwitting creators. Publication was a significant component of the 1909 Act, meaning publication without observing formalities (such as the "circle C" copyright notice) would land the work squarely into the public domain. As a result, litigation concerning works under the 1909 Act includes a publication analysis to determine if the initial publication met the formal requirements or, conversely, if the work is in the public domain. Under the 1909 Act, publication occurs when by consent of the copyright owner, the original or tangible copies of a work are sold, leased, loaned, given away, or otherwise made available to the general public. Sometimes, the analysis hinges on whether the initial "publication" was by consent of the copyright owner. Formalities of notice were required until March 31, 1989, when the U.S. finally joined the Berne Convention Treaty.

For instance, in 1971, Fantasy Inc., released the Lenny Bruce Album *Live at the Curran Theater* in a three LP set. The album contained a photograph of Lenny and Kitty Bruce that Edmund Shea took in 1966. The photograph in the album is not credited to Shea, nor does it contain a copyright notice. In 1972

(after the album was released), Shea had a conversation with Ralph Gleason, a Fantasy employee. Shea allegedly informed Gleason that no permission was granted to Fantasy to publish the picture. According to Shea, Gleason assured the photographer that Fantasy would not publish the photo in the future without permission and that Shea would receive payment for any such future use. The LP was distributed to the general public through retail outlets and by catalog purchase from 1971 to 1991. Shea acknowledged that that he was aware the album and accompanying photograph were publicly available for several years after the Gleason meeting.

Traveling forward in time to 1999, we find Fantasy re-released *Live at the Curran Theater* on CD format with the photograph of Lenny Bruce appearing on a page of the liner notes. On September 20, 1999, Shea registered the photograph with the Copyright Office as an "unpublished photograph." In June 2003, Shea filed a complaint for copyright infringement against Fantasy. Fantasy filed a motion to dismiss the complaint asserting that the work entered the public domain.

There was no issue that the album containing the Lenny Bruce photograph was available from 1971 to 1991. The issue was whether that publication was with consent. Remember that Shea had a conversation with Gleason back in 1972, where they discussed the use of his picture. The essence of the talk between Gleason and Shea was that Fantasy could continue to use Shea's photograph when distributing the LP; however, Fantasy would have to pay Shea royalties if it wanted to use the photograph in any other context or format. Based on this arrangement, Fantasy's distribution of Shea's photograph after his conversation with Gleason constituted a consensual "publication" for the purposes of the 1909 Copyright Act. Because Shea failed to comply with the statutory formalities of the 1909 Copyright Act (affixing notice of copyright to every distributed work), the Court found that Shea forfeited his copyright and the photograph was considered to be in the public domain.

After the court determined that the photo was in the public domain under the 1909 Act, the Court then looked to the 1976 Act to see if Shea could rely on any of its provisions to save his copyright claim. The Copyright Act of 1976 does not provide protection for works that entered the public domain before January 1, 1978. There is a statutory presumption that all copyright registrations are valid under the 1976 Copyright Act (17 U.S.C. §410(c)), but it only applies when the certificate of registration is made before or within five years after first publication of the work. Since the Court determined that the photograph was "published" in the early 1970s, Shea was not entitled to a presumption of validity.

Unfortunately, the 1909 Copyright Act is a landmine when it comes to protecting artists' works. The risk of non-compliance with the notice requirement is high. Fortunately, when the United States joined the Berne Convention in March 1989, the formalities of notice were eliminated. The elimination of the requirement was not retroactive, so proper notice is still a concern with older works. However, if the publication without notice was truly without the author's consent, the publication will not be considered a "publication" for purposes of the Copyright Act.

Another case concerning the 1909 Act's formal requirements involved the publication of some 1950s publicity stills of Marilyn Monroe. In *Milton H. Greene Archives, Inc. v. BPI Communications, Inc.*, we had a plaintiff who cried infringement when the defendant published seven photographs of Marilyn Monroe in a book of film stars. These photographs came from a photo archive of entertainment industry publicity pictures, historic still images widely distributed by the studios to advertise and promote their then new releases. While not considered valuable at the time, avid collectors have created complete archives by salvaging and cataloging movie and television photographs, preserving a significant facet of American culture. These archives are a valuable cache for publishers who rely on these archives as a resource for entertainment material. It has been assumed that these images are most likely in the public domain or owned by studios that freely distributed the images without any expectation of compensation. Archives will lend these images for a fee to publishers and producers of documentaries for "editorial" uses, in keeping with the original intent to publicize the movie or promote the actor. Seeing these images in print years later, some photographers, or the heirs, attempt to assert rights that most believed to be extinguished or abandoned. Some are more aggressive than others.

In this infringement action, the copying prong of the infringement test was plain. The opinion reads, "defendant published a book, *Blonde Heat*, displaying photographs of Marilyn Monroe." What's left to dispute? When copying is without dispute, ownership—or the proper observance of formalities—is attacked.

Usually, the certificate of registration is enough evidence of ownership and validity of copyright for purposes of litigation. With ownership as the only issue left on the table, BPI's counsel had an ethical duty to at least wonder if the registration was valid. As we learned from the previous case, Section 410(c) of the Copyright Act tells us that the presumption of validity is not ironclad. According to that part of the statute, "registration constitutes prima facie evidence of validity if the registration is made before or within five years after

first publication of the work." If the work is registered outside of this window, the plaintiff may not be able to stand on the certificate. In *Greene Archives,* the photos were allegedly originally published in the 1950s. The certificates are dated anywhere from the late 1990s to 2003, depending on the photo in question. Clearly these photographs fell well outside the five-year window if publication indeed occurred in the 1950s.

Since these photos were "published" before the passage of the 1978 Act, the analysis involved the former Copyright Act. The 1909 Federal Copyright Act requires publication with copyright notice in the name of the holder in order to enjoy federal protection. The math is easy: publication plus notification equal protection. Since these photographs appeared in press kits, at theatres, and in articles and advertisements, the court found that Milton Greene, the photographer, permitted publication. Justice Taylor also found that the plaintiff didn't provide any evidence that the publication included copyright notice in Greene's name. Indeed, the evidence showed the photographs were not affixed with notice. This doesn't bode well for the plaintiff, since, you guessed it, if the putative copyright holder fails to meet the 1909 Act's notification requirements, the work enters the public domain.

The plaintiff countered by putting the publication element back into play. The Greene Archive argued that there was a legal distinction between general and limited publication. General publication includes publication of a photograph in a newspaper or magazine, for instance. Courts hold that a limited publication may apply where the work in question "was distributed (1) to a 'definitely selected group,' and (2) for a limited purpose, (3) without the right of further reproduction, distribution, or sale." This isn't a multiple choice; the plaintiff has to satisfy all three or lose protection.

The court found that Greene had once handed the photographs over to a wide group of publicists and studios. Further, since Greene allowed these parties to use the photographs in newspapers and magazines, and since historians testified that these stills were available to the general public, the plaintiff failed the first element. The court went on (which may not have been necessary in light of the determination on the first issue, but helpful nonetheless) to explain that the plaintiff did, however, fulfill the second element.

The court found that the purpose was probably limited. One photo includes some text which explicitly limits the purpose to "display only in connection with the exhibition of this picture at your theatre" with instructions for prompt return of the materials. That was enough to satisfy the second element. Even so, the limited purpose definition requires the holder to "preclude recipients from reproducing, distributing, or selling any copies." The court found

that since the whole idea behind the press kits was to encourage distribution, then the plaintiff couldn't be heard to say that they precluded recipients from distributing the photographs. Remember, all three elements make the case for limited publication, and our plaintiff only scored one.

That entire analysis brings us back to the threshold issue: valid ownership. The plaintiff needs to prove copying and ownership. Copying, in this case, is a given. Registration proves ownership as long as it occurs before or within five years of first publication. We had publication and latent registration. Publication *with* notice might keep the work out of the public domain. But no notice exists in this case. The limited publication doctrine may serve to pull the work published without notice back out of the public domain, but here we had general publication. General publication without notice under the 1909 Act means the putative copyright holder does not have a single claim. So we have copying, but no ownership vesting in the plaintiff. Summary judgment in favor of the defendant is the only choice.

This *Greene Archives* holding is the first time a court has clearly reviewed the "publication" requirement under the 1909 Act and its effect on older images that were not published in the name of the copyright owner. There is a vast body of photographs, including but not limited to publicity stills, that have no notice as to who may have created them. As was the case with the Marilyn Monroe photographs, they may be quite sought-after for licensing purposes. Without knowing where the photos came from, or what long lost parent may appear and claim the "orphaned work," licensing the work becomes risky business. For publishers, museums, and other archives that are risk-averse, this leads to a large body of works that will never be published. Presumably, this is bad news, since the idea behind copyright is to create and disseminate information in order to promote public welfare.

The *Greene Archives* case and the 1909 Act protect the museum or image library rather than the work in question and as a result, the images continue to reach the public. On the other hand, the creators of these works (or their deserving heirs) may find themselves dispossessed of an interest in their creation that would otherwise still be viable if not for some "formal technicality." While the Copyright Revision Act of 1978 and subsequent amendments removed many of the former Act's formalities, the publication requirement was not revoked until March 1989. As a result, there are many pre-1989 works that can be more freely published. Note that works that were created before March 1989 but never published could still be protected by copyright and do not fall into the public domain.

4 LICENSING AND COPYRIGHTS

. .

A s an author of a (hopefully registered) work, the photographer holds the bundle of rights afforded copyright holders. These rights constitute a sort of monopoly in the work, which the law grants as a means of protecting the copyright holder's economic interest in the work. Now that the holder enjoys the protection, how does she translate this into dollars and cents?

The cash flow derives from licenses for use of the works. These licenses, which are contracts, can either support or eviscerate the rights granted under copyright, depending on the term or length, the scope or coverage, the thought and care that goes into the drafting of the contracts, and the liability they impose on a party in case of breach. Indeed, contracts and licenses are another layer of protecting the economic return for the photographer.

In order to get the most economic value from your copyright, it is important to write clear and effective licenses. While photographers can grant non-exclusive rights without written documentation, any exclusive uses must be in writing. A written agreement clearly defining the scope of the use intended is important to clearly communicate with your client regardless of whether the grant of rights is exclusive or non-exclusive. If permitted uses are written too broadly, a copyright holder may be giving the client more uses than those actually negotiated over lunch. Depending on the industry, the "rights package" granted should be carefully crafted to identify the scope of use. Editorial licenses and advertising licenses will naturally vary because of the general nature of the use. Nonetheless, precise language regarding the use is equally important. Limitations should be expressed clearly. Common limitations are geographic scope, languages, size, placement, length of use and number of instances, to name just a few. Even if granting broad rights in a royalty free license, permitted uses should be clearly drafted and restrictions should be conspicuously noted. Most royalty free license agreements prohibit uses such as templates, downloads, defamatory use, and use a trademark, among others.

A federal court issued a decision reinforcing the importance of inserting specific terms and conditions in license agreements. This Pennsylvania case, *Perry v. Sonic Graphic Systems Inc.*, involved a professional photographer who issued a license agreement to the defendant's company for use of his photographs in conjunction with an advertising brochure to be distributed within a specific local area. The agreement contained very specific terms as to the type, area, and time frame of use of the images. The agreement also contained a clause stating that "no alterations may be made in these provisions without the express written consent of the photographer."

Approximately one month after the agreement was signed, the plaintiff photographer discovered that the terms of the agreement had been violated and the images were being used in a much broader area and type of use than was agreed upon. Immediately upon making this discovery, the photographer initiated discussions with the defendant about the unauthorized activity. The defendant's reply to the photographer's concerns was that he did not think that clauses in the agreement were serious and he based this assumption on previous "more casual" transactions that the parties had entered into.

The photographer brought suit in federal court against the defendant for copyright infringement and breach of contract. In an effort to prove the validity of his assumptions, the defendant requested that the court look further than the actual words of the contract, towards evidence explaining the past transactions between the two parties. The defendant hoped that if the court did look to the extrinsic evidence, it would see that the contract was not "serious." The court refused the defendant's request, stating that evidence as to disputed terms in a contract is only admissible when the contract is ambiguous. The court held that the contract here was not ambiguous, but was instead very clear as to its terms and conditions. Based on the defendant's infringing behavior and the clear and concise wording in the licensing agreement, the court issued a ruling in favor of the photographer.

Because there are countless numbers of licensing agreements that change hands in the photo industry, it is very important that the terms of the contract always be clearly and completely worded in the actual agreement. It has been said that creative types don't do contracts; they do lunch. While separate written instruments and oral conversations may sometimes be allowed into evidence, as this case shows that is not always the case. The possible exclusion of evidence can harm photographers and stock photo agencies as easily as it can help them in these types of disputes.

"IN ADDITIONAL MEDIA" TERMS

A poorly drafted license agreement or one that the parties do not understand is almost as good as none at all. A federal judge in New York had an opportunity in *MAI Photo News Agency v. American Broadcasting Company* to examine a license agreement for television film footage and interpreted a typical "in all media clauses" to include video usage. Plaintiff Gregg Mathieson had valuable footage. He had shot some material on Hi-8 film during a January 1993 trip to Northern Iraq. He also had a VHS film copy of a Kurdish military offensive, which he received from Kurdish fighters. In the spring of 1997, ABC was collecting material for a news special about Iraq and the CIA. They wanted to use Mathieson's material. After getting in contact with the show's producers, Mathieson was told to get in touch with ABC's Rights and Clearances Department because they handled licenses and paying contracts. Ultimately, the two parties negotiated a written contract. ABC was granted a non-exclusive license to use the footage two times. Mathieson's license granted ABC the right to include the footage in the ABC News program *Peter Jennings Reporting*, "as distributed two times worldwide in all media now known and hereafter conceived or created." ABC was also to pay forty dollars per second of footage used and give Mathieson end credit except if prohibited by time. This was an integrated agreement, which means it usurps all past agreements, whether oral or in writing.

ABC then aired "Peter Jennings Reporting: Unfinished Business–The CIA and Saddam Hussein." They used eighty-five seconds of footage, and paid Mathieson accordingly. At the end of the broadcast, however, ABC announced that viewers could purchase a video copy of the broadcast, and 248 units were sold. Mathieson argued that this was in violation of the license, and demanded compensation in the amount of $576,000–forty dollars per every second sold. In December of 1997, ABC aired a re-edited broadcast of the program without using any of Mathieson's footage. Mathieson argued that the home video distribution was outside the scope of the agreement. He interpreted "in all media" to relate to ABC's right to copy the tape from one format to another (e.g., VHS to Beta). He did not understand the phrase to include multiple copies of the program for home video distribution. ABC had made multiple copies of the tapes during their editing procedures.

The court held that Mathieson granted ABC the right to use the footage twice in all media for a period of two years. Further, the court found that ABC's home video distribution fell under the umbrella of "all media" and did not

result in a breach of contract. The court reasoned that this is very similar to a situation where a grant of the right to exhibit a motion picture by television would include the right to exhibit the motion picture on any device that would enable the picture to be seen on a television screen. Quoting authority, the court said "licensees may properly pursue any uses which may reasonably be said to fall within the medium as described in the license."

In a situation like this, the party seeking exception or deviation from the meaning reasonably conveyed by the terms of the license bears the burden of negotiating for language that expressly prohibits certain use. In other words, if Mathieson did not expressly prohibit home video use, then he has implicitly given ABC that right. If he did not want ABC to issue a home video with his footage, he needed to clearly insert language into the agreement that reflected this condition. Consequently, the court found that ABC had only used the footage twice, as contracted for in the first place—once in the original broadcast, and then once in the home video distribution—so ABC was not in violation of the license agreement.

At the end of the broadcast, ABC failed to give Mathieson credit for this footage, and instead gave only one non-production credit to a fictitious character as an inside joke for the staff at ABC. The court reasoned that since ABC gave no other credits, they did not breach their contract by failing to provide Mathieson with a credit for his footage. In fact, the judge found this case, and the manner in which it was handled, to be so frivolous and outrageous, not to mention without merit, that he sanctioned the attorney representing Mathieson.

As a lesson in license drafting, media which you intend to *exclude* from a license should be clear, particularly if a grant of rights includes the "in any media now known or later developed" language. In film and television, alternative media, such as video, should be expressly excluded since it is now assumed that films will also be distributed on video and soon, via download to handheld devices. Further, if credit is required as part of the license, having a set fee for failing to provide credit is better than resorting to the courts.

NEGOTIATING TERMS

Equally important is to review "standard" contracts you are asked to sign by publishers, advertisers, and other clients. Always ask if you do not understand a term. If the scope of the use is broader than what you think the client needs or you negotiated, ask to have the language changed. Cross out terms that are too broad or onerous. Be careful when being asked to sign a "buy-out," or an

"all-rights" contract. These terms are vague and can prevent you from further exploitation of your photograph in the future.

An example of a type of contract that is drafted with overly broad or onerous provision is the standard purchase order agreement provided by many advertising agencies, which inform photographers and photo libraries of the terms under which the advertising agency will work. Many "Art/Photography Purchase Orders" require a total transfer of copyright. To make the situation even worse, these agreements often state that no deletions will be acceptable. It's a "take it or leave it" agreement. These agreements cannot be signed as written particularly by stock agencies and can be changed with persistent negotiations. These types of contracts ask for greater rights than most photo libraries can legally transfer. Not only do most agreements between contributors and stock agencies prohibit the complete transfer of copyright, the Copyright Act requires a signed agreement by the copyright owner for a transfer to be valid.

The lesson is to not be afraid to cross out terms such as those in the example above. Onerous clauses that cannot legally be agreed to must simply be crossed off. Affirmatively reject contract terms and purchase orders that are in direct conflict with your license terms. One strategy is to refer to the terms of your own license agreement and state that in the event of a conflict, the terms of the photographer or representative's license agreement controls.

So the next time you are provided with a purchase order from a user that has onerous terms, (i.e., transfer of copyright, over broad indemnities, jurisdictions other than yours), cross out the unacceptable terms and state that the license is subject to your terms and conditions, and if there is any conflict between the two, the terms and conditions of your company's license agreement controls.

The term or length of a contract determines the lifespan of the license. Once the license has expired, the licensee can no longer use the image or images covered by the license agreement without paying an additional fee. Of course, if the license grants perpetual rights, then the licensee is free to use and reuse the image for however long it wishes, eliminating the possibility of further payment.

When images are incorporated in a product, such as a film, DVD, or book, the publisher or producer prefers to have perpetual rights that avoid reuse fees, or terminate prior to sales of the inventory. Consequently, the publisher or producer of a product frequently requests that the license to use the image(s) continues on perpetuity. Nonetheless, almost no products have a perpetual shelf life. Books need to be revised and updated and even films will not

be available forever. With books the approach is to limit the term of the license to the reasonable number of years that the book will be in print. An approach to licensing images that will be used in a film or DVD is to limit the time period in which the image or footage used can be incorporated into the product, such as a year or two, but permit the final product, such as the film, to be sold for the life of the film product.

Many magazine publishers include language in their contracts permitting the publisher to use any photograph included as part of its cover in perpetuity. This recognition that something should be in writing concerning a magazine's continued use of cover shots for advertising use is a result of a court decision in the Southern District of New York (*Wolff v. Institute of Electrical and Electronic Engineers*). Brian Wolff brought this case against a magazine publisher based on a reuse of a magazine's cover in an advertisement after the initial issue was out. The license agreement limited the use of the photograph to the initial issue. The publisher argued that it had the right under the fair use doctrine to show its cover as part of an advertisement for the magazine without obtaining further permission from the photographer. The court disagreed and held that it was an infringement to use the image outside the terms of the license agreement. Consequently, most magazines changed their contracts to permit further use of covers. Presumably one should obtain higher fees from the publisher in exchange for the continued right to display the cover.

It would seem reasonable that a magazine might want the rights to use a cover within a year, to accommodate year-end reviews. In addition, with new technologies, many publishers reach back over many years, publishing books, CD-ROMs, and other compilations. Whether additional permissions and fees are required is the outstanding and controversial issue (see the discussion of the *Tasini* and *National Geographic* cases in chapter 7).

The advent of new technologies and the emerging new delivery formats such as streaming and delivery via download have increased the desire for publishers and other producers to seek broad rights up front in the license agreement.

COPYRIGHT INFRINGEMENT AND USES EXCEEDING THE SCOPE OF THE LICENSE

The scope of the license determines the extent of the licensee's rights regarding the manner of use. As noted, licenses can limit the use to certain types of media, to a specified number of uses, and to a defined geographic region. The

following cases demonstrate the types of conflicts that can arise when use goes beyond the scope of the license.

Quite often, when a client is contacted about an overextended use, the excuse is that the client "didn't know" of the extended use, that the image was in a database, or it was only one employee who did not follow company policy, etc. While the following case deals with a subscription to a financial services report and not images, the same principles apply to any unauthorized reproduction and distribution of copyrighted work. This case discusses the meaning of what constitutes an "implied license" and the consequences of distributing contents licensed to one subscriber firm wide via e-mail.

Lowry's Reports, a financial newsletter publisher, sued Legg Mason, Inc., a financial services firm, as well as its wholly owned subsidiary, for copyright infringement in violation of the Copyright Act of 1976, common law unfair competition and breach of contract. The complaint focuses on Legg Mason's use of a financial newsletter, which Lowry published in both daily and weekly editions.

The daily *Reports* newsletters reflect and analyze market conditions at the close of business the previous day. Lowry's sends them to subscribers by fax or e-mail within two or three hours after the market has closed. All subscribers receive their copy before the market opens the next day. The weekly edition analyzes trends apparent from the entire week's market activity.

For more than a decade, Legg Mason paid for and received a single copy of the daily and weekly *Reports.* Since 1994, that copy had been sent to an employee in Legg Mason's research department at its Baltimore headquarters. Beginning in September 2000, she received her copy from Lowry's by e-mail. Each business day, shortly before the New York stock market opened, an employee of the research department placed a "morning call" to all Legg Mason brokers throughout the United States. The call would be broadcast by intercom or similar device. It provided brokers various up-to-date information about the stock market. For as long as Legg Mason received the *Reports,* it included the Lowry's numbers.

From 1994 until July 1999, the research department regularly faxed copies of the complete *Reports* to branch offices, where employees further duplicated and distributed them. In July 1999 the department began posting every issue of the *Reports* on Legg-Mason's firm-wide Intranet. The Intranet posting continued into early August 2001. From late 1999, additional copies were distributed to every member of the research department first on paper, later via e-mail. The recipients of these copies used them to prepare for the "morning call" and to respond to brokers' questions by telephone.

When Lowry's found out about this, they sent a cease and desist letter to Legg Mason and by August 2001, the *Reports* no longer appeared on Legg Mason's Intranet; however, copies were still made and distributed to the offices. To establish copyright infringement, Lowry's had to prove two elements: 1) that it owned valid copyright; and 2) that Legg Mason "encroached upon one of the exclusive rights conferred." As proof of ownership, Lowry's submitted the certificates of copyright registration for all the *Reports* at issue. Legg Mason had no evidence to rebut the validity of Lowry's ownership. Therefore, as a matter of law, Lowry's had established the first element of its claim of copyright infringement.

Under the Copyright Act, the copyright owner has the exclusive rights to reproduce and distribute copies of the copyrighted work. Violation of either right constitutes illegal copying unless the infringer can mount a successful fair use defense. After weighing the various factors, the court found that the copying inside the research department did not constitute fair use, primarily because the use avoided the purchase of additional subscriptions.

Legg Mason invoked the defense of implied license for the paper and e-mail copying within its research department (not for the use on the Intranet). An implied license to reproduce copyrighted material may be granted orally or implied from conduct. Such an implied license does not transfer ownership of copyright; rather it simply permits the use of the copyrighted work in a particular manner. While federal copyright law recognizes an implied license from the parties' course of dealing, state contract law determines its existence and scope.

Legg Mason pointed to the following undisputed facts: once, a researcher at Legg Mason complained that the issue in question had not gotten through and Lowry sent a copy directly to the researcher; and at least once, Lowry's sent historical data about its numbers–but not copies of any *Reports*–to another member of Legg Mason's research department.

These two isolated actions failed to create a course of conduct that implied usage within the research department. The court noted that no one at Legg Mason requested permission to make any copies of the issue Lowry's sent him. Nor did anyone request more than a single copy of a single issue. Moreover, the copy Lowry's sent contained clear notice of copyright. The court concluded that no rational fact finder (i.e., jury) could find that Lowry's and Legg Mason had mutually assented to such a licensing agreement that would permit copying within the research department. The mere transferring of a copyrighted newsletter does not imply a license to engage in copying that newsletter. According to 17 USC 202, "transfer of ownership of any material object,

including the copy ... in which the work is first fixed, does not of itself convey any rights in the copyrighted work embodied in the object." Therefore, Legg Mason's defense of implied license had to fail.

The Court would not dismiss the contract claim arising from the defendant's breach of its subscription agreement in which the individual subscriber agreed "not to disseminate or furnish to others, including associates, branch offices, or affiliates, the information contained in any reports without consent." The court noted that this contract provided a private agreement that governed fair use of the copyrighted works.

In addition to the importance of registration (each report since March 25, 2002 was registered), this case demonstrates that clear subscription agreements limiting the use of copyrighted material can serve as both a basis for copyright infringement and breach of contract claim if the copyrighted material is used beyond the license. The copyright notices on the material were significant to this court as well. The Court dismissed all of defendant's equitable defenses such as estoppel and innocent infringement because of the notices on the *Reports.* Further, it demonstrates that a company needs to be vigilant and ensure that its employees' conduct does not violate policy that prohibits copying. It is not enough to have a legal department draft lofty policies if the policies are not enforced and the employees not supervised.

USES RESTRICTED BY CONTRACT

Entrance tickets to tourist attractions, museums, sports, and other entertainment events include restrictions in the fine print on the actual ticket. The question is whether the language is binding on the recipient. Now sports leagues are going further and requiring signed agreements to gain access to the events. These major sports leagues have been imposing contracts to restrict the type of uses that can be made of photographs taken at a sporting event. Professional sports photographers from magazines and other photo news services and agencies are required to obtain credentials to gain access to the arena, to carry photography equipment, and to stand at advantageous positions to capture images. These credentials were usually in the form of small print on the back of the pass, much like a ski ticket. However, sports leagues have recently begun to require that a written agreement be signed prior to allowing the photographer access to the game. In July 2000, the NBA sued the *New York Times* after the newspaper began selling a collection of photographs from a Knicks-Pacers playoff series. The NBA alleged that this use violated the

conditions that were agreed to when applying for credentials to cover the game. The restrictions limited the use of photographs to "news coverage."

The *New York Times'* position was that the sale of prints was a privilege of the copyright holder and protected as expression by the First Amendment. This tension between the right of an owner of a private arena to control what it believes is commercial property derived from the event and the right of copyright holder to exploit the rights in a photograph has been growing recently.

Other leagues have similar policies A few years ago on opening day of Major League Baseball (MLB), professional photographers were asked to sign a MLB contract restricting the use of photographs to news coverage and prohibiting the transmission of any images while the game was occurring. This agreement was to cover the entire season. Images taken during the course of the game are in demand for Web sites that use photographs to illustrate news coverage of the game. Most photographers and the AP would not sign this agreement and were permitted to photograph on a daily basis. Negotiations ensued and the number of images permitted to be transmitted during the game increased from three to seven.

What was considered the final contract by MLB at the time permitted the transmission of up to seven images during a game. It also allowed the coverage of a newsworthy event, so presumably a photograph of a grand slam in extra innings after the seven-image maximum has been met would be permitted. The unified refusal to agree to the initial contract among the various publishers and photo agencies helped in forcing changes to the agreement.

With respect to the *New York Times*, it settled its case with the NBA. The press release described the terms of the settlement as an agreement to provide a direct link from the publisher's online store to NBA.com. A marketing component of the agreement includes the use of the NBA logo on the *New York Times* Web site and in print advertisements promoting the sale of the photographic prints. What is certain is further contracts that tie access rights to control of the resulting image use will be seen whenever an event is held in a private arena.

5 ENFORCING COPYRIGHT:

DISSECTING THE INFRINGEMENT CASE

It's time now to take a look at what all of the talk about ownership, originality, registration, exclusive rights, and the rest really means. All of these considerations we've discussed in turn act in concert in the main event: the copyright infringement suit. The civil infringement suit is the means by which a copyright owner enforces her rights. When bringing a copyright infringement claim, the party who claims their work was infringed must establish two main points. First, they must prove they own a valid copyright in the work. Second, they must show that *protected* elements in their work have been copied.

THE TWO-PART TEST FOR COPYING: PART 1 – ACCESS

When the actual work itself is copied, proof of copying is obvious. However, many infringements are alleged based on works that look similar to the original but there are some differences between the works. In such cases, proof of copying is required. The test for unauthorized copying is a two-part test. The first part requires proof that the infringer had access to the copyrighted work. The second part requires substantial similarities as to the items that are considered subject to copyright protection.

The issue of what constitutes access is the subject of a number of cases. With respect to access, it is not enough to simply show that the accused party had a bare possibility of access. You are required to prove access by showing a particular chain of events or link by which the alleged infringer might have gained access to the work. For instance, an owner of a copyright in a song in *Jorgenson v. Careers BMG Music Publishing* claimed that a record company copied elements in his music resulting in two other songs. The original copyright owner, Jorgensen, had recorded a demo tape of his song, "Lover," and sent the unsolicited demo tape to a record company. Later, after hearing songs entitled

"Amazed" and "Heart," Jorgenson became convinced that his work was copied. He argued that since employees who regularly interact with industry artists received the demo tapes, it is possible that his music was disseminated through the industry system and somehow got into the hands of the writers of "Amazed" and "Heart." Jorgensen could not mention any specific instances or factual occurrences by which the demo tape was allegedly circulated through the industry and into the hands of the writers of the two songs, but argued that access was possible by virtue of the demo tape being sent in and the record company's natural association with other artists.

The court was not persuaded by the evidence of access Jorgenson put forth to support his claim of copyright infringement. Jorgensen could have attempted to prove access by showing a particular chain of events by which the alleged infringer might have gained access to the work. However, merely alleging receipt of an artist's work by a corporate defendant is insufficient to establish access according to the court. Further, the court noted that Jorgensen could not even prove that the tape was actually received but only that he sent it in. His speculation as to what happened after he submitted his demo tape included a myriad of possibilities and neglected to offer evidence of meaningful access and opportunity to copy. The court found it too far-fetched.

The general rule is, absent proof of access, courts turn to the works and compare them for striking similarities. In instances where the similarities are so pronounced to preclude any possibility of independent creation, access will be presumed. In cases where the similarities are subtle, as in this music case, a stronger showing of access is required.

THE TWO-PART TEST FOR COPYING: PART 2 – SUBSTANTIAL SIMILARITY

The second requirement is that the copied image must be "substantially similar" to the original. In the event of a lawsuit, a court or jury must compare the two images to determine if the images are substantially similar. The standard of comparison is the "Ordinary Observer Test." That is, would the images look substantially similar to the ordinary layperson? In examining the photos the court will pay attention to those elements that are within the photographer's control, such as lighting, posing, angle, background, perspective, shading, color, and viewpoint. The original photographer will, of course, point to the similarities in the two works while the alleged copycat photographer will

© *Louis Sahuc* © *Lee Tucker*

point to the differences. There is no mathematical calculation that the court applies, such as a percentage of similarity. The word "substantial" really refers to those elements that give the work originality. Remember, "originality is the sine qua non" of copyright—meaning that a copyright can be held only in a work that can be considered original. If the alleged copycat has deviated from the original image to the extent that the copy contains enough originality that it is really not a copy at all, no infringement will exist. A simple photograph, such as one of an existing natural subject, will gain less protection than a complex photograph—one that is more contrived. In other words, the two "simple" photographs must be nearly identical to be found infringing.

A good example of how a court compares photographs is the case *Sahuc v. Tucker*, concerning two photos of a well-known gate located in the French Quarter of New Orleans, Louisiana—a famous tourist spot. "Decatur Street Gate" was taken by Sahuc, while "Breaking Mist" was taken by Tucker. No people are present in the Sahuc photograph and fog obscures the view of St. Louis Cathedral. In his photograph, Sahuc chose to include the surrounding banana leaves, which appear vivid and bold against the foggy backdrop and stand out more prominently than the grand cathedral, which towers over them in the background. According to the court's description, the "photograph

includes the statue of Andrew Jackson, the urn located centrally in the Square and the Mediterranean palms." It was established that Tucker took his photograph after having viewed "Decatur Street Gate" in Sahuc's gallery and after having a poster in his possession that included Sahuc's photograph. "Breaking Mist" is a photograph of Jackson Square in the early morning hours when the fog is rolling in off the Mississippi River. The Decatur Street gate is open in the photograph and the lights on the fences are illuminated. "Breaking Mist" includes St. Louis Cathedral, the statue of Andrew Jackson, the urn in the center of the square, banana leaves and the Mediterranean palms. There are no pedestrians present in Tucker's photograph. "Breaking Mist," unlike "Decatur Street Gate," includes puddles of water at the bottom of the frame.

The appeals court found the images were not substantially similar. Expert testimony as to their similarity was introduced at trial but the testimony was deemed irrelevant on appeal. The appeals court took note that the framing of the cathedral is different, specifically, "Decatur Street Gate" does not show the curb while "Breaking Mist" does. Also the lighting is different. "The banana leaves frame the shot, protruding more boldly than even the Cathedral in the background, which is muted by the fog. All objects appear to be perfectly placed by Sahuc: the urn, the Mediterranean palms, the gates, and the Cathedral." Of course one is in black and white and the other is in color. The feeling was that these differences would be evident to a layperson despite what the expert said. This may be an example of a simple photograph of a common subject that was afforded less copyright protection than if it had been an uncommon scene.

IDEA/EXPRESSION AND *SCENES A FAIRE*

The idea/expression and *scenes a faire* doctrines we've discussed show up primarily in the substantial similarity analysis. For instance, we've mentioned the case *Ets-Hokin v. Skyy Spirits, Inc.* In this case, a photographer who was originally hired to take a product shot of a vodka bottle sued for infringement when Skyy hired another photographer to take a similar shot after rejecting the first photographer's image. The court found that there is a "narrow range of artistic expression available in the context of a commercial product shot." Remember, under the merger doctrine, courts will not protect a copyrighted work from infringement if the idea underlying the work can be expressed only in one way, lest there be a monopoly on the underlying work's idea. Also recall that under the related doctrine of *scenes a faire*, courts will not protect a copyrighted work

from infringement if the expression embodied in the work "necessarily flows from a commonplace idea." In *Ets-Hokin*, though the photographs were similar, their similarity was described as "inevitable, given the shared concept, or idea of photographing the Skyy bottle." The court went on to say that the two shots must therefore be virtually identical for an infringement to exist. In denying the infringement claim, the court stated, "The lighting differs; the angles differ; the shadows and highlighting differ, as do the reflections and background. The only constant is the bottle itself."

The case of *Gentieu v. Getty Images, Inc.*, is again instructive as to how these two issues play out in an infringement case. The court ruled that "Gentieu cannot claim a copyright in the idea of photographing naked or diapered babies or in any elements of expression that are intrinsic to that unprotected idea." The only thing that would be protectable would be the "particular compositional elements of her expression that do not necessarily flow from the idea of photographing naked babies." Penny Gentieu lost the case because she cannot hold a copyright in the idea of babies against a white background.

In the line of cases fleshing out the idea/expression issues of the substantial similarity analysis, the New York case *Kaplan v. Stock Market Photo Agency, Inc.*, appears to be the highest hurdle for plaintiffs. As we've pointed out, the court denied the original photographer's claim of copyright infringement even though it was established that the defendant used the photograph in creating his own.

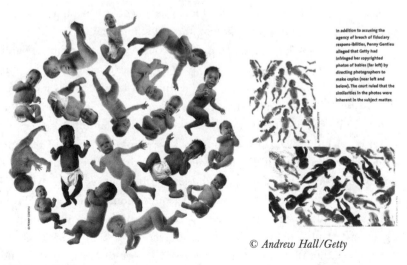

In addition to accusing the agency of breach of fiduciary respons-ibilities, Penny Gentieu alleged that Getty had infringed her copyrighted photos of babies (far left) by directing photographers to make copies (near left and below). The court ruled that the similarities in the photos were inherent in the subject matter.

© Penny Gentieu

© Andrew Hall/Getty

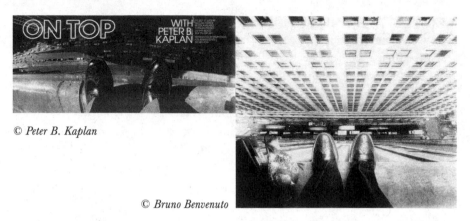

© *Peter B. Kaplan*

© *Bruno Benvenuto*

According to the *Kaplan* court, the idea of a businessman about to jump from a building is simply not protected despite the similarities. The court went on to say that the similarities in the expression are a product only of the similarities in the idea. Our *scenes a faire* doctrine embodies the oft-told principle that "sequences of events necessarily resulting from the choice of setting or situation . . . are not protectible under U.S. copyright law." The judge felt that the second photographer added his own originality to the underlying unprotectible idea. The judge went on to explain, "Moreover, as the situation of a leap from a tall building is standard in treatment of the topic of the exasperated businessperson in today's fast-paced work environment, especially in New York, the subject matter of the photograph is also rendered unprotectible by the doctrine of scenes a faire."

Again, the *Mannion* case really took this line of reasoning to task. In *Mannion*, the defendants again relied on the old axiom that copyright does not protect "ideas"–only their expression, urging "when a given idea is inseparably tied to a particular expression, courts may deny protection to the expression in order to avoid conferring a monopoly on the idea to which it is inseparably tied." As the above examples show, this merger doctrine in its various forms has historically stymied many a copycat photography plaintiff.

Yet here, Judge Kaplan tries to move away from this type of reasoning. He begins by pointing out that the "idea" put forth by defendants "does not even come close to accounting for the similarities between the two works, which extend at least to angle, pose, background, composition and lighting." Employing a little imagination, Kaplan points out that it is quite possible to imagine any number of depictions of the subject in question which might look nothing like either of he photographs at issue. As we discussed before, Judge Kaplan averred that this contributed to his finding that the "idea/expression"

distinction "*useless*" when dealing with works of visual arts.

One should be aware that in a few states, such as New York and Georgia, there is a legal concept known as "Total Concept and Feel." When one photographer has copied the

© Jack Leigh

Warner Bros. Entertainment Inc.

overall concept and feel of another's photograph, an infringement may exist. This is difficult to determine because no photographer may own a copyright in a style. In *Leigh v. Warner Brothers, Inc.*, two images of the famed Savannah, Georgia "Bird Girl" sculpture were compared. The Appeals Court determined that there could be copyrightable elements for a jury to decide. Such elements included lighting, shading, timing, angle, and film and the overall combination of elements in the photograph.

In *Fournier v. Erickson*, a photographer took a picture for a Microsoft Windows 2000 advertisement. When negotiations broke down, the ad agency hired a second photographer to recreate the image for the final ad. The advertisement was to illustrate a slogan stating, "the old rules of business no longer apply" alongside an image of a young businessman in casual dress walking down the street. The court ruled there was no protection as to the irreverent casual business dress but there are for some "protectible elements." Again, the artistic elements are the posing of subjects, lighting, angle, selection of film and camera, all contribute to total concept and feel. After this decision, the parties reportedly settled the matter for a confidential sum.

RESHOOTING IMAGES

Examples like these are typical of the infringement claims we see in commercial photography, and there has been an increasing trend in re-shooting stock images. As a bit of

© Frank Fournier © McCann Erickson

background, for years ad agencies have used stock images in making "comps" for clients. Clients like the idea but want an element in the image changed, for example, a different model, the removal of a prop, or the alteration of the background wall color. Often, instead of obtaining permission to alter the image, the ad agency will hire another photographer and recreate the shot. The question becomes, do you really need permission to re-shoot to change an element within a photograph?

The answer is yes, because you are creating an infringing derivative work. Photographers, as "authors," are granted exclusive rights, among which is the right to create a derivative work, which means the right to adapt or modify a work. A derivative can be created in a number of ways such as combining different elements, or adding or subtracting elements in a photograph.

The cases we've outlined above, whether or not they made an ultimate finding of infringement, all assume that you can violate the right of reproduction and the right to create a derivative work by creating a photograph that is substantially similar to someone else's work. As explained, the courts determine whether two photographs are substantially similar by comparing the two photographs to identify if copyrightable elements have been taken. In examining the photos, the court will pay attention to those elements that are within the photographer's control, such as lighting, posing, angle, background, perspective, shading, color, and viewpoint. The likelihood of finding substantial similarity is much greater when the image has been set up by the photographer and contains creative and original elements, in contrast to a photograph that exists such as a familiar tourist site like the Statute of Liberty.

These are often factual questions for a jury to determine. Since lawsuits can be quite expensive, most cases settle if they are not dismissed early on in the summary judgment stage. The best advice is to contact the stock library or photographer and inquire about obtaining a license to create a derivative work. Otherwise, the ad agency and the client can be liable for copyright infringement.

The damage caused by recreating photographs is not insignificant. Rights management cannot be maintained if clients recreate photographs without permission. If one client shells out for an exclusive license, and a second company uses the same image to create a similar photo with many of the same elements, the first company is going to be furious that it paid a premium and did not get the rights it bargained for. Photographers work hard to develop original ideas that will be selected for stock use, often coming up with innovative ways to express an idea. If these shots are ripped off, the value of the original is greatly decreased. The copycat photograph will have gained advertising exposure, diminishing the market for the original photograph.

6 FAIR USE

E ven when the substantial similarity comes out in favor of a finding of copy-ing, copyright is not an absolute. There are situations where one can "copy" an image without permission. Fair use is a defense to copyright infringement and it is codified in the Copyright Act in 17 U.S.C. §107. The defense is founded in the purposes for which the use of another's work may be considered "fair" such as criticism, comment, news reporting, teaching, scholarship, and research. Fair use considers four factors: 1) the purpose and character of the use, includ-ing whether such use is of a commercial nature or is for non-profit educational purposes; 2) the nature of the copyrighted work; 3) the amount and substantial-ity of the portion used in relation to the copyrighted work as a whole; and 4) the effect of the use upon the potential market for or value of the copyrighted work. In the United States there is no list set in stone of what uses are considered fair and what uses are considered infringing. The factors must be weighed against the facts in each case. We have guidelines instead of hard rules. As a conse-quence, it is difficult to give advice in this area. You can compare your facts to those described in previous cases to see if they are similar or not. In the end, cases in this area have results that can be hard to reconcile.

PHOTOJOURNALISM AND FAIR USE

The term "fair use" is thrown around frequently as a reason the publication of a work, without permission, is not an act of copyright infringement. The defense of fair use does allow for the reproduction of copyrighted material in certain instances, and the reproduction of copyrighted material in these instances is not an infringement of copyright, whether the copyright owner agrees with the new use or not.

The purpose of this defense is to balance the public's interest in knowledge against the right of the copyright holder to control the reproduction of the work. When it comes to photographs used to illustrate news articles, fair use is

commonly misunderstood and relied upon to avoid infringement. Fair use includes the use of a work for "news-reporting." However, if the only measure for using a photograph without permission is whether the subject matter is newsworthy, there would be no field of photo journalism, as all photographs depicting a news event could be used without permission. This is certainly not the case.

A practical way to explain the difference between fair use of a photograph and an infringement is the difference between a photograph that is used merely to illustrate a factual news event and a photograph that in itself is newsworthy based on the fact that it was taken. A photograph depicting events requires permission or the use is an infringement, and a photograph that is itself the news may be published without permission under the doctrine of fair use. Any broader interpretation of fair use would encompass all photojournalism. One can always write about the news using words, it's the images that illustrate the facts described. But both journalists and photojournalists are paid based on the reproduction of either the written word or the image.

One example of an image that is newsworthy in its creation is the Zapruder film of the Kennedy Assassination. In *Time, Inc. v. Bernard Geis Associates*, the judge, after speaking of the "public interest in having the fullest information available on the murder of President Kennedy," relied upon the doctrine of fair use in upholding the defendant's copying of the Zapruder film. The fact that the film of the assassination was made was itself part of the news story of the assassination. On the other hand, most news photographs are used to illustrate events and a publisher could not rely on the fair use defense. In other words, the public could learn the news without that particular photograph. The photographs simply made the news article more interesting.

The Internet has made photographs more available, and has given almost anybody the ability to share opinions without being associated with a traditional publisher. Bloggers are including photographs in their blogs because it draws traffic to the site and makes their comments more interesting. In the case of bloggers, it is not fair use to display the photographs without permission just because what they are writing or commenting about may be newsworthy or interesting to readers. Merely because a blogger does not earn any money in connection with the use does not convert an "infringing use" to a "fair use." It just makes him less attractive to pursue for infringement damages.

Then when is the making of a photograph "the news"? The Associated Press recently asked a federal judge to dismiss a lawsuit claiming AP violated both copyright and privacy laws by publishing photos of Navy SEALs and

Iraqi prisoners posted online by a serviceman's wife. The lawsuit was initially filed by five Navy SEALs and the wife of one of the Special Forces members.

One of AP's arguments is that the case should be dismissed because the plaintiffs cannot demonstrate a probability of winning and that the lawsuit is an attempt to punish the news organization for "truthful, accurate and balanced" reporting. Under a California statute "anti-SLAPP" (Strategic Lawsuit Against Public Participation) law the courts can quickly dismiss meritless cases that stifle free speech.

In its motion to dismiss the suit, the AP said that the photos were freely available to the public on the Internet, on a commercial photo-sharing site, despite steps the wife could have taken to limit their accessibility. The AP also argued that the claim of copyright infringement lacks merit, in part, because the agency's use of the photos for legitimate newsgathering purposes is a "fair use" allowed under federal copyright law. The fact that the photographs were posted was the news story and the story could not be told without showing the photographs. The judge concluded that the photos were distributed in a truthful story of public interest and that the SEALs' faces were an *"integral part"* of the report on possible prisoner abuse.

PARODY AS FAIR USE

Another example of fair use is the case *Leibovitz v. Paramount Pictures, Inc.* involving a photograph of Demi Moore. The photographer Annie Leibovitz took a shot of actress Demi Moore nude and quite pregnant for the cover of

© Annie Leibovitz

Paramount Pictures

Vanity Fair magazine. Paramount used a similar photograph to advertise the release of its film, *Naked Gun 33 1/3: The Final Insult.* In the Paramount photograph the face of actor Leslie Nielsen appeared on the body. The court found that the fair use exception should be applied since Paramount's advertisement was a parody of the Demi Moore photograph. In order for something to be a parody it is not sufficient for it to simply be funny. It must criticize or comment on the underlying material. In other words, it must be consistent with the idea of fair use and still satisfy the four factors above.

© *Art Rogers*　　　　© *Jeff Koons*

Conversely in *Rogers v. Koons*, decided in 1992, a sculpture of a couple holding puppies bore close resemblance to a photograph and was not protected under fair use. Koons, the often controversial artist and maker of the sculpture, saw the photograph on a note card. He wanted to copy it because he felt the image commented on mass culture and would fit well with the theme of an upcoming exhibition. Roger's sued and Koons contended, among other things, that his "primary purpose was for social comment" and therefore the copying was fair use. The court analyzed the case under the four fair use factors. Under the first factor it found that "the copied work must be, at least in part, an object of the parody . . . otherwise there would be no real limitation on the copier's use of another's copyrighted work to make a statement on some aspect of society at large." In other words, if it is not the little-known photograph that is being commented on, then any work could be copied simply by claiming some vague commentary on society was behind the copying.

Under the second factor, the court found that the nature of the copyrighted work was commercial and was made by a professional photographer, which militates against finding fair use. Assessing the third factor, the amount and substantiality of the work used, the court found the amount was very great. With regard to the fourth factor, the court asserted that "it is plain that where a use has no demonstrable impact on a copyright owners' potential market,

the use need not be prohibited to protect the artist's incentive to pursue his inventive skills." The court found that even though it was adapted in a different medium, photographs of the sculpture could harm the original photographer's market.

In 2006, Koons had better success convincing a court that his inclusion in his artwork of a photograph belonging to another artist was permitted under the fair use doctrine. The Second Circuit found that it was fair use for Koons to create a collage using part of a photograph created by plaintiff Andrea Blanch. The Second Circuit (the appellate court in New York) affirmed the

© *Andrea Blanch: Silk Sandals*

District Court's grant of summary judgment to all defendants. The different result is based on what uses courts now find to be "transformative."

The plaintiff in the recent case, Andrea Blanch, has been a photographer for over twenty years. In 2000, Blanch created a photograph entitled "Silk Sandals" as part of an editorial six-page article entitled "Gilt Trip" about metallic makeup that appeared in *Allure Magazine*. The photograph shows the lower part of a woman's bare legs crossed at the ankles. Gucci silk sandals with an ornately jeweled strap are on her feet, which rest on a seated man's knee in an airplane cabin.

Koons admitted that he copied, scanned, and superimposed the legs, feet and Gucci sandals from the photograph, and incorporated them into a collage, which he then gave to his assistants to make the painting "Niagara" at issue in this case. "Niagara" was part of a seven-painting series commissioned by Deutsche Bank for $2 million, and displayed first at the Deutsche

© *Jeff Koons: Niagara*

Guggenheim Berlin and subsequently at the Guggenheim Museum in New York. In the painting, Koons merely altered the orientation of the legs from a forty-five–degree angle in the photograph to vertically downward. Koons described "Niagara" as featuring "four pairs of women's legs and feet which dangle over a landscape. Below them

is a monstrous chocolate-fudge brownie, served with a mound of ice cream and flanked by trays of glazed donuts and apple Danish pastries." According to Koons, his painting comments on "the ways in which some of our most basic appetites–for food, play, and sex–are mediated by popular images."

The Court emphasized that the most important part of the first fair use factor is whether defendant's use is *transformative*. Crediting Koons' explanation, the Court found that he used Blanch's image for a "sharply different" purpose than Blanch's purpose in creating the image. While Blanch wanted "to show some sort of erotic sense" and get "more of a sexuality to the photographs" Koons used the image as "a fodder for his commentary on the social and aesthetic consequences of mass media." The Court also viewed the character of the uses as different: The court found Blanch's fashion photograph was "created for publication in a glossy American 'lifestyles' magazine," unlike Koons' "massive painting" commissioned by a leading world bank and exhibited in art galleries.

While Koons made a substantial profit from the sale of his work, the Court discounted the commercial use because the work was transformative, and did not even comment on the commercial aspects of Deutsche Bank's commissioning of the work. The Court also found that Koons' failure to seek permission for the copying was not in bad faith.

According to Blanch, her key creative decisions in the shoot "were the choice of an airplane cabin as a setting and her placement of the female model's legs on the male model's lap." Koons extracted the legs, feet and sandals from the photograph. Again crediting Koons' professed purpose, the Court found that he copied "only that portion of the image necessary to evoke 'a certain style of mass communication,'" and that this was "reasonable in relation to the purpose of the copying," although Koons took approximately one-third of the photograph.

The Court found that the market effects factor greatly favored Koons, because Blanch had never published or licensed the photograph after publication in *Allure*, and never licensed any of her photographs for use in other visual art works. Koons' use therefore did not "cause any harm to her career or upset any plans" for the photograph or for any other Blanch photographs.

The Court quoted considerably from Koons' affidavit explaining his reasons for taking parts of Blanch's photograph, but did not find it necessary to decide whether "Niagara" was a parody or satire, because Koons justified his borrowing as a commentary on mass communication. The Court therefore did not need to "depend on [its] poorly honed artistic sensibilities" to decide whether Koons had a "genuine creative rational for borrowing Blanch's

image," or whether Koons merely borrowed the image "to get attention or to avoid the drudgery in working up something fresh."

The Court gave heavy weight to the transformative purpose and nature of "Niagara." So what did Koons do differently this time? Unlike earlier cases, this time Koons took only parts of plaintiff's photograph, changed them by placing them at a different angle, and incorporated them in a collage with other elements. However, the Court seems to shift the transformative analysis from the nature of the transformation to the *purpose of the person making it.* This would seem to make it very difficult to determine if a use would be fair without first asking the photographer what their purpose was in creating the photograph. However, the court had no issue with Koons never seeking permission or inquiring Ms. Blanch for her purpose. Such a shift could create a slippery slope. Many photographs are created for a narrow purpose, for example sports or commercials, and a user can easily profess a different purpose than that of the copyright proprietor. The shift in the court's analysis to the purpose could be a dangerous move by pushing the balance between copyright owners' exclusive rights and the public's right to fair use in a direction that leaves copyright holders stripped of their right to make and license derivative works.

Simply because a photograph has not been previously licensed for an artistic use does not rule out the potential that it may be licensed for an art related use in the future. Particularly if you have a recently created image without any usage history, there would be no market in which to measure market harm. The fact that the image was used without a license in a market deprives the copyright owner of exploiting that market in the future.

DOCUMENTARIES AND BIOGRAPHIES

As fair use is a very fact-sensitive analysis, it helps to see how it plays out in a variety of situations. It seems, since the Copyright Act allows fair use of another's work for educational purposes, that it would apply to the context of informative documentary films. As an example of how this worked out, we can look at the case of *Hofheinz v. A&E Television Networks.* A&E produces video documentaries to air on its cable channel. Most of the channel's viewers seem to enjoy watching them. Susan Nicholas Hofheinz, however, did not enjoy the network's documentary on Peter Graves entitled *Peter Graves: Mission Accomplished.*

At the start of Graves' career, he appeared in a 1956 science fiction film about an alien invasion called *It Conquered the World.* While the movie is no

longer available for retail sale, rent, or theater showings, it is available through exclusive license from the holder of its copyright. And because the film was one of Graves' first major acting roles, the network felt that a comprehensive biography should mention the film when highlighting Graves' entry into motion pictures. Accordingly, A&E used twenty seconds of footage edited from the film's trailer in its forty-four minute piece on Graves (the other sixteen minutes of the hour-long program were dedicated to commercials). The network then spliced the edited scenes together in such a fashion that they did not chronologically follow the original release.

Hofheinz didn't care much for the Graves special because she owns the copyright in *It Conquered the World*. (As of October 31, 2006, the copyright office lists the claimant for *It Conquered the World* as Selma Enterprises, the proprietor of copyright in a work made for hire, while Ms. Hofheinz is the claimant for *It: a.k.a. Beulah* as a new related version of *It Conquered the World*. Ms. Hofheinz, as widow to the late producer James Nicholson, holds the copyright for films such as *I Was a Teenage Werewolf* and *Invasion of the Saucermen* in addition to *It Conquered the World*.) She felt that A&E infringed her copyright through an unauthorized showing of parts of the film, and ultimately filed an action against A&E in federal court. Hofheinz, as the court notes in passing, did not own the copyright to the trailer. However, she argued that the qualitative essence of the film was embodied in the network's unauthorized twenty second use of footage. A&E, on the other hand, argued that their use of *It Conquered the World* was a fair use, and moved for summary judgment. The court granted A&E's motion.

In doing so, it evaluated the usual factors used to determine if what would otherwise be an unauthorized use is permitted under the fair use doctrine of copyright law. First, it examined the purpose and character of A&E's use, focusing on "whether the work merely supersedes the objects of the original creation or instead adds something new, with a further purpose or different character, altering the first with new expression, meaning, or message." This boiled down to an evaluation of whether the new work "transformed" the previous work. The court found that A&E created a new copyrightable film biography, a factor that often favors the defendant when the work created is "criticism, comment, news reporting, teaching, . . . scholarship, or research." Biographies, the court said, along with critical biographies, fit well into this protected category of activity, which favored a finding of fair use.

Then, the court looked at the second fair use factor—nature of the copyrighted work. As a general proposition, published works enjoy less fair use

protection than those that have never been published, but creative and other non-factual works are entitled to greater fair use protection than factual material. The film was obviously a creative work, which cuts in Hofheinz's favor, but it was published, which pushes this element in A&E's favor. The film, however, is no longer in general circulation, and is only available through a lease. The trailer is not shown anymore at all—a key factor, since if material is unavailable for purchase through normal channels, the user may have more justification for reproducing it than he would under ordinary circumstances. In the end, however, the court found that this factor tipped more in Hofheinz's favor.

Next, the court analyzed the amount and substantiality of the portion of footage that A&E used. Because the network used twenty seconds from a seventy minute film, and showed it in a different chronological sequence that did not give away the plot, characters, themes, or resolution of the film, the court found this factor favored a finding of fair use.

Finally, the court examined the effects on the market of the defendant's use. In essence, the court held that these twenty seconds of footage—out of order—when the footage didn't give away plot, theme, or resolution, would in no way deter consumers from wanting to see the film. Because the court found that A&E's use would not gut Hofheinz's market for people who would want to see the film, this factor also tipped in A&E's favor. Consequently, as the majority of factors supported a showing of fair use in A&E's use of twenty seconds of edited footage from the trailer of *It Conquered the World*, it granted A&E's motion for summary judgment.

What if instead of use in a film bio, the images appear in a book biography? A New York district court used the historically accepted four-part fair use analysis to determine that seven thumbnail reproductions of Grateful Dead concert posters in a biography of the rock band were not a violation of the Copyright Act. The concert poster images were reproduced in their entirety at a reduced "thumbnail" size in the book *Grateful Dead: The Illustrated Trip*. The book was published by the defendants, Dorling Kindersley Limited, Dorling Kindersley Publishing Inc., and R.R. Donnelley Publishing, Inc., and authorized by the head of Grateful Dead Productions. The plaintiff, the Bill Graham Archives, LLC, claimed that the defendants' reproduction of the posters without permission was copyright infringement and asked the court to halt further distribution of the book, the destruction of all unsold books, and money damages. The defendants moved for summary judgment, citing that their reproduction of the images was fair use of the copyrighted works under Section 107 of the Copyright Act.

In considering the fair use factors, the court stated if the new use does add value as new information and new insights, then the fair use doctrine tends to protect this use as a benefit for the greater cultural good. The defendants' book is a Grateful Dead biography that serves as a written and visual timeline of the band's history. To commemorate certain historic events of the band, the defendants placed the posters in chronological order on this timeline. That type of use is different from merely printing reproductions of the posters for their own sake since the book use was illustrating the past concerts with the reproductions.

Similarly, as the images in the book were used in conjunction with other pieces of art and photographs in a creative layout, the use was different from the original purpose of a concert poster advertising an event. In other words, the defendant did not reproduce the posters for purely aesthetic value. In addition, the commercial release of an allegedly infringing use does not invalidate fair use. Here, the commercial factor was minimal since the poster images were drastically reduced in size and incorporated into an overall layout. In light of these considerations, the court decided that the first factor weighed in favor of the defendants.

As for the second fair use factor, the posters were unquestionably creative and therefore the court saw this factor in favor of the plaintiff. However, courts have recognized that this factor has little use in a case where a copyrighted work has been used in a new format.

This court's holding fleshed out the meaning of the third factor of fair use. The third factor considers the amount and substantiality of the portion of the allegedly infringing work used in the book against the copyrighted work as a whole. Accordingly, the more changes that a work has undergone, the factor will lean towards fair use. This analysis has both a qualitative and a quantitative analysis. Quantitatively, this factor looks to the degree that the original work was copied and whether the borrowed material forms the "heart" or essence of the original work. Neither party disputed that the seven images were reproduced in their entirety. However, each image was reduced to a size of two inches by three inches, and each reproduction takes up one tenth of one page in a 480-page book. The works as used in the book were only a small part of the book that, as a whole, shows the entire history of the Grateful Dead through hundreds of other images and text. Therefore, the images as used in the book did not capture the essence of a full size Grateful Dead concert poster.

Moreover, the defendants' intent of using the images in the book was to commemorate certain concerts in the band's history. While the concerts could be noted without the thumbnail reproductions, the quality of the creative

nature of the promotional material in the band's history, such as concert posters, could not be shown effectively without samples of the material in their entirety. This factor, therefore, favors the defendants.

The fourth factor—looking to the effect that the use will have upon the potential market or value of the copyrighted work—fits with the copyright rationale that a copyright holder has the ability to market their work, but that the use of a copyrighted work that does not encroach on the copyright holder's market leans towards fair use. The harm that the plaintiff alleged to suffer was the loss of licensing revenues for the posters. Since the defendants' use transformed the work and will not likely replace the full-size poster market, the market loss was determined to be insubstantial. Accordingly, the fourth factor also favored the defendants.

Ultimately, the fair use analysis favored the defendants because the use of the thumbnail reproductions was substantially different from the plaintiff's use for the posters in the market. If the book had been a collection of concert posters, the court noted that the factors could have favored the plaintiffs since a fair use analysis is determined on a case by case basis and reaches its outcome based on all the factors involved in each situation.

OBITUARIES

When actor Robert Mitchum died on July 1, 1997, the networks, including CBS, CNN, and NBC, had all prepared obituaries of a few minutes in length detailing his acting career and noteworthy aspects of his personal life. His one Academy Award nomination was for Best Supporting Actor in the 1945 movie *Story of G.I. Joe*. Clips ranging from nine to twenty seconds from *G.I. Joe* were included in the various segments produced by each network.

At the time of Mitchum's death, the film was owned by the University of Southern California (USC). However, Larry Stern of Video-Cinema Films in New York was negotiating to purchase the rights, and sat with his stopwatch in front of his television set watching each obituary, measuring the amount of time that the film clip was aired on each station. He thereafter negotiated contract terms with USC to include retroactive rights to pursue copyright infringements.

As soon as his deal closed he sent letters to each station demanding payment of five to ten thousand dollars for the use of the *G.I. Joe* clips. Each news organization responded that the use was fair. When Stern sued for copyright infringement, the defendants brought a motion to dismiss the action on the grounds that the use of the film clip was fair use under the Copyright Act.

The court in *Video-Cinema Films, Inc. v. CNN, Inc.* held that the obituary that aired the clips was transformative as it was a different work than the movie and was not intended to supercede the movie. Further the clips were used because of their relevance to Mitchum, and not to summarize the movie. Even though the networks were for-profit companies, the court found that this factor weighed in favor of fair use.

Moving on to the second factor, the court found that although the film is clearly fictional, this factor alone is not dispositive. The courts noted that the film had aired many times since on television. As such, no first rights to air were usurped. The court found that this factor was neutral, or slightly against a finding of fair use. The court then examined whether the clips formed a significant portion of the film, whether they were the heart of the film and whether the quantity used was reasonable in relation to the purpose of copying. In this instance, the court found that each aspect of this factor favored fair use given the small amount of copying in relation to the whole.

Finally, the court asked whether the challenged use competes with, by providing a substitute for, either the original copyrighted work, or derivative works that the copyright owner would traditionally expect to create or commission. Although Stern admitted that the obituary did not compete with the market for the film, he argued that he was deprived a license fee if the use is deemed fair use.

The court denied this rationale since in every legitimate fair use the user could have obtained a license from the owner. That's the entire point of the doctrine. Further, the court found that there was no regular traditional market for obituaries. In examining these four factors, the court found that the balance favored a finding of fair use and granted the defendants' summary judgment. It is likely that there would be a different result if the obituaries contained non-public domain still images, since the entirety of the images would be used, and there *is* arguably a market for licensing such uses in obituaries or biographies.

But fair use is a strong doctrine in American law and copyright owners need to understand what uses are legitimately fair and which ones are not, since the term is used often, and with little understanding of the meaning. Because a program itself is newsworthy alone does not entitle a network to use *any* image without permission. The image itself would have to be newsworthy independent of the program to satisfy the fair use defense in most instances. This is not an easy concept to grasp or explain, and the courts continually wrestle with the meaning.

VISUAL DATABASES AND SEARCH ENGINES:
FAIR USE OR INFRINGEMENT?

Web use of images brings up interesting fair use issues. Over the past near-decade, we've seen this area track the parallel changes in copyright and the Web in general. The first "visual Web-crawler" copyright infringement case was decided in favor of the Internet search engine and against the photographer. In *Kelly v. Arriba Soft Corp.*, a federal court in the Southern District of California found that the creation of an index of "thumbnail" size images from various Web sites fell within the fair use defense under the Copyright Act.

Photographer Leslie A. Kelly brought an action against Arriba Vista. Arriba operated a visual Web crawler that would search Web sites for images rather than words. It would produce the now familiar index of thumbnail-size images that the user could click on to see a full-size version and an indication of the Web site from which it originated. A user could type in a key word that would correspond to Kelly's image and bring up the thumbnail of his image. By clicking on the thumbnail, a user could view the original full-sized image. However, the full sized image remained framed by Arriba's Web site, which included its text and advertising. The user could then click on the Web site for the image. Kelly had two Web sites that featured his images of California gold rush country and promoted his books on the subject. Thirty-five of his images were indexed by the Web crawler and placed on Arriba's database in thumbnail form.

Kelly sent Arriba a notice of copyright infringement in January 1999 and filed a copyright infringement action in April that included an allegation that Arriba violated the then new Digital Millennium Copyright Act (we'll discuss the DMCA at length later). Although Arriba removed most of the images belonging to Kelly after the notice, a few remained available until August. Since Arriba did not contest that it reproduced and displayed Kelly's images in thumbnail size, its only defense to a successful copyright infringement claim was fair use.

Looking at the first factor, the court found that the use by Arriba was commercial but more "incidental" than if it had been used to advertise its Web site since it indiscriminately searches for images to offer a large database. The court found that the use was "transformative" because the images were reduced in size. The thumbnail could not be enlarged without being blurred because the resolution could not be enhanced. Further, the court found that the use of the thumbnails to be quite different from the images on the actual Web site,

since they were to be used for reference purposes and were not "artistic." This factor weighed in favor of Arriba.

Regarding the second factor, the nature of the work, the court found in favor of the photographer since photographs are in the class of works that are intended to be protected under the Copyright Act. Although the third factor looks at the amount of the work taken, the court found that this factor favored the visual search engine, even though the entire photograph was taken, because of the reduction in size and the low resolution. This amount of copying was found reasonable.

Looking at the direct impact of the market, the court looked at the broad impact on the value of the Web site and not just the market for the individual photographs. Even looking at this broader market, the court felt ambivalent. While the possibility existed that the Arriba's conduct might increase the chance of improper use, the majority of users, the court concluded, might never have found Kelly's site if it were not for the search engine. Without evidence on this issue, the court gave this factor very little weight. In balancing the factors, the court found in favor of fair use, largely based on the importance of search engines and the usefulness of the reduced versions of images for organization and access.

The *Kelly* case was the first fair use case that looked at the size and resolution of the unauthorized use. But it should not be misunderstood to indicate that any thumbnail use is considered "fair use." What seems evident is that the court does not want to stand in the way of the "technology" revolution. Like the former industrial revolution, courts are reluctant to tread where they do not see or understand the harm in the use and see a rational purpose.

The U.S. Court of Appeals for the Ninth Circuit reviewed the case. The court noted that the user "typically would not realize that the [framed] image actually resided on another Web site." The court decided that Arriba was making *two* different uses of Kelly's images. The thumbnails were found to fall under the fair use exception to copyright infringement. However, the full-sized images constituted infringing uses. In both instances the court did a fair use analysis, weighing the fair use factors.

The court affirmed the lower court's decision in part and found that creating a database of thumbnail images to search for images on the Web was fair use. Even though the thumbnails were commercial uses of the images, which were creative works all used in their entirety, the court determined that the fair use defense still applied. The use by Arriba was considered transformative because the thumbnails were smaller, lower-resolution images that served an entirely different function than Kelly's on-line images. The court pointed out

a commonly noted doctrine that states the more transformative the new work, the less important the other factors, including commercialism, become.

The appellate court reversed the lower court's decision that Arriba's displaying of the full-size images was fair use. This was the first time any court considered whether inline linking and framing infringed copyright. In this instance, Arriba's use of the full-sized images was found to infringe Kelly's right of display, one of the copyright holder's exclusive rights under copyright. Showing the images to a visitor of the Arriba Web site was considered a public display without Kelly's permission. It was irrelevant in determining infringement whether anybody saw the images, but simply that they were made available.

The court rejected the defense of fair use for the full-sized images, since the use was not transformative and served the same esthetic function of the end product—the images themselves. According to this court, search engines that are capable of combing through a database of images are helpful to users on the Internet and the resolution of the thumbnails are so poor that no one would use them for aesthetic purposes. However, if technology improves, and thumbnails can be increased in size with little loss of quality, the balance of the four factors may change to weigh against fair use when thumbnails are no longer used just for reference. Soon after, the court revoked its decision rejecting the fair use defense for Arriba's displaying of the full-size images because the issue was not brought to the court in the parties' motion. Therefore, the earlier decision was too broad since the parties didn't have the opportunity to contest or brief that portion of the case. In essence it was error for the court to extend the decision to the full-size images.

FAIR USE AND THE INTERNET

This next case illustrates how quickly technology can change the landscape of fair use. Judge A. Howard Matz of the U.S. District Court for the Central District of California issued an order granting in part and denying in part an adult Web site's motion for a preliminary injunction against Google. For the few who may have never heard of the plaintiff, Perfect 10 publishes a magazine and runs a pay Web site, both featuring nude photos of what it calls *natural* models. Aside from the magazine and subscription Web site, Perfect 10 also provides reduced-size images for use as wallpaper on multimedia cell phones. Money flows into this plaintiff's business on one stream of income—the fees its subscribers pay for access to adult, and more importantly, copyright-protected material.

Perfect 10 v. Google is another in a long line of cases that will eventually help us feel our way through the sometimes tug-of-war between ever evolving intellectual property rights and the ever expanding online frontier. Indeed, the adult entertainment industry is the major presence in defining copyright on the Internet, undoubtedly since the high money stakes make the cases worth trying.

Google offers users an image search, or a feature, which lists links to sites containing images of almost anything one could imagine. Users enter search terms, and Google responds with a grid of relevant thumbnail images, which refer the user to a site, much like *Kelly v. Arriba Soft Corp.* To make a long story short, Google's use was commercial, since it "*derives significant commercial benefit*" from traffic and advertising. Judge Matz further found that Google's use was transformative (rather than merely consumptive) as it was intended to locate desired images rather than provide adult content. *But* here's where this case diverges from the earlier thumbnail image cases. Since users can download the thumbnails on Google's site and use the images as cell phone wallpaper, Judge Matz found that the use hedged too closely to the plaintiff's market for reduced-size images of nudes. As a result, the court found this part of Perfect 10's infringement claim would stand up to a fair use defense. Both parties have appealed the case. *Perfect 10 v. Google* serves to illustrate how fair use is very fact-sensitive and that the holding from *Kelly v. Arriba Soft Corp.* should not be read to extend fair use to all thumbnail images. In addition to this point, this case brings up some other important issues we'll be discussing later.

7 COLLECTIVE WORKS:

The National Geographic
Cases, North and South

There are instances where the rights of the owner of a "collective work" and the underlying copyright owner collide. The 1978 Copyright Act provided a separate copyright to the owner of a collective work. An example of a collective work is a magazine. The publisher holds a copyright in the entire publication, which covers the selection and arrangement of a work. This copyright is separate from the copyright held by the author of the individual articles, illustrations, and photographs that are contributed to the work. Section 201(c) of the Act is entitled "Contributions to Collective Works." It provides: "Copyright in each separate contribution to a collective work is distinct from copyright in the collective work as a whole, and vests initially in the author of the contribution. In the absence of an express transfer of the copyright or of any rights under it, the owner of copyright in the collective work is presumed to have acquired only the privilege of reproducing and distributing the contribution as part of that particular collective work, any revision of that collective work, and any later collective work in the same series. A collective work is defined under Section 101 as "a work, such as a periodical issue, anthology, or encyclopedia, in which a number of contributions, constituting separate and independent works in themselves, are assembled into a collective whole."

With the advent of digital technology and the distribution of content in more than print form, these dual copyright ownership interests have begun to conflict. Such was the case when the Supreme Court decided to review the monumental Second Circuit decision in *Tasini v. New York Times*. The case was brought by six freelance writers who claimed that the right to publish a printed version of an article does not automatically include the right to publish it electronically. The writers originally brought the case after several newspapers and magazines began to publish articles in databases such as

LexisNexis, without obtaining the additional consent of the writers. The publications claimed that this activity was not a violation of the writers' copyrights because the new format was simply a revision of the print publication, and since they owned the copyright in the printed version they had the right to also publish revisions electronically. The Second Circuit Federal Court disagreed and ruled in favor of the writers, determining that the publication's activity constituted a violation of the writer's copyrights. More specifically, the court held that electronic databases do not qualify as revisions of an original newspaper or magazine, and if the publications wanted these additional rights they would have to contract for them.

While this was going on, freelance photographer Jerry Greenberg sued the National Geographic Society and National Geographic Enterprises (collectively "NGS") in the Federal District Court of the Southern District of Florida for infringing the copyright in four of his photographs included in the thirty-volume set of CD-ROMs, *The Complete National Geographic*. One image was used in the set's introductory animated sequence of ten covers while the others were within the digitally reproduced magazines. The lower court dismissed Greenberg's action on summary judgment in favor of the NGS, finding that the CD-ROM was a "revision" of a prior collective work that the NGS was entitled to publish under the copyright it owned in the original magazines as a collective work.

On appeal to the Eleventh Circuit (the Appellate Division for Florida), the court held that the CD-ROMs were not revisions, but new works that fell outside the scope of the magazine copyright in the collective work. The individual magazines are considered "collective" works under the Copyright Act and are defined as "a work in which a number of contributions, constituting separate and independent works in themselves are assembled into a collective whole." The individual photographs are works of authorship in which the photographer owns a separate copyright. As copyright owner, Greenberg owned the exclusive right to reproduce the photographs, distribute them, create derivative works, and to publicly display and transmit the works.

The creation and distribution of the CD-ROM of back magazines in digital form, and the creation of the introductory sequence, clearly violated these exclusive rights. However, the NGS relied on Section 201(c) of the Copyright Act in contending that it was entitled to use the photographs in its electronic versions of the magazine editions as part of the privilege afforded the copyright owner of a collective work. NGS argued that the thirty-volume set was a compendium of back issues and therefore it was allowed to use the photographs because this compendium was simply a revision of the earlier works. The court

disagreed and stated: "in layman's terms, the instant product is in no sense a 'revision.'" Using a "common sense" copyright analysis, the court concluded that NGS in collaboration with Mindscape (the software company) created a new product. Looking at the opening sequence in which one of Greenberg's photographs was used to create a moving visual sequence, the court found that this use of the photograph also violated Greenberg's exclusive right to create a derivative work. It refused to find, as NGS suggested, that this use was "fair use," even though the *Complete National Geographic* may serve an educational purpose. The sale of the work was for profit and the inclusion in the sequence was found to diminish the photographer's opportunity to license the photograph to other potential users. Neither did the court find that the use was *de minimus* (too small to rise to the level of infringement).

The court directed judgment on these copyright claims in favor of Greenberg. In addition, it found Greenberg the prevailing party and entitled to attorney's fees under the Copyright Act. The court directed that the court below ascertain damages, attorney's fees, and any injunctive relief, and urged that the court consider alternatives to an injunction such as mandatory licensing fees, in lieu of preventing the public access to this work.

The case relied upon by the lower court in initially dismissing these copyright claims, *Tasini v. New York Times*, was scheduled for oral argument before the Supreme Court just a short time after this opinion hit the street. The Eleventh Circuit felt that the issue of the creation of a new work on a CD-ROM was more than just reproducing the work in another medium, one of the issues to be decided in *Tasini*. As a consequence, it did not withhold its decision. Eventually, the Supremes refused to hear the appeal from the Eleventh Circuit.

Meanwhile in the Southern District of New York, Judge Kaplan had an opportunity to decide a similar case involving the CD compilation of National Geographic. In *Faulkner v. National Geographic Enterprises* the court dismissed most of the copyright claims brought by various freelance photographers whose works appeared in the NGS CD and DVD compilation product upon a motion for summary judgment. Freelance photographers Douglas Faulkner, Fred Ward, and David Hiser sued the National Geographic Society and National Geographic Enterprises in the Federal District Courts of the Southern District of New York and freelance photographer Louis Psihoyos sued in the Federal District of Colorado for infringing the copyright of multiple photographs included in the thirty-volume set of CD-ROMs. Psihoyos' case was transferred to the Federal District Court of the Southern District of New York, and all cases were assigned to a single judge. Again, the freelance photographers' work had originally appeared in a monthly edition of the print version

of the magazine. The National Geographic Society did not seek permission from these contributors to republish the works in the digital version. Again, NGS relied on Section 201(c) of the Copyright Act. NGS's position was that *The Complete National Geographic* is a republication or revision of its magazines for which it owns copyright and it is therefore entitled to publish the digital version without additional permissions.

Greenberg v. NGS previously held that the NGS could not rely on this part of the Act: that the CD-ROM product was not a revision but a new work that went beyond the privilege afforded the publisher to reproduce the collective work under Section 201(c). An issue in the New York Court was whether this decision prevented the court from reviewing the same issue under a legal doctrine of *collateral estoppel*. This means that a party to litigation who had an opportunity to litigate an issue will not be allowed another chance to rehear the same issue fairly decided against them.

Judge Kaplan determined that he was not foreclosed from deciding this issue by the decision in *Greenberg*. In contrast to the court in *Greenberg*, Kaplan determined that the privilege of 201(c) applies because the magazines included in *The Complete National Geographic* were essentially scanned intact, with the same cover, contents, and order as the print version, with additional advertising and software tools to make searching for articles easier. Kaplan noted that the 1976 Copyright Act was intended to be "medium neutral" and that the NGS should not be deprived of its privilege to reproduce the collective work simply because the medium changed from print to digital.

When the decision came out, it was clearly contrary to the *Greenberg* decision. It seemed obvious that Judge Kaplan believed that the decision rendered by the Eleventh Circuit was wrong. The decision was appealed to the Second Circuit, the appellate court for this district. This made the scene such that if the Second Circuit's decision would be in conflict with the Eleventh Circuit, the Supreme Court may be asked to decide this Section 201(c) question.

So the saga of the National Geographic cases continued and on appeal to the Second Circuit the court affirmed, upholding Judge Kaplan's decision. Before reaching the merits of the case, Judge Winers dealt with *Greenberg*. In discussing the *Greenberg* case, this court had to do its own take on recent 201(c) history. *Tasini v. New York Times* was first decided in the Second Circuit *before* Greenberg. In *Tasini*, the Second Circuit held that electronic and CD-ROM databases containing individual articles from multiple editions of various periodicals did not constitute "revisions" of individual periodical issues within the meaning of Section 201(c). Then *Greenberg* came out against NGS. The Supreme Court affirmed *Tasini*, holding:

> [In] agreement with the Second Circuit ... that Section 201(c) does
> not authorize the copying at issue here ... because the databases
> reproduce and distribute articles standing alone and not in context,
> not "as part of that particular collective work" as to which the author
> contributed.

Against this background, the photographers claimed that the doctrine of offensive collateral estoppel barred NGS from litigating its Section 201(c) argument. The court here stated that "[in] our view, the Tasini approach so substantially departs from the Greenberg analysis that it represents an intervening change in law rendering application of collateral estoppel inappropriate." In doing so, the court could then turn to the merits of the case.

Here, the photographers owned the copyright in each of their photographs. The NGS owned the copyright in the magazine edition in which each photograph was first published. NGS argued that the thirty-volume set was a compendium of back issues and therefore it was allowed to use the photographs because this compendium was simply a revision of the earlier works. I suppose if you had to you could insert a "*deja vu* all over again" here.

The court agreed with NGS and quoted language from *Tasini*: "in determining whether the [underlying works] have been reproduced and distributed 'as part of' a 'revision' of the collective work in issue, we focus on the [underlying works] as presented to, and perceptible by, the user of the [CD-ROMs]." But the court went further:

> The [CD-ROMs] present the underlying works to users in the same
> context as they were presented to the users in the original versions of
> the magazine. The [CD-ROM] uses almost identical "selection, coor-
> dination, and arrangement" of the underlying works as used in the
> original collective work. *The [CD-ROMs] present an electronic replica*
> *of the pages of the magazine.*
> (Emphasis added.)

Faulkner also claimed that his contractual agreement with NGS was "intended to grant NGS limited publication rights in paper format only." The

court stated that in the absence of a contract stating otherwise, publishers acquire "only the privilege of reproducing and distributing the contribution as part of that particular collective work, any revision of that collective work, and any later collective work in the same series." The court also stated that "[t]he mere existence of contracts does not, therefore, render Section 201(c) inapplicable." In this case, the court found that Faulkner's failure to negotiate for pertinent contractual provisions or even communicate to NGS his intention to limit publication rights to a non-digital format were fatal to his claim.

As many publishers are located in New York, which is within the jurisdiction of the Second Circuit, they are probably pleased with this result. In many ways, the issue of whether a CD-ROM of back issues is a "revision" may be moot. Publishers, since the first *Tasini* decision, have been rewriting contracts with freelance contributors to extend the right to publish text and images within a magazine in electronic *and* print format. If electronic rights are to be reserved, they must be expressly reserved in the written agreement or the right to reproduce the printed work in the same context would arguably be permissible in accordance with this Second Circuit ruling, even if the grant of rights stated "one-time use, North American rights only."

As a result of this decision, there was what is known as a "split" in the circuits. When this arises, a party can request that the Supreme Court review the case and resolve the inconsistent result. Understandably, the conflicting outcomes were intolerable for both parties as well as inimical to a fair, predictable, and unified federal standard. The Supreme Court then elects whether to hear the case or not and may deny or accept the petition.

After failing in the Second Circuit, the photographers did seek Supreme Court review of their claims against NGS, still arguing that the CD-ROMs were markedly different from the original magazines as to constitute a new work rather than a revision and characterizing the discs as "an engine of infringement."

On December 12, 2005, the Supreme Court denied the photographers' petition for certiorari in *Faulkner v. National Geographic Enterprises*. Even the National Geographic Society had wanted the Supreme Court to hear the case to resolve a conflict between two federal courts of appeals. It is not clear what the NGS will do now—it has stopped selling the CD-ROM set after the *Greenberg* decision in the Eleventh Circuit.

Since *Tasini, Greenberg, and Faulkner*, other courts have applied Section 201(c). In *Jarvis v. K2, Inc.* the U.S. District Court for the Western District of Washington applied the 201(c) privilege to advertising works and dismissed in part copyright infringement claims brought by Chase Jarvis against K2 for the unauthorized use of his photographs. The court permitted K2 to publish print

advertisements on the Web whose license terms had expired relying on the collective work copyright Section 201(c).

The lower court, seemingly confused as to the definition of "*collective works*," interpreted the statute in such a way that could permit advertisers greater rights than initially granted or beyond the scope of the license without additional payment to the copyright owner. In extending the Section 201(c) privilege to advertisements, it expands the definition of what is considered a "*collective work*" beyond the language of the statute and its meaning within the industry. The decision essentially permitted K2 to run print advertisements on the Web long after the print license expired. Instead of considering this an infringement for which damages were owed, the court considered it part of the right to publish revisions of a previously published collective work. There is no legal precedent to extend Section 201(c) copyright is a collective work to an advertisement it had previously only applied to magazines and books. Chase Jarvis appealed this decision to the Ninth Circuit. As of this writing, the Ninth Circuit has not issued a decision.

Needless to say, this section of the Act has successfully resisted all efforts of courts and litigants to come to a unified, workable interpretation of its effect. Certainly, this is a recurring challenge for Copyright law, as it strives to balance the rights of authors past and present with the benefits of disseminating information in future works.

8 DELAYS IN BRINGING CLAIMS

Copyright actions are usually brought to recover money damages. The statute of limitations can work to reduce the amount of damages an infringer must pay. In *Polar Bear Productions, Inc. v. Timex Corp.*, a recent Court of Appeals decision for the Ninth Circuit (essentially the West Coast: California, Oregon, Washington, Nevada, Arizona, Idaho, Montana, as well as Hawaii and Alaska) answered an important question involving an infringement of licensed film footage regarding whether the statute of limitations of the Copyright Act of 1976 prohibits copyright plaintiffs from obtaining any damages resulting from infringement occurring more than three years before filing the copyright action.

The Polar Bear case involved a clear case of copyright infringement of a film production created by Polar Bear Productions and licensed by Timex Corp. for a flat fee of $25,000. Timex agreed to sponsor the creation of an extreme kayaking film called *PaddleQuest* in exchange for a one-year exclusive license to the work to help promote its "Expedition" line of watches. Under the agreement, Timex had the option to retain Polar Bear to produce a promotional video using images from the film, but Timex informed Polar Bear that it planned to produce its own promotional video. Polar Bear reminded Timex that the watch company could not use images from the film without permission. However, about two years later, the producer of *PaddleQuest* saw the Timex promotional video at a trade show (one of twelve trade shows featuring the promotional video) and about one-third of the video was comprised of footage from the *PaddleQuest* film. Images from *PaddleQuest* were also used in a Mountain Dew soft drink promotion and in training videos. At trial, a jury awarded over $2 million on the copyright infringement aspect of the case against Timex. With that much money at stake, Timex appealed, alleging the claim was time barred and that the damage award was improper.

In the Polar Bear case, Timex raised an issue that was heard for the first time in the Court of Appeals for the Ninth Circuit: whether the statute of limitations (§507(b)) under the Copyright Act barred plaintiffs from recovering damages that

resulted from infringing conduct that occurred more than three years before the copyright infringement action was filed. (The statute reads: "No civil action shall be maintained under the provisions of this title unless it is commenced within three years after the claim accrued.") The Ninth Circuit held that in this case, the statute of limitations did not prohibit recovery of damages incurred more than three years before the filing of suit, because Polar Bear was unaware of the infringement and the lack of knowledge was reasonable under the circumstances.

The Ninth Circuit analyzed §507(b) of the Copyright Act by looking at the basic purpose of all statutes of limitations—to promote the timely prosecution of grievances and discourage undue delay. With this in mind, it made no sense to the Ninth Circuit to penalize plaintiffs who reasonably have no knowledge that a claim exists, because in these situations, the statute has no influence in speeding up the process. All it can reasonably do is impose a duty of diligence upon all potential claimants. In this case, the Ninth Circuit found it more than reasonable that Polar Bear had no knowledge that Timex was using footage from its copyrighted film, considering the fact that Polar Bear had expressly warned Timex that the watch company needed Polar Bear's permission before using any footage from the film in its promotional materials and the fact that much of the infringing material was in Timex's possession and control.

The result is that a plaintiff in the Ninth Circuit can recover damages for infringing conduct that occurred more than three years before the filing of the suit, as long as the plaintiff reasonably had no knowledge of the infringing conduct. Other circuits may have different tests and rules.

LACHES

So what if you do "sleep on your rights" and drag your feet in bringing a claim for an alleged infringement you *do* know about? Recall the claim concerning the Lenny Bruce images brought by the photographer Edmund Shea against Fantasy when it re-released the comic's album including the disputed image. As if things weren't bad enough for Shea (remember, his photos fell into the public domain because he didn't comply with the 1909 Act's formal require-ments), the court barred his claim for infringement by a doctrine known as *laches*. Laches is an affirmative defense that must be proven by the party assert-ing the defense. To prove laches, a defendant must show two things: 1) a plain-tiff's unreasonable and inexcusable delay in asserting a claim, and 2) prejudice or injury to defendant as a result. This delay is measured from the time that the plaintiff knew or should have known about the potential claim at issue.

For laches to work in this situation, Fantasy records would have to prove that Shea waited an unreasonably long amount of time before he made any claim and because of that, they have been injured. In this case, the album containing Shea's photograph was first published in 1971. Shea stated that he believed he first became aware of the Fantasy album in 1972. In that event, his photograph was in publication for at least sixteen years with Shea's knowledge. The new CD *Live at the Curran Theater* was published in August 1999. Shea did not file suit until June 3, 2002. Shea knew about Fantasy's allegedly infringing conduct for roughly thirty years and failed to pursue copyright remedies for that entire period. Thirty years was considered unreasonable. (Mr. Shea had claimed that he took the photograph in 1966 and that if you actually remember any of the sixties, you weren't part of it. However, asserting a sixties-induced hole in memory defense has *never* worked for copyright claimants faced with the laches defense.)

Further, the court agreed that this long delay in commencing an action did indeed cause prejudice, both in establishing evidence after such a long time period and in the conduct of the record company. Gleason, the main witness, was long dead, memories had faded like an old tie-dye, and the likelihood of lost evidence was higher than Mr. Bruce after a midnight set. Further, the record company testified that had it known that the use of the photograph was infringing, it would have not used it in the liner notes. In sum, the court agreed with Fantasy in all respects and dismissed Shea's claim of infringement.

EQUITABLE ESTOPPEL

In *Dallal v. New York Times*, brought in the Federal District Court of the Southern District of New York by freelance photographer Thomas Dallal, the court dismissed Mr. Dallal's complaint through summary judgment. Mr. Dallal alleged copyright infringement for the online use of his photographs outside of the scope of his license agreement with the venerable news organization. Delay in bringing the copyright action influenced the court's decision.

During the years of 1994 to 2002, the newspaper strung out various freelance assignments to Dallal. In 1996, The *Times* launched its online version, which, from time to time, included Dallal's photographs. According to the opinion, by 1997 Dallal began including boilerplate language in his invoices indicating that he was only granting the *Times* a "first exclusive, one-time use" of his work. Dallal complained that he should receive extra money for the online use. The newspaper refused to pay any additional compensation for the

online version, and Dallal continued to take assignments from the *Times*. He didn't take legal action until late in 2002. According to the court he brought his claim far too late.

So why did Mr. Dallal find himself on the wrong end of a summary judgment motion? Certainly not because he didn't have a valid copyright; he had registered all of the works well before taking any legal action. As a matter of fact, the court does not reach the issue of copyright infringement. The reason has less to do with the substantive law behind copyright and everything to do with a principle called *equitable estoppel*. *Estoppel* simply means to prevent a litigant from using a certain argument. In this case, the court *estopped* (prevented) the photographer from using the infringement argument altogether. The *equitable* part of the term means that the court is not making its decision according to any specific law or any statute on the books, rather according to its own sense of fairness. The controversy and upheaval over courts acting in equity is probably just as old as equity itself. It is an unpredictable and uneven terrain beset with all sorts of snares and filled with legal maxims such as "equity will not suffer a wrong to be without a remedy," "he who seeks equity must do equity," and "delay defeats equity."

This last maxim is what effectively slammed the doors to the halls of justice in Dallal's face in the District Court. The court was quick to point out that Dallal took about six years to sue the *Times*. There are four requirements the *Times* had to meet in order to put equitable estoppel into play, but the fact that for six years Mr. Dallal kept delivering and the *Times* kept paying proved most fatal to his cause. Judge Hellertstein characterized these six years as "a protracted attempt to negotiate a better deal" that just never met much success. The gist of the opinion is that Dallal should have put the on brakes much earlier if he sincerely hoped to keep his copyright infringement gun from shooting legal blanks.

In the end, the court decided that the *Times* was justified in believing Dallal would not sue based on his delay. Hellerstein characterized the *Times* as "proceed[ing] on the understanding that its relationship with the plaintiff was acceptable to both parties." The court was under the (mistaken) impression that Dallal was lulling his opponent into a state of hunky dory with one side of his mouth while phoning his lawyer with the other.

The Second Circuit Court of Appeals thought that the decision resulted in an unfair result and that the lower court should hear more facts before invoking equitable estoppel. On appeal, the court believed that Dallal's oral objections to the Web use as well the language on his invoices at least raises doubt as to "whether Mr. Dallal intended the *Times* to rely on his acceptance of assignments as authorization for its display of his photographs on its Web site." As

a practical matter, this means that instead of putting Mr. Dallal in a "damned if you do . . ." situation, the appeals court is willing to distinguish between accepting assignments and giving up the copyright protection claim, which seems infinitely more fair.

The *Times* could still prove that equitable estoppel is proper based on further developed facts. If the *Times* can prove that 1) Mr. Dallal intended the *Times* to rely on his continued acceptance of assignments as authorization for its display of his photographs on its Web site, 2) that the *Times* was ignorant of the fact that such use was unauthorized, and 3) that the *Times* was reasonable in believing Mr. Dallal was blessing the Internet use by taking more assignments, *then* the case should go no further.

As of yet, no one has even begun to argue the actual copyright infringement claim. It remains to be seen if that will happen considering the facts may or may not warrant estoppel after all. It would be interesting to see how the underlying copyright action plays out, considering the *Times* will probably raise a 201(c) defense. The case does tell us that it may be that you need to acknowledge in writing that continued business relations does not waive any right to pursue a copyright claim if the negotiations do not work out. The odds are that the case may now settle and there will be no written decision.

9 INTERNET LICENSES

Internet license agreements typically require users to affirmatively assent to the license's conditions rather than just read terms posted on a Web site. This practice is a result of a New York decision in *Specht v. Netscape Communications Corp.* that held that users who obtained software from Netscape's Web site were not bound by the site's license agreement. The driving force behind the judge's decision was that users were neither required to agree to Netscape's terms and conditions, nor even review them. One of the general principles of contract law is that in order for a contract to become binding, both parties must agree to be bound. This assent can be done in any manner sufficient to show agreement, including conduct. These ideas flow swimmingly into the realm of software licensing. Software is often packaged in a container or wrapped, and the user is advised that the purchaser of the item is subject to the terms of the licensing agreement. If the purchaser does not wish to be bound, she merely refuses to open the package and sends it back within a stated period of time. In other words, by returning the unopened software, the user clearly does not assent to any terms or conditions and therefore is not bound by them.

This is legal, and works out fine as long as the terms and conditions do not run afoul of contract law. Netscape argued that users who downloaded its software product "SmartDownload" from their site agreed to submit to arbitration in California if a dispute should arise, and that the New York court should dismiss the case. (SmartDownload is a plug-in for Netscape browsers that is designed to assist users in downloading files from the Internet.) The court refused. Unlike its other programs that are on-line and available for download, Netscape chose not to use a "click-wrap" license for SmartDownload. A click-wrap license presents the user with a message on her computer screen, requiring that she indicate her assent to the terms of the license agreement by clicking on an icon. Courts have held this type of license to be similar to the wrapped or shrink-wrapped licenses that require an affirmative indication of assent. When Netscape asks in its click-wrap licenses "Do you accept all the terms of the preceding license agreement? If so, click on the Yes button. If you select

No, setup will close," they have put forward a valid licensing agreement because clicking on "Yes" indicates assent.

With the SmartDownload product, however, they failed to do this. The court concluded that SmartDownload's license agreement resembled more of a "browse-wrap" licensing agreement. With these agreements, notice of a licensing agreement *does* appear on the Web site and by clicking on a link, a separate browser pops up and contains the entire text of the agreement. What is missing, however, is the critical element of assent. At no point is the user required to click on an icon expressing assent to the license, or even view its terms, before she proceeds to the information. Bottom line: Netscape's SmartDownload allows a user to download and use the software without taking any action that plainly manifests assent to the terms of the associated license or indicates an understanding that a contract is being formed. What makes the situation even worse for Netscape is that they fail to inform the user that she is entering into a contract. The court likens SmartDownload to a free neighborhood newspaper where the item is "there for the taking."

Netscape does include a suggestion that a contract is being formed. At the bottom of the download screen, at a place where the user does not need to go in order to get the software, Netscape places the following text: "Please review and agree to the terms of the Netscape SmartDownload software license agreement before downloading and using the software." The judge viewed this as a mere invitation to view the agreement, and concluded that the language is therefore not strong enough to inform the user that a contract is being formed, or that assent is required. Consequently, the judge ruled the license agreement inapplicable, and held that arbitration was not binding upon the users. This case demonstrates that basic contract law applies to the Internet.

HOW TO MAKE SURE THERE IS AN "AGREEMENT"

If you are creating any form of online licensing agreement, even a comping agreement, make sure that the contract is designed so a user must agree to the terms before proceeding to download any image. It is recommended that terms of the agreement be available to view and not merely buried in a link that only suggests that a user should view them. The good news is, if done properly, "click-through" agreements are binding.

In crafting these contracts, the same principles that apply to a traditional written contract apply here. The difference is that the Internet offers unique ways to view a contract and to accept the terms. The question is, will these

transactions hold up under traditional contract law scrutiny? It is a basic contract principle that all parties who are expected to be bound by the terms knowingly agree to the terms and conditions to make an enforceable agreement. Do you knowingly agree to terms if only a portion of the terms is visible on your screen unless you actively scroll through the entire screen box? Do terms need to be brought to your attention in order for an agreement to be made knowingly?

Forrest v. Verizon Communications, Inc. involved a dispute over notice of the forum selection clause of a click-wrap agreement between plaintiff Forrest and defendant Verizon. The forum clause determined where a case would be brought if a claim was filed over a contract dispute. The plaintiff in this case argued that the forum selection clause was unenforceable because the click-wrap agreement did not provide adequate notice of the forum selection clause. The click wrap text was contained in a scroll box that included the statement "PLEASE READ THE FOLLOWING AGREEMENT CAREFULLY" at the top of the text. A button labeled "I Accept" was located below the scroll box. The user was required to select this button to complete the transaction. Only a small portion of the click wrap text was visible in the scroll box at one time and the entire text of the agreement was thirteen pages long when it was printed out. The forum provision clause of the agreement was included in a final portion of the text and was only visible in the scroll box after scrolling through most of the agreement.

The court rejected the plaintiff's assertion of inadequate notice, relying on the traditional notion of contract law that "one who signs a contract is bound by a contract which he has an opportunity to read whether he does so or not." The court likened the scroll box to the series of pages in a traditional contract and determined therefore that adequate notice of the forum selection clause was provided by the click wrap agreement.

ARE "LINKED CONTRACTS" ENFORCEABLE?

In designing your Web page, can you link to a lengthy contract where the full terms can be read instead of inserting the terms in a scroll box? In *DeJohn v. The TV Corporation International et al.*, plaintiff DeJohn attempted to purchase Internet domain names from defendant TV Corp. through the Web site of defendant Register.com. To do this, the plaintiff had to enter into a click-wrap service agreement with defendant Register.com. A hyperlink on Register.com's Web-page connected the plaintiff to a Web page containing the service agreement. To complete

the purchase, DeJohn had to click a box, located just below the hyperlink, to indicate that he had read, understood, and agreed to the terms of the service agreement. Among other arguments, DeJohn asserted that the click-wrap service agreement failed to provide adequate notice of its terms, since the terms were only visible after following a link to a separate Web page. The court rejected this argument, finding that DeJohn was able to review the terms of the agreement by selecting the link.

Consent is another important legal issue with regard to the enforceability of click-wrap and browse-wrap agreements. Click-wrap, as discussed above, typically provides a means to indicate consent and requires the user to select the means before proceeding with a transaction. For example, the presentation of a click-wrap agreement in a Web page may include a button or link that is labeled "I agree" or "I accept." Thus, click-wrap agreements typically provide a sufficient means for a user to indicate consent to an agreement, although there is some legal dissension over the appropriate particulars for this means.

In *i.Lan Systems, Inc. v. Netscout Service Level Corp.*, the court dealt with the issue of whether the buyer of software was subject to the terms of a click-wrap license agreement which did not appear on the seller's Web site until after the purchase of the software was completed. i.Lan Systems had paid for the software and was required either to accept or reject a license agreement within the software before proceeding further; i.Lan Systems selected the "I Agree" box. i.Lan Systems argued that it had not assented to the terms of the license agreement since they were not known to it at the time of the purchase and, therefore, were not part of the bargained-for exchange.

The court rejected this argument and held that i.Lan Systems explicitly consented to the click-wrap license agreement when it clicked on the box labeled "I Agree." In coming to this conclusion they relied on the holding of *ProCD Inc. v. Zeidenberg* and application of the Uniform Commercial Code.

ProCD was the first "shrink-wrap" case involving the enforceability of a shrink-wrap license in its packaged software. In *ProCD*, the court upheld software license terms included in the packaging. While the terms of the license were included within the package, its terms afforded the purchaser an opportunity to review the product and its terms before being bound. The court held that "terms inside a box of software bind consumers who use the software after an opportunity to read the terms and to reject them by returning the product." They concluded that the absence of a timely rejection was sufficient to show assent. Following *ProCd*, it turns out i.Lan accepted the click-wrap licensee agreement when it clicked on the box stating "I agree."

These cases demonstrate that click-wrap agreements will be enforced and are here to stay. Consumer as well as business-to-business transactions are handled via the Internet at an ever-increasing rate. It is important to set up your licensing transactions so these contracts will be enforced. Make sure that there is a true acceptance of the contract terms and the user hits an "I accept" or "I agree" button. Give the user an opportunity to review the terms whether by a hyperlink, or in a scroll box. Make sure the terms and the "I accept" button are located in close enough proximity that it is obvious that the terms are being accepted. In other words, treat these online agreements the same as a paper contract. Make sure that the basic contract principles are followed.

10 THE DIGITAL MILLENNIUM

COPYRIGHT ACT (DMCA): PROTECTION OF COPYRIGHT MANAGEMENT INFORMATION

When the Copyright Act was revised in 1978, the Revision Act was intended to be technology neutral to avoid the problems of the prior 1909 Act that did not anticipate many technological advances such as film, TV, Cable, and the Internet. Even in light of such good intentions, the ease with which copies could be disseminated via the Internet required changes to the Act that would address technological manipulations attendant to Internet-based infringement. The Digital Millennium Copyright Act (DMCA) was signed into law on October 28, 1998. The DMCA is a complicated piece of legislation—at the time of its promulgation, technical corrections were already planned. Part of the DMCA includes Section 1202 of the Copyright Act, which protects the integrity of copyright management information (CMI). An example of CMI would be a Digimarc style system that imbeds copyright information into the digital image. This section acknowledges that, although the Copyright Act currently prohibits unauthorized copying of work, technology has enabled copying to be done with ease and often in the privacy of one's home. Since policing of such copying is unrealistic, technological "self-help" is necessary to encourage digital commerce. Section 1202 recognizes this need and prohibits tampering with CMI.

Section 1202 addresses both false CMI and the removal or alteration of CMI. In order to be liable, the falsification or removal of the CMI must be done with knowledge (for criminal penalties) or with reasonable grounds to know that it will induce, enable, facilitate, or conceal an infringement. CMI is defined as identifying material about the work, the author, the copyright owner, and, in certain cases, the writer, director, or performer of the work, the

terms and conditions for use of the work, and such other information the Register of Copyrights may prescribe by regulation. Law enforcement, intelligence, and governmental activities are exempt from this section.

Unlike other copyright actions, which require registration before filing a claim, a person may bring a civil action in federal court against anyone who violates this section. The court can reduce or remit damages if the violator proves that it was not aware and had no reason to believe that the acts constituted a violation. Moreover, non-profit libraries, archives, and educational institutions are entitled to a complete remission of damages in these circumstances. In order to avoid a claim that the violator was unaware, it is recommended to include a notice on a Web site that contains CMI advising users that tampering with CMI is a violation of the Copyright Act. In addition, criminal penalties apply to willful violation for purposes of commercial advantage or private financial gain. Penalties are severe and can range up to a $500,000 fine or up to five years imprisonment for a first offense, and up to $1 million fine or ten years imprisonment for a subsequent offense. Non-profit libraries, archives, and educational institutions are exempt from criminal liability.

One of the first DMCA claims came up in a *Kelly v. Arriba Soft.* In reviewing the new DMCA claim, the court found that it did not apply to this case. The DMCA requires that no one may intentionally remove or alter CMI. Since in this case, the copyright information was only in the *text* surrounding the photographs, and not in the images themselves, there was no violation. To find a violation, the court concluded that the information must be embedded in the work and the user must intentionally separate the information from the work and know that this would lead to possible infringements. At the time of the action, a full-size version of the thumbnail image could be found by clicking on the image, and a Web site name was made available where copyright information could be obtained. The search engine home page also contained a warning that use restrictions and copyright limitations *may* apply to images retrieved by the search. Based on the above, the court did not find that Arriba had "reasonable grounds to know" that its conduct would cause infringement. Further, the home page of the Web site warned the users about copyright, so it did not seem that the search engine was intentionally trying to encourage copyright infringement. The court dismissed the photographer's DMCA claim under this section on summary judgment. It was expected that Section 1202 would deter online infringements. However few courts have found liability against anyone as the burden of showing that CMI was removed with knowledge that it would induce infringement is too high a hurdle.

DMCA—LIMITATION OF LIABILITY FOR INTERNET SERVICE PROVIDERS

In addition to protecting CMI, another provision of the DMCA was to protect Internet Service Providers from monetary damages for inadvertently hosting infringing content. Internet service providers (ISP) lobbied hard for a limitation of liability from copyright infringement actions under the DMCA, arguing that it was impossible to monitor the Web and what users were uploading. Prior cases had found liability against ISPs who hosted "bulletin boards" for the content posted by users. A "service provider" is defined under the law as anyone who provides online service or network access, operates a facility that provides network access, or transmits, routes, or provides connections for digital online communications between or among specified users, of unmodified materials of the users' choosing. This definition is fairly broad. A compromise was struck that gave an ISP a safe harbor from liability if they followed certain procedures and guidelines. The result is Title II, Section 512 of the DMCA. Section 512 limits the liability of an ISP for copyright infringement. If an infringing work is posted on the Internet, section 512 may limit you from holding a service provider liable for the copyright infringement. However, these limitations are closely defined and the ISP may shield itself from monetary damages and injunctive relief only if it falls within one of the four enumerated categories.

These categories are limited to situations where:

1) the provider merely acts as a data conduit, transmitting digital information from one point on a network to another at someone else's request (Section 512[a]);

2) the provider regularly retains copies, for a limited time, of material that has been made available online by a person other than the provider, and then subsequently transmits them to a subscriber at his or her direction (Section 512[b]);

3) the provider has infringing materials on Web sites hosted on their systems (Section 512[c]); or

4) the provider refers or links users to a site that contains infringing material (Section 512[d]).

However, an ISP must fulfill conditions for immunity. First, the provider must not have actual or circumstantial evidence of the infringing activity.

Second, the provider must not receive a financial benefit directly attributable to the infringing activity, in a case in which the service provider has the right and ability to control such activity. Upon receiving proper notification of claimed infringement, the provider must expeditiously take down or block access to the material. In addition, upon notification of claimed infringement, the provider must respond expeditiously to remove, or disable access to the infringing material. If the provider does not violate any of these conditions and has in addition filed with the Copyright Office a designation of an agent to receive notifications of claimed infringement, then no monetary damages or injunctive relief may be ordered against the ISP.

HOW TO EFFECTIVELY SEND A DMCA NOTICE LETTER

It is important, however, for the copyright owner to provide proper notification of the infringement. If you find an infringing work on the Internet, specific procedures must be followed in order for the notification to be considered proper. It must be in written form, including a physical or electronic signature of a person authorized to act on behalf of the owner of the exclusive right that has been allegedly infringed, provided to the designated ISP agent, and must include a specified amount of information, including identifications of the copyrighted work and the infringing work, contact information for the complaining party (address, telephone number, e-mail address), and the location of the infringing work. The complaining party must include a statement that it has a good faith belief that the use of the material is not authorized by the copyright owner, its agent, or the law. A second statement is also required that information provided in the notification is accurate and, under penalty of law, that the complaining party is authorized to act on behalf of the owner of the exclusive right that is allegedly infringed.

To prevent fraudulent notification, the alleged infringer may file a counter-notification.

Once the ISP has received notification of the alleged infringement, it will remove or deny access to the work that has been allegedly infringed. The counter notice must contain a physical or electronic signature of the alleged infringer who asserts rights to use the work. It must also include identification of the work that has been moved, or made inaccessible and the location where the work appeared before it was removed or disabled as well as the standard statement under the penalty of perjury that the alleged infringer has a good faith belief that the work was removed or disabled as a result of a mistake or a misidentification of the

work to be removed. Finally, the counter notice should state the person's name, address, and telephone number and a statement that the person signing consents to jurisdiction of the Federal District Court for the judicial district in which the address is located, or if the alleged infringer is outside the United States, for any judicial district in which the service provider may be found, and that the person will accept service of process from the person or its agent who provided the initial notification. If the counter-notification states that the infringing work was removed because of mistake or misidentification, the provider can put up the work again within ten to fourteen business days, unless you, as the copyright owner, file an action seeking a court order against the alleged infringer.

The following is a form DMCA letter.

· ·

DATE
By EMAIL
ADDRESS OF ISP
Re: DMCA Copyright Infringement

Dear Registered Agent:

I am the COPYRIGHT HOLDER [or/represent COPYRIGHT HOLDER who has authorized me to act as on its behalf for copyright infringement notification].

Infringement(s) of COPYRIGHT HOLDER'S photograph (the "Photograph") has/have been detected on the Web site www.address.com. [Details of the infringements are listed on the attached report.] *or in the alternative* The infringing photograph appears on the Web site as follows: INSERT DESCRIPTION OF LOCATION. *A copy of the infringing photograph is attached for your assistance in removal.*

This letter is an official notification under the provisions of Section 512(c) of the Digital Millennium Copyright Act to effect removal of the detected infringements. I hereby request that you immediately issue a cancel message, as specified in RFC 1036, for the specified postings and prevent the infringer, who is identified by its Web address, from posting the infringing photograph(s) to your servers in the future. Please be advised that by law, as a service provider, you must "expeditiously remove or disable access to" the infringing photograph(s) upon receiving this notice. Noncompliance may result in a loss of the possibility of immunity under the DMCA.

I have a good faith belief that use of the material in the manner complained of herein is not authorized by [me/COPYRIGHT HOLDER], its licensing representatives, or the law. The information provided herein is accurate to the best of my

knowledge. I hereby swear under penalty of perjury that I am the COPYRIGHT HOLDER [or authorized to act on behalf of COPYRIGHT HOLDER for matters pertaining to notification of infringement of its exclusive rights in its copyrighted material].

Please send to me at the address above a prompt response indicating the actions you have taken to resolve this matter.

Very truly yours,
SIGNATURE/NAME
Enclosure

. .

The DMCA is meant to protect service providers that merely post Web sites without any knowledge or control of the contents. In order to protect your rights to the full extent, you may bring a copyright infringement claim against the infringer as well as the service provider for any works that may infringe upon your exclusive rights under Copyright law. However, if the service provider complies with the statutory requirements of Section 512, you may find that you will not be able to prevail in your claim against the provider. By following specified "notice and take down procedures" ISPs can limit their liability for certain activity by removing any alleging infringing material.

What must the Service Provider do to limits its liability? The Service Provider will not be liable for taking down the allegedly infringing material if it:

1) takes reasonable steps to notify the alleged infringer that it has removed or disabled access to the material;

2) upon receipt of counter notification, promptly provides the person who provided the notification with a copy of the counter notification and inform the person that it will replace the removed material or cease disabling the material in ten (10) days;

3) replaces the removed material and ceases disabling access to the material not less than ten (10), no more than fourteen (14) business days following receipt of the of the counter notice unless its designated agent receives notice from the first person who sent a notice of infringement that such person has filed a court order to restrain the alleged infringer from engaging in infringing activity relating to the material on the service provider's system.

These measures help prevent the continued infringement of photographs since it may be difficult, expensive, or time consuming to locate the infringer who uploaded the copyrighted work and commence a copyright action. If a Web site contains unlicensed photographs that you believe in good faith are yours, or are an infringing copy, you can notify the hosting service provider of the alleged infringement, identifying that you are the copyright owner or authorized agent of the copyright owner and identify the copyrighted work. If the notice complies with the requirements, the service provider must remove the offending material. Unless the service provider receives a counter notification, this notice will probably guarantee the removal of the material without further activity. However, if a counter notification is filed, you must commence a legal proceeding or the material will be reinstated. If you do not have a copyright registration for the material, you will have to seek expedited registration from the Copyright Office that entails a steep fee plus the normal application fee in addition to any court costs. It is rare that an unauthorized user will send a counter notification submitting to federal jurisdiction. In my experience, no counter notices are provided as the works are clearly posted without permission. The DMCA has proven to be a valuable tool if the goal is to remove the offending material quickly and not seek monetary damages.

One organization that has effectively been using the DMCA to shut Web sites down (particularly its critics) is the Church of Scientology. The online community of Scientology critics has long copied, distributed, and annotated hundreds of "top secret" and copyrighted documents from the Church of Scientology while invoking fair use laws (which allow publishers to excerpt copyrighted material for the purpose of comment or criticism) to defend their actions. The Church of Scientology has aggressively sought to shut down Web sites that have republished its material on the Internet and is now using the DMCA to demand that Internet service providers disable these sites or reveal the identities of anonymous Usenet posters.

WHO IS A SERVICE PROVIDER UNDER THE DMCA?

In mid-2004, the stock photography company Corbis Corporation instituted copyright infringement actions against vendors selling posters and photographs of celebrity images. The suit included claims against online retailer Amazon.com as many of the posters or photographs were offered for sale and displayed on Amazon.com. Corbis ultimately reached settlement agreements against the vendors, but Amazon.com maintained that it was immune from

liability under Section 512 of the DMCA. Both Amazon and Corbis filed motions for summary judgment and partial summary judgment, asking the court to determine whether copyright liability existed under the DMCA. The resulting decision of *Corbis Corp. v. Amazon.com, Inc.* examined the complex requirements an ISP must satisfy in order to receive the benefits of the DMCA's limited liability provisions.

The question in this case is whether Amazon was an ISP under the DMCA. The definition of an ISP is quite broad, and includes any "provider of online services or network access, or the operator of facilities therefore." A previous decision had already found that Amazon.com fit well within the definition, since it operates a Web site, provides retail and third party selling services to Internet users, and maintains computers to govern access to its Web site. This court agreed.

After Amazon.com satisfied the court that it was a service provider, in order to be eligible for the limited liability protection offered under section 512, Amazon was required to demonstrate that it: a) has adopted and reasonably implemented, and informs subscribers and account holders of the service provider's system or network of, a policy that provides for the termination in appropriate circumstances of subscribers and account holders of the service provider's system or network who are repeat infringers; and b): accommodates and does not interfere with standard technical measures.

Corbis maintained that Amazon did not qualify for the 512(c) exemption because it did not meet the initial threshold conditions. Prior decisions involving a user policy require the ISP to meet three conditions: 1) adopt a policy that provides for the termination of service access for repeat copyright infringers; 2) inform users of the service policy; and 3) implement the policy in a reasonable manner. Amazon.com required vendors who wished to sell products to consumers under its zShops platform to accept terms of a Participation Agreement that included the policy guidelines. The Participation Agreement prohibited vendors from listing or linking to any item that "infringes any third party intellectual property rights (including copyrights, trademark, patent and trade secrets) or other proprietary rights (including rights of publicity or privacy); is counterfeited, illegal, stolen or fraudulent."

In addition, the Participation Agreement referred to Community Rules regarding the prohibition of selling copyrighted media without permission. The Participation Agreement described Amazon.com's right, but not the obligation, to monitor activity and take action as necessary. Among the action that Amazon.com could take was a reference to termination of services and removal of materials. Amazon.com listed a designated agent for notice of complaints and

provided the name of the agent to the Copyright Office and listed the information on its Web site. Corbis contended that Amazon.com's policy was insufficient to satisfy the conditions of the DMCA because the policy was too vague with regard to issues of copyright infringement, the policy did not include the term "repeat infringers," and did not describe its methodology in determining which users will be terminated for repeat copyright violation.

Despite these shortcomings, the court held that Amazon.com's policy was sufficient and that the DMCA did not require the user policy to be as specific as Corbis suggested it should be. Amazon.com had notified vendors of violation of intellectual property rights and community rules and had terminated access to zShops to hundreds of vendors for violating its policy. Amazon.com had not, however, been able to prevent certain vendors from returning under a different name, although it terminated access once it was notified. The court did not require the policy to be perfect, only reasonable.

Corbis argued that certain vendors were blatant infringers and that Amazon.com had received multiple notices of infringed listings by various senders and Amazon.com did not terminate these vendors until after the Corbis lawsuit was filed. The court interpreted the definition of "blatant infringement" quite narrowly and stated that Amazon.com would have to have knowledge just by looking at the material listed on the vendor site that the work was pirated. The court discounted notices from senders of infringement, stating the notices under the DMCA only require "good faith belief" and that this belief could be wrong.

Having found that Amazon.com met the threshold requirements of Section 512(c), Amazon.com still had to demonstrate that it satisfied the specific requirements for the particular safe harbor that protects a service provider from monetary liability for "infringement of copyright by reason of the storage at the direction of a user of material that resides on a system or network controlled or operated by or for the service provider." To qualify under this exemption the ISP must demonstrate that it:

- Does not have actual knowledge that the material or an activity using the material on the system or network is infringing. In the absence of such actual knowledge, is not aware of facts or circumstances from which infringing activity is apparent;

 or

- Upon obtaining such knowledge or awareness, acts expeditiously to remove, or disable access to, the material; Does not receive a financial

benefit directly attributable to the infringing activity, in a case in which the service provider has the right and ability to control such activity; and Upon notification of claimed infringement as described, responds expeditiously to remove, or disable access to, the material that is claimed to be infringing or to be the subject of infringing activity.

While agreeing that Amazon.com had responded expeditiously to remove infringing material, Corbis argued that Amazon.com failed to satisfy the other requirements because it knew or should have known that the celebrity posters and photos on several of its vendor Web sites were infringing, received a financial benefit directly attributable to the activity, and had the right and ability to control the activity.

The Court disagreed with Corbis' assertion that Amazon.com should have known that these celebrity posters were infringing and noted that Corbis never attempted to notify Amazon.com that zShop vendors were selling infringing images that violated Corbis' copyright. Corbis argued Amazon.com should have had notice without Corbis sending direct notification, but the Court did not hold Amazon to such a high standard of knowledge and only acknowledged that Amazon may have been aware that celebrity photos were vulnerable to infringement. However, there was nothing about these vendor sites on their face to suggest that they were pirate sites.

Moreover, the court disagreed that Amazon "has the right and ability to control" the infringing activity and noted that a prior decision of *Hendrickson v. Amazon.com* in California found that Amazon met this criteria of Section 512(c) and that it merely provided a forum for third parties to sell merchandise and did not control the sale. The court agreed and found that Amazon.com had met all the threshold conditions for protection under the 512(c) safe harbor.

This decision clarifies for ISPs what steps need to be taken in order to receive the benefits of the DMCA's safe harbor. The good news is that ISPs must have an effective copyright policy that it communicates to its users and must in fact respond to notices to remove infringing material. The courts do seem reluctant to impose direct liability on ISPs for third party content and rather appear to encourage copyright owners to send notices to any ISP with suspected infringing material requesting a removal of the infringing material. In order to obtain monetary damages, copyright owners will be required to commence infringement actions against the direct infringers, the poster companies and others selling unauthorized images, rather than the online stores. This of course places a much greater burden and expense on copyright owners to seek out the third party sellers. One thing the Internet offers users is the

unique ability to operate anonymously, whether sending e-mails, chatting, or operating Web sites. Unfortunately copyright infringers have learned how to hide behind the veil of secrecy as well.

OBTAINING THE IDENTITY OF THE ACTUAL INFRINGER UNDER THE DMCA

We've seen that the DMCA can limit the liability of various categories of ISPs for acts of copyright infringement by the ISP's users so long as these ISPs meet certain criteria set out in the law. A provision within the statute provides that a copyright owner may request the issuance and enforcement of a subpoena to a service provider in order to obtain the identity of an allegedly infringing customer. The enforcement of this provision was the subject of a somewhat recent court decision of *RIAA v. Verizon.*

Not surprisingly, the case involves peer-to-peer music sharing. The Recording Industry Association of America (RIAA), on behalf its members, served a subpoena on Verizon Internet Services (Verizon) under the authority of §512(h) of the DMCA. RIAA wanted Verizon to reveal the identity of one of its subscribers who was downloading more than 600 songs in a single day from the Internet through peer-to-peer software provided by KaZaA. The RIAA knew the user's Internet protocol (IP) address, but only Verizon knew the subscriber's identity. Verizon failed to comply with the subpoena, stating in a response letter that in its view, the subpoena power of the DMCA applied only if the infringed material was stored or controlled on the service provider's network, and in this instance, the network was only a conduit for the infringing material. RIAA brought suit in the District Court of D.C. to enforce the subpoena.

This action compelled the court to interpret the language and structure of the DMCA in order to clarify the power and scope of the subpoena provisions in §512(h). The Court determined that the subpoena power under §512(h) applies to all Internet service providers, and therefore it ordered Verizon to comply with the RIAA's subpoena.

The Court went on to discuss in great length the policy, purpose, and history of the DMCA. Congress, the Court stated, had a dual purpose in enacting the DMCA. First, the DMCA is designed to preserve copyright enforcement on the Internet and protect against unlawful piracy, which is enabled by the subpoena power. The second purpose is to promote the development of electronic commerce by providing immunity to service providers from liability for copyright infringement for actions initiated by online users without

the knowledge of the service provider. The Court said that this balance and dual purpose were built into the DMCA, and that the best results can only be reached if the statute is construed to extend the authority of the subpoena provisions to all service providers within the DMCA.

Finally, the Court stated that the free speech guarantees of the First Amendment do not protect copyright infringement and that this is not an instance where the "anonymity of an Internet user merits free speech and privacy protections." Although the Internet provides an "unprecedented electronic megaphone" for expression, and even though the right to speak anonymously is protected by the First Amendment, the Court failed to see how anonymously downloading 600 songs without authorization was protected speech. Moreover, the Court agreed with the RIAA, "the alleged infringer [was] not truly anonymous . . . Verizon knows the identity."

This decision would have effectively discouraged other service providers from refusing to respond to subpoenas served to learn the identity of copyright infringers of music and images as well. But a year later, this decision was reversed on appeal. The court interpreted this section of the DMCA as *not* authorizing the issuance of a subpoena to an ISP acting solely as a conduit for communications, the content of which is determined by others. Because the infringing material is not stored on the ISP server, but on the *users'* computer, Verizon argued and the court agreed that it could not remove or disable content. Since this decision, the music industry has been forced to file "John Doe" lawsuits against suspected peer-to-peer file sharers in order to obtain the name and address of the alleged infringers. This reversal does not apply to ISPs who actually have the infringing content residing on their server.

SATISFYING THE NOTICE REQUIREMENT UNDER THE DMCA

The requirement of notifying a provider that it is hosting infringing photographs has proven to be a major obstacle in efforts to remove infringing images from Web sites that allow communities to upload images for sharing, similar to communities that permit the sharing of music. Whereas music has titles that are easily searched and recognized on a site, it is difficult to discover infringing photographs on a large site co-mingled with thousands of others. A federal court has looked at case involving Title II of the DMCA that deals with the notice issue in *ALS Scan, Inc. v. RemarQ Communities.*

ALS Scan Inc. (ALS) is in the business of creating and marketing "adult" photographs. It brought an action against an ISP, alleging violations of the

Copyright Act and Title II of the DMCA. The ISP, RemarQ, provided access to newsgroups to share information on a wide range of topics. Although it did not monitor, regulate, or censor the contents of the articles posted in the newsgroup by the subscribing members, it had the ability to filter information and screen its members from logging onto certain newsgroups, such as those containing pornographic material. Two of the newsgroups contained ALS's name in the title and contained hundreds of postings that infringed its copyrights in the photographs. Upon discovering these postings, ALS sent a letter to RemarQ stating that both newsgroups were created for violating its copyrights and contained virtually all copyrighted images. RemarQ was ordered to cease carrying the newsgroups within twenty-four hours. RemarQ refused to comply with the demand but advised ALS Scan that it would eliminate individual infringing items from the newsgroup if ALS Scan identified them "with sufficient specificity." Thereafter an action was commenced.

ALS in its complaint alleged that RemarQ possessed actual knowledge of the infringing material but refused to block or remove access to the material. RemarQ filed a motion to dismiss stating that ALS's failure to comply with the notice requirement under the DMCA provided it with a defense to the copyright claim. The District Court granted the motion. An appeal followed.

ALS contended that it substantially complied with the notification requirement of the DMCA, depriving RemarQ of its safe harbor from copyright liability under the provisions that protect ISPs. RemarQ argued that it did not have knowledge of the infringing activity as a matter of law because the copyright holder had failed to identify the *pictures* that formed the basis of the copyright complaint. The court looked at Section 512(c) and determined that, in order for an ISP to qualify for this safe harbor, it must meet all three requirements that are described above. In reviewing the purpose of the DMCA, the court noted that immunity is granted only to "innocent" service providers who can prove that they do not have actual or constructive knowledge of the infringements. The protection of the DMCA is lost the moment that the ISP loses its innocence. Balancing the interests between the copyright holder and the service provider, the court found that the DMCA allowed the holder to put the ISP on notice that only substantially complied with the prescribed format and did not require perfection.

Significantly the court held that "in addition to substantial compliance, the notification requirements are relaxed to the extent that, with respect to multiple works, not all must be identified, just a representative list." And with respect to location information, the copyright holder must provide information that is reasonably sufficient to permit the service provider to "locate the material." The court found that the notice requirement was not intended to

burden the copyright holder with the responsibility of identifying every infringing work or even most of them.

In this case, the initial letter satisfied the DMCA notice requirement in that it identified two sites created for the sole purpose of publishing ALS works (virtually all the material was its copyrighted work) and referred RemarQ to its Web address where it could find ALS copyright information. It noted that ALS material could be identified because its name and copyright symbol *was next to it.* Therefore the court reversed the ruling dismissing the action and sent the case back to the district court to proceed on its copyright claims.

While most stock libraries and photographers will not be so fortunate to find infringing photo community sites which identify newsgroups with the copyright holder's name, this case is relevant in that it relaxes the burden on copyright holders of multiple works who cannot perfectly meet the DMCA notice requirements of identifying with particularity each infringing photograph on a site. It may be sufficient to satisfy the location requirement by identifying community members by name that have posted some infringing photographs and either send the ISP to a Web site with a database of copyrighted photographs, or send a disk or catalog to the ISP with multiple images. Under this ruling, this notice would place the burden on the Web site to remove any infringing images included on its site or face liability for copyright infringement. This is significant since few have the staff to scan through what could be up to millions of images located on photographic community sites where potentially thousands of images are added daily. The relaxed interpretation of the notice requirement should be helpful to copyright owners and their representatives in removing infringing photographs from Internet Web sites.

HOW TO ENFORCE COPYRIGHT ON THE INTERNET

What can we take away from these cases for practical purposes? After finding an unauthorized use of an image on a Web site, what do you do next? The first step is to contact the company using the image. You can send them a cease and desist letter, by regular post or e-mail. You may need to educate the company who owns the Web site about copyright. The most common response is for the company to claim that it hired a Web designer to create the site and assumed it had the right to use the images. It will apologize, take the image down, and expect you to be satisfied. It never expects to pay any fee.

Because so many Web site owners who display photographs are unfamiliar with copyright and may not have properly licensed images, upon receiving

a notice of unauthorized use, they immediately remove the photographs and are shocked when a retroactive license is demanded. These Web site owners, unlike ISPs, are not passive but direct infringers. A photographer's bag of tricks should include not only lenses and filters, but a letter to send to Web site owners explaining why a retroactive license is required as a consequence of displaying photographs without a license. This is part of educating new "users."

You need to explain that the copyright act provides for liability and damages even if the user did not know the work was not licensed properly or did not intend to infringe. If a user reproduces, distributes, or displays the image, he has violated the copyright owner's exclusive rights under the Copyright Act. It is irrelevant if the user knew that the reproduction was unauthorized or not. In other words, if a person uses it, he must pay (unless there is a legitimate defense of fair use which is not typically the case). If the image is registered, the copyright owner may seek statutory damages and attorney's fees. Many use a multiplier of a license fee as a measure of actual damages. If not, the copyright owner is entitled to the market value of the use and the infringer is not in a position to haggle.

If the infringer will not remove the images and refuses to respond, you, the copyright owner, can go to WHOIS.com and determine the ISP that hosts the Web site. (If the ISP is identifiable by a numerical sequence, the American Registry for Internet Numbers at www.arin.net can locate the ISP). You can contact the ISP and identify the image and the Web page it is located on and ask to have the image removed. You must represent that you have the right to administer the copyright of the work. If a Web site is using your image to enhance its Web site, do not send a DMCA notice and takedown letter to the site. It is not acting as an ISP, and it will assume by the language in the letter that if it removes the infringing image, it will have no liability. Only use the notice and takedown letter when dealing with the ISP, not the Web site owner. Send the Web site owner a notice of infringing use letter and seek payment. There is no guarantee you will always collect but your chances are much better if you do not give the Web site owner the idea that if it takes the work down, it will have no liability.

DIRECT LIABILITY VERSUS SECONDARY LIABILITY

Under the Copyright Act there is direct infringement, for example, Web sites that use copies of protected work as part of their content. There is also secondary liability, where, for instance, a Web site contributes to or receives

a vicarious benefit from infringement. Litigation under the DMCA has proven to be useful in defining copyright law area concerning direct liability versus vicarious liability and contributory infringement. In *CoStar Group, Inc. v. LoopNet, Inc.*, the Fourth Circuit of the United States Court of Appeals took the opportunity to revisit the issue of direct liability of an ISP to copyright owners for the conduct of their users that results in copyright infringement. This case involved alleged copyright infringement of photographs posted on a Web site that belonged to and was hosted by the ISP LoopNet. The Fourth Circuit found that that LoopNet had not directly infringed the copyright owner's copyrights in the photographs uploaded to its site.

Readers now know that in order to be liable for copyright infringement, there must be a violation of an exclusive right such as unauthorized "copying." According to the Appeals Court, if an ISP merely passively stores material at the direction of its users, it has not engaged in "copying" under the current Copyright Act. The court also held that the DMCA did not supercede or replace any aspects of the Copyright Act, but merely added to it—meaning that the DMCA did not change the definition of copyright infringement for ISPs, but simply added an additional defense and offered certain ISPs a safe harbor. The court equated the passive ISP to an owner of a copy machine who is not liable if a user infringes a work by making a copy with his machine.

The plaintiff CoStar owned the copyrights to numerous photographs of commercial real estate. The defendant, LoopNet, Inc., was an ISP whose Web site allowed users, generally real estate brokers, to post listings of commercial real estate on the Internet. LoopNet did not post any real estate listings on its own account; rather it provided a Web hosting service for users to display their listings on the Internet. As with many services of this type, before posting anything on the Web site, a user had to fill out a form and agree to "Terms and Conditions" that included a promise not to post copies of photographs without authorization and a warranty that the user has "all necessary rights and authorizations" from the copyright owner of the photographs. Once the user had uploaded a photograph, it was stored in a LoopNet computer for review. A LoopNet employee then cursorily reviewed the photograph to (1) determine if the photograph actually depicts commercial real estate, and (2) find any obvious indicators that the copyright might belong to someone other than the user (such as text or copyright notice). Otherwise, the employee selected the "Accept" button and the photograph was posted on the Web page with a matching property listing.

CoStar sued LoopNet for copyright infringement, among other claims, of the photographs owned by CoStar that were posted by LoopNet users without permission. Essentially the argument was that by posting these copyrighted

photographs on their Web site hosted by their ISP, LoopNet was itself "copying" the photographs without permission. Both the District Court and the Fourth Circuit disagreed with CoStar. The key to the Fourth Circuit's opinion was its interpretation of the role of an ISP (and message board service) as a "passive" provider of Internet services. The Fourth Circuit inferred from the Copyright Act that either "volition or causation" was required to hold a party directly liable for infringement. This meant that despite the strict liability enforcement of copyright infringement, the court required some kind of "meaningful" conduct by the infringing party.

In this case, the Fourth Circuit did not find any of LoopNet's actions to constitute "meaningful" conduct that made it more than a passive party. CoStar argued that LoopNet was more than just passive, because of LoopNet's screening process (described above). The court disagreed that a cursory review would impose liability and equated the act to the owner of a copy machine that has a guard at the door to turn away persons with obviously copyrighted material.

Two policy rationales seemed to emerge from the opinion: (1) where a user is clearly directly liable for infringement (in this case, the person who posted the copyrighted photograph), the court is reluctant to hold an ISP accountable for the same infringement, especially because such accountability would discourage the growth and use of the Internet, and (2) the court will avoid "punishing" an ISP for taking reasonable steps to monitor and deter copyright infringement (good-deeds-should-not-be-punished rationale). LoopNet had previously acted promptly in removing CoStar's photograph upon notice and had taken steps to review those reported listings to make sure the same photographs were not reposted.

This case will certainly give guidance to ISPs who want to further limit liability for copyright infringement. The Copyright Act does permit actions against contributory and vicarious infringers but these types of infringement require more than passive activity on the part of the infringer. A lesson to copyright holders (or their representatives) is to make it obvious that the photographs are protected by copyright. This can be accomplished by a watermark or metadata that stays with the image file. The direct infringer (the one posting the images) is still liable.

IS THERE LIABILITY ON THE INTERNET BASED ON INDUCEMENT?

Unlawful downloading of music has made a significant impact on the music industry. Consequently, many cases have been brought against software companies who create the peer-to-peer software. In *Metro-Goldwyn-Mayer Studios*

Inc. v. Grokster, a unanimous Supreme Court held that peer-to-peer software companies might be liable for software user's copyright infringement, such as downloading music and movies, *if* the companies promote their product for illegal activities. Grokster and StreamCast had been granted judgment in their favor without trial in Court of Appeals for the Ninth Circuit. The lower court held that under *Sony Corp. v. Universal City Studios*, or the Betamax case, a product's legitimate functions protected the manufacturer from claims surrounding infringing uses by rogue third-party end users. The high court decided that the lower court interpreted the Betamax rule too broadly. While the peer-to-peer networks are legitimately used at universities and to distribute public domain material such as Shakespeare, Grokster and StreamCast had advertised their software as a means to download copyrighted material. The case was sent back to the Ninth Circuit for a full trial. Grokster settled with the plaintiff, leaving defendant StreamCast in the case. At the end of September 2000, the district court granted Plaintiff's motion for summary judgment against defendant StreamCast for copyright liability based on the intent to induce copyright infringement.

DOES "INLINE LINKING" VIOLATE THE DISPLAY RIGHT?

Perfect 10 v. Google offered some insight regarding fair use and thumbnails, which we've discussed. The court also sought to determine the liability of a search engine that "calls up" copyrighted images. As for the infringement question at hand, Judge Matz posed the query, "Does a search engine infringe copyrighted images when ... through inline linking, it displays copyrighted images served by another Web site?" In other words, there's a debate over inline links in addition to the fair use question regarding thumbnails. Google offers users an image search, or a feature that lists links to sites containing images of almost anything one could imagine. Users enter search terms, and Google responds with a grid of relevant thumbnail images, which refer the user to a site. These thumbnails are the "*unauthorized images*" prong of the suit. As for the "*inline linking*" prong, when a user clicks on one of the thumbnails Google responds by displaying a sort of mutant window that has the head of a Google page and the body of another site, the product of what is known as "*framing.*" As the head of the new page, the Google frame includes the thumbnail and information about the hosting Web page. As for the body, users will see the actual content from the site Google has fetched. However one

makes sense of the concept of inline linking, the point is this lower frame includes the full-size image, which a hosting site may or may not include in violation of copyright law.

Perfect 10 alleged that Google infringed the plaintiff's exclusive right to display its images. With this question before it, the court had to define "*display*" as it related to inline linking. Inline linking is not exactly the same as the links we're perhaps more familiar with. "*Links*" are text or images that transport the user to a new page when she clicks on one. When a reader clicks text that looks like this: www.soulcare.org/images/Boston-Terrier.jpg, she's experienced a link. "*Inline linking*" is a different creature—one that incorporates content stored on another Web site with the referring page. When users click on a thumbnail retrieved in a Google image search, the result is a product of inline linking. Try it and chances are you'll see a framed page, which includes a space allotted for "*ads by Google.*"

In terms of inline linking, two competing approaches to defining "*display*" emerge. Each definition conveniently corresponds to one or the other party's standpoint as to whether Google is somehow infringing Perfect 10's display rights. On one hand, we have the "*server test*" embraced by Google. On the other hand, we find the "*incorporation test*" proposed by Perfect 10.

Google's server test defines "*display*" as the act of actually serving content over the Web. According to the server test, the Web site referred to in the lower half of Google's framed page would be displaying the images (if, in fact, that site physically has the images on its server and is not itself using inline linking from another site), while Google would merely provide the upper frame of the other site's display. After all, according to Google, if the site Google inline links to is in violation of copyright for displaying an infringing image, and that site has an infringing copy of that image on its own physical server, why should Google feel the heat? Google urges this more technical perspective because it holds a "don't shoot the messenger" appeal.

From where Perfect 10 is standing, "display" should mean the mere act of "incorporating" these images into a Web page. Perfect 10's test sees Google, "the host of its own Web page which incorporates" images from other sites, as the entity that "displays" the image. After all, when viewing a framed Google page the URL in your browser's address line should read something like, "http://images.google.com/ . . . etc." From a visual perspective, Google is the one "displaying" the image by incorporating it into a page that it hosts.

Judge Matz points out that these perspectives have their own flaws lying at the extremes of each. Under Google's test, as long as a Web site only uses inline

links to other sites that actually serve the infringing content, the site operator could inline link to a million and one infringing photos and not be directly liable (although it may be liable under contributory or vicarious infringement). On the other hand, Perfect 10's test could be taken to an extreme. Judge Matz uses the example that the incorporation test would make it a violation to operate a Web site that exists for the sole purpose of bringing copyright infringement to the attention of the FBI by using inline linking to infringing sites.

Ultimately, the court adopts Google's server test. Judge Matz concluded that the third-party Web sites were responsible for the infringement, since users observing the framed page "are not viewing images that Google has stored or served" but are "engaged in a direct connection" with other Web sites that are technically displaying the images. Here, the court seemed very concerned with the "chilling effect" the Perfect 10 incorporation test would have on what Judge Matz heralds as "the core functionality of the Web–its capacity to link." Aside from that, Judge Matz avers that the server test only precludes search engines from being directly liable for infringement. And indeed, the server test seems easy to apply. In addition, in cases like this, the plaintiff could always go after the site serving the infringing images. Finally, Judge Matz asserts that the server test, by allowing Google to fulfill a very important role in indexing the Web so users can readily find images while holding the serving site responsible for the direct infringement, allows a balance (a very uneasy balance) between "encouraging the creation of creative works and encouraging the dissemination of information."

In order to prevail on the contributory infringement claim, Perfect 10 had to show that Google had knowledge of the infringing activity and that Google "induced, caused, or materially contributed to that activity." Perfect 10 asserted that Google had actual knowledge of the infringing sites and supported this with the fact that it sent Google notices of the infringement dating back to mid-2001. The court then moved through the analysis on material contribution. Perfect 10 relied on the Napster case (discussed below) to support its argument that Google "engages in conduct that encourages or assists the infringement." Ultimately, Judge Matz found Perfect 10's reliance on the Napster case misplaced. In a Napster situation, the infringement machinery provided by the peer-to-peer platform was absolutely necessary for the infringing acts. Here, it is true that third-party Web sites would exist even without Google's image search. True, they do receive benefits from Google's advertising program, AdSense, but there was no proof that these sites relied on Google adverts for their continued existence or that they were created as mere vehicles for Google ads. In addition, there was no proof that Google had sufficient authority to prevent the sites' infringing conduct.

Another creature of secondary liability, slightly similar to contributory infringement, is vicarious infringement. The analysis here requires Perfect 10 to demonstrate Google enjoys a "direct financial benefit" from the infringing activity of third parties and that Google has declined to exercise the right and ability to supervise or control the infringing activity. Of course, Google enjoys a financial benefit in the revenue derived from the AdSense program. However, the court found that, unlike the Napster situation, where Napster controlled the particular environment of its closed-universe, peer-to-peer file-sharing service, Google has no control over its particular environment–the wide-open expanse of the Web itself. Google may have the ability to remove a link from its searches, which could have the effect of making the site virtually invisible, but Judge Matz points out that does not mean Google has the responsibility to render the Web site inaccessible.

Revisiting the court's holding as it relates to inline linking, there has to be a better answer than what the court concludes. It seems Judge Matz's server test results in a sort of handbook for online infringement. The court's "*extreme*" example of the site includes nothing but infringing instances of images, but only through inline linking. Under this holding, this "*extreme*" example could become the norm, if it is all that unordinary to begin with. Site operators could use nothing but protected works to build their site's identity, an identity, which may assist in sales of a service or products. But under the server test, since they don't store any infringing images, they are in the clear. That can't be right, even considering the balance copyright law always seeks to achieve. Indeed, what type of a "balance" have we found when an entire class of unauthorized use goes unchecked? Certainly, it's an unsatisfactory balance if indeed one at all. The server test has never been adopted before this case. If that becomes the norm, in the extreme case images would not need to be licensed. Web site operators could search for appropriate images on Google or other image search engines and simply frame their site over the enhanced (enlarged image) to make it appear that the enhanced images were part of the site design, without any risk of infringement. This case is currently being appealed by both sides, as Google disagrees that the thumbnails are not fair use and Perfect 10 disagrees that Google has not violated the display right.

11 OTHER RIGHTS OF ARTISTS:

Le Droit Moral

In addition to copyright, there is a European tradition respecting the personal rights of authors embodied in various laws known as *le droit moral*, or moral rights. Rather than protecting the artists' economic rights to a work, these rights protect the right of attribution and the integrity of his or her work. Generally speaking, European law protects the right to be known as the author of your work; the right to prevent others from falsely attributing to you the authorship of a work that you have not in fact written; the right to prevent others from being named as the author of your work; the right to publish a work anonymously or pseudonymously, as well as the right to change your mind at a later date and claim authorship under your own name; and the right to prevent others from using the work or the author's name in such a way as to reflect adversely on his or her professional standing. These are collectively referred to as the rights of attribution and integrity.

The laws of different countries vary to some extent, with France recognized as being a strong protector of an author's *le droit moral,* a right belonging to the author as a person, and not the work. These rights are independent of the artist's economic rights, and in the EU may not accompany the transfer of ownership of the work. In some countries, moral rights may not be waived by the author.

The United States had traditionally resisted enacting laws endowing an author with moral rights protection, as it was seen to impede transactions in the art and entertainment industry. In 1988, the United States became a signatory to the Berne Convention, an international treaty whose purpose in part is to harmonize member state laws. Consequently, Congress had to enact a version of moral rights protection to comply with Berne standards. Thus, we now have the Visual Artists Right Act of 1990 (VARA), included in our copyright laws (17 U.S.C. 106A).

WHAT WORKS ARE PROTECTED BY VARA?

A "work of visual art" under VARA is defined as:

> (1) a painting, drawing, print, or sculpture, existing in a single copy, in a limited edition of 200 copies or fewer that are signed and consecutively numbered by the author, or, in the case of a sculpture, in multiple cast, carved, or fabricated sculptures of 200 or fewer that are consecutively numbered by the author and bear the signature or other identifying mark of the author; or (2) a still photographic image produced for exhibition purposes only, existing in a single copy that is signed by the author, or in a limited edition of 200 copies or fewer that are signed and consecutively numbered by the author.

Congress severely limited VARA and there are multiple exceptions to this definition. Most notably, works made for hire are excluded from being classified as works of visual art. Generally speaking, any type of applied or commercial art is also denied the protection of VARA as well. Stock photographs and illustrations, as they are not limited editions or signed, would not by granted protection under VARA.

WHAT PROTECTION DOES VARA OFFER?

The type of protection offered by VARA is markedly different from copyright protection. Unlike economically driven transfers and licenses governed by the Copyright Act, VARA makes artists' rights inalienable (non-transferable). Specifically, VARA confers upon artists several rights of attribution and integrity. First, the author has the right to claim authorship. Second, in addition to that attribution right, the author enjoys the right to prevent use of his or her name as the author of a work that he or she did not in fact create. Third, the author may prevent use of his or her name as the author of a work of visual art that—although she might have created it—has been subject to a "'distortion, mutilation, or other modification of the work which would be prejudicial to . . . his or her honor or reputation."

There are, however, limitations on these rights as well. Modification that is a result of the passage of time or the inherent nature of the materials is not

considered to be a violation of moral rights. Also, unless caused by gross negligence, the modification of a work of visual art that is the result of conservation, or of the public presentation, including lighting and placement, is exempt. Finally, all works not covered by the right of attribution are also not protected by the right of integrity.

For works created after VARA became effective, the artists' rights extend for the life of the author. For works preceding VARA, the rights expire with the author's rights granted under the Copyright Act. For works of joint authorship, rights exist for a term of the life of the last existing author.

Again, the rights may not be transferred. However, they may be waived if the author expressly agrees to such waiver in a written instrument signed by the author. Such instrument shall specifically identify the work, and uses of that work, to which the waiver applies, and the waiver shall apply only to the work and uses so identified. In the case of a joint work prepared by two or more authors, a waiver of rights under this paragraph made by one such author waives such rights for all such authors. Also, a transfer of ownership does not convey a transfer of the artists' rights.

CASES APPLYING VARA

Judge Friedman of the U.S. District Court for the District of Columbia recently ruled on the application of VARA to photographs used by another artist in *Lilley v. Stout.* Photographer Gary D. Lilley's VARA claim may have failed, but Friedman's decision clarified what types of photographs qualify for protection under the VARA.

In the case of photography, the artist must present a still photographic image produced for exhibition purposes only, existing in a single copy signed by the author or in a limited edition of 200 copies or fewer that are signed and consecutively numbered by the author. This definition brings up about three or four points for dispute. For instance, is a "photographic image" found in the negative or in the subsequent print? What determines if an image is "for exhibition purposes only"? As is the case with most laws dealing with photographic works, we don't know the answer to such questions *vis-à-vis* any given fact pattern until someone goes to court and a judge sorts out what the legislature left open to interpretation.

In *Lilley v. Stout,* Judge Friedman closed one question raised by VARA. Specifically, Friedman set out to decide whether or not Mr. Lilley's photographs satisfy the statutory requirement of "produced for exhibition purposes

only." As for the factual background, the photographer Gary Lilley was a one-time friend of the painter Renee Stout. As friends and fellow artists, the two were known to produce collaborative works from time to time over a period of nearly ten years. At some point in 1998, Lilley took some shots of a friend's home "as studies for paintings" that Stout planned to create. It seems Lilley indeed shot the home's interior and reviewed the subsequent photographs with Stout for just that purpose. With the review completed, Lilley claims he allowed Stout to use the images on the condition that he receive a complimentary copy of Stout's work as well as proper credit for the photos. Lilley did get his free copy, but when he looked into that gift horse's mouth, he didn't like what he saw. The draft colophon (a notice with information concerning publication and authorship) with the work claimed that the photos were the work of Stout and Lilley produced under Stout's direction. Claiming this colophon violated his VARA right of attribution, Mr. Lilley filed suit against Ms. Stout. As it turns out, no matter how upset he may be with Stout, Lilley has one substantial hurdle to overcome. Here, the hurdle is whether or not Mr. Lilley's work qualifies as one "produced for exhibition purposes only."

Based on the facts of the case, Friedman answered that question in the negative. At the outset, Lilley had to establish his intent to exhibit the photographs. In this inquiry, Friedman recognized the reality that "a negative produced in one instant and a print produced in another may correspond to different intentions or purposes of the author." In terms of the negative, Judge Friedman points out that we could inferentially determine Lilley's purpose from his artistic background, his past experience, and previous collaboration to create art for exhibition. But in this case the resulting prints, as opposed to the negatives, are at issue as indeed Mr. Lilley's intent to exhibit these prints could differ from his purpose when he clicked the shutter.

The facts demonstrate that Lilley didn't produce the prints for exhibition purposes only. As Lilley asserted in his own pleadings, the litigants discussed which photos would make good studies for a series of paintings. This wasn't a discussion about which pictures were suitable for exhibition, but primarily to assist Stout in her own creative endeavor. Most damning to Lilley's case is the fact that he handed the prints over to Stout. Judge Friedman characterizes this act as one that belies an intention to produce the prints for exhibition purposes only. As a result, we find these discrete photographic prints outside of "work of visual art" (for purposes of VARA, at least) and Lilley finds himself without a VARA claim.

As Judge Friedman points out, *Lilley v. Stout* recognizes that as any single work of visual art may be created for a variety of purposes, it follows that it

will be difficult to determine an author's specific intent. As for photography, Friedman notes that there are several moments in the creative process where we might assign or infer the artist's intent. By extension, this means the legal system realizes there are various points of production wherein a photographer may have room to exhibit her originality—a good sign, since so much about protecting creative works hinges on originality. At the same time, Friedman refuses to take the protection afforded by VARA lightly. As a result, he takes artists to task when it comes to satisfying the statutory definitions of the Act. In spite of what seems like a harsh outcome for our plaintiff, Judge Friedman is being very sensitive to the creative process.

This decision will deny VARA protection to images created by a commercial photographer to be published in a magazine or advertisement. However, if subsequent to the initial published use, separate prints are created for exhibition purposes solely, these prints may entitle the artist to VARA rights. Photographic works initially created for stock would also fail the test of being created for exhibition purposes. However, when you think of some of the most recognized fine art prints, these photographs may not have been taken primarily for exhibition purposes yet the subsequent prints are regarded as works of fine art. Arnold Newman's portraits were taken on assignment by some of the leading magazines of his time. Similarly, many of Annie Leibovitz's photographs were taken for *Vanity Fair* articles. This decision clarifies that it is the intent of the photographer in the creation of the print that matters and not the intent of the artist when the negative (or digital file) is made that controls.

12 WHAT'S IT ALL FOR?

THE REMEDIES AVAILABLE
FOR COPYRIGHT CLAIMS

W hat good is copyright if there is no remedy for those times when it's infringed? When entering into any legal action, the claimant usually has the end of the road in mind. For copyright, that means injunctions, money damages, or both.

An injunction is a court order that either prohibits a party from continuing or compels a party to continue a certain activity. This includes preliminary injunctions, temporary restraining orders, and permanent injunctions. At the outset of a copyright claim, the plaintiff may want to stop the defendant from doing whatever it is (displaying, selling, or otherwise) that infringes the copyright through a preliminary injunction in attempt to halt whatever alleged injury is taking place at least until the claim's merits are judged in court.

The *Perfect 10* case (See chapter 6, *Perfect 10 v. Google*) shows how a court operates in determining whether or not a preliminary injunction is appropriate and what form it should take. Perfect 10's broad preliminary injunction was actually the main issue before the court. The gist of the injunction was that Perfect 10 wanted Google to stop doing *anything* that resulted in users seeing thumbnails or framed pages containing Perfect 10's protected images collected from infringing Web sites, including "displaying" images, providing links to infringing images, or linking to sites that provided unauthorized username/ password combinations to Perfect 10's site. In Google's case, this type of a preliminary injunction could have imaginably shut down Google completely if not fashioned properly. Since injunctions can impose some harsh measures on the target (let alone making the defendant look like a no-goodnik before the trial even begins), a court has to make an equitable inquiry before issuing them. The general rule, as stated by the court here, is that "a preliminary injunction should (only) be granted if a plaintiff can show either a combination of

probable success on the merits and the possibility of irreparable harm or that serious questions are raised and the balance of hardships tilt in the plaintiff's favor." In other words, the judge has to forecast the result of the case, consider how badly the plaintiff has been hurt already, while fashioning the roadblock the injunction will pose to the defendant in relation to the heartache he may have already handed the plaintiff.

As for the success on the merits, this means that the court generally goes directly to the fair use defense. Since it is a broadly sweeping defense, it can eviscerate a plaintiff's case right out of the box. Otherwise, the court might look at defenses that bring the validity of the copyright into question or its scope (limited by idea expression and *scenes a faire*), which can also take the wind out of the plaintiff's sails.

As we know, part of Google's fair use defense didn't fly. Judge Matz found that the injunction ultimately has to balance the merits of each party's arguments. On one hand, the courts saw some value to Google's position in that the defendant does "facilitate and improve access to information on the Internet." On the other hand, the court had to recognize the public benefit of protecting copyright holders like Perfect 10. With only part of the opinion coming out in its favor, Perfect 10's proposed injunction had to be pared down, a process Judge Matz ordered the parties to complete *together*. Whether the parties come up with something workable remains to be seen.

The Napster case, which pitted the Recording Industry of America against the music file sharing company, tested the reach of the DMCA. Napster also involved a preliminary injunction. The plaintiffs argued that Napster should be held liable for the unauthorized copies of plaintiffs' material made by Napster users. Moreover, the plaintiffs argued that a pre-trial injunction should be issued to restrain Napster from operating until the question of Napster's liability was resolved at trial. Again the plaintiffs would only be entitled to a pre-trial injunction if they could show both that they were likely to succeed at trial and that irreparable harm would result if a pre-trial injunction is not issued.

After hearing arguments on both sides, a district court found that the plaintiffs sufficiently demonstrated that they were likely to succeed at trial and issued a pre-trial injunction that prohibits Napster from "copying, downloading, uploading, and transmitting or distributing" plaintiffs' copyrighted works until trial. Napster appealed the issuance of this pre-trial injunction to the Ninth Circuit and persuaded the Ninth Circuit to delay enforcing the injunction (to let Napster stay in business) until the Ninth Circuit heard Napster's appeal. Napster argued that the district court incorrectly found that Plaintiffs were likely to succeed at trial and that, therefore, the pre-trial injunction issued

against Napster was wrongfully issued. Napster alleged that plaintiffs are not likely to succeed at trial for a number of reasons including that Napster is exempt from copyright liability under the "Safe Harbor" provision of the Digital Millennium Copyright Act. As an aside, an injunction was ultimately ordered, shutting down the Napster network. Although Napster partially settled the case by agreeing to pay copyright owners millions of dollars, it ultimately liquidated its assets in a bankruptcy and the name was acquired by Roxio.

DAMAGES AVAILABLE UNDER COPYRIGHT LAW

Injunctions take care of the prospect of ongoing infringement by a defendant, but the point of the Act is to insure *financial* returns from an author's works. This is where damages come into play. When lawyers talk damages, they mean money. As it relates to copyright law, money can find its way into the hands of the plaintiff in the form of actual damages, recouped profits, and what are known as willful damages.

The Digital Theft Deterrence and Copyright Damages Improvement Act of 1999 was put into effect just a few short years ago. This amendment to the 1976 Copyright Act imposes stiffer penalties for both willful and non-willful copyright infringement provided that the work infringed upon is registered promptly. In order to fall within the Act's protection, the copyright owner must have registered the work before the infringement occurred or within three months of its first publication. The amendment increases minimum statutory penalties for non-willful infringement from $500 to $750 per infringement and increases the total allowed recovery from $20,000 to $30,000. In the case of willful infringement, the total penalties allowed for each infringement were also increased, rising from $100,000 to $150,000. The amendment applies to any infringement that is brought on or after December 9, 1999, regardless of the date on which the alleged activity that is the basis of the action occurred.

ACTUAL DAMAGES

To understand concept of damages in litigation, a Second Circuit case demonstrates how a court arrives at a figure for "actual damages." In *Davis v. The Gap Inc.*, the plaintiff Davis was in the business of designing artful and original designs of eyewear. These designs were particularly striking and unusual as perforated metallic discs or plates replaced what would be otherwise be occupied

by regular lenses. The plaintiff went to great lengths to market his products to "stylish and popular entertainers," as well as various fashion designers and publications. The Gap clothing company ran a series of advertisements exhibiting people of diverse lifestyle and backgrounds. One of the ads depicted a group of young individuals of Asian appearance, standing in a V formation, dressed in black, each wearing distinctive eye shades. The subject at the apex of this V formation wore our plaintiff's eyewear design. Although all of the subjects were provided with Gap clothing to wear for the photo shoot, each was apparently told to wear their own accessories. The plaintiff brought a copyright infringement action seeking a declaratory judgment of infringement as well as damages for an unpaid license fee, a percentage of the Gap's gross profits resulting from the use of plaintiff's eyewear, punitive damages, and attorney's fees.

In order to recover damages for the infringer's profits, a plaintiff must submit sufficient evidence of defendant's profits that bear a reasonable relationship to the act of alleged infringement. In other words, it is not enough to show the defendant's revenues from the sale of everything sold, but rather a plaintiff must specifically show how these revenues are reasonably related to the infringing act. This was precisely the problem in *Davis*. The plaintiff submitted evidence of increased net sales in the corporate parent of the Gap stores. As this corporate parent oversees the sale of numerous items, only one of which is eyewear, the court deemed this evidence insufficient to disgorge the Gap of an appropriate percentage of profits.

Since the artwork was not registered before the infringement, statutory damages, punitive damages, and attorney's fees could not be awarded. Actual damages, on the other hand, focus on the plaintiff's lost sales, lost opportunities to license, or diminution in the value of the copyright. Davis' actual damages were a lost opportunity to license his product to the Gap. The court held that a lost opportunity to license is recoverable as compensatory damages under appropriate circumstances. Factors the court considered were 1) whether the infringement was innocent, 2) whether the owner is reasonably compensated by other elements of the award, and 3) whether such an award would impose an unreasonable burden on the infringer. Most importantly, the amount of damages may not be based on undue speculation. The copyright owner must be able to show that the thing taken had a fair market value in order to make out his claim that he has suffered actual damages because of the infringer's failure to pay the fee. Market value therefore plays a crucial role in determining the amount of the actual damages. Mr. Davis prevailed in his claim of actual damages for loss of a licensing opportunity by submitting evidence that a magazine previously compensated him with a certain amount

when using one of his designs for a particular picture. This dollar amount provided the court with sufficient evidence to calculate an appropriate amount of damages.

This case has relevance for photographers and stock companies for two reasons. First, in licensing photographs, care should be taken to make sure that no unique objects that are in themselves works of art are depicted in the photographs, such as copyrighted jewelry, eyeglasses, furniture, or other works of art that would require a license. Second, the case confirms that an appropriate measure of actual damage when a photograph is reproduced without permission is a license fee based on market value. Since photographs are typically licensed based on use, evidence as to licenses for similar uses should enable the copyright holder to prevail in an action for damages. Of course, if the photograph is registered before the infringement occurred, actual damages need not be established, and the court can award statutory damages as well as attorney's fees.

PROFITS

Another measure of damages, although hard to ascertain, can be the defendant's profits. Jack Mackie, a Seattle-based artist specializing in public outdoor artwork, filed a copyright infringement suit in *Mackie v. Rieser* against the Seattle Symphony Orchestra Public Benefit Corporation and Bonnie Rieser, a graphic designer. In 1979, Mackie was commissioned by the City of Seattle to create a series of sidewalk installations entitled, "The Dance Steps." The series depicted various dance steps including one called "The Tango." In 1995, the Seattle Symphony contracted with Rieser to create a direct mail subscription campaign for the 1996–1997 season. Rieser created a montage for the "Pops" series comprised of images from the Symphony's then future buildings as well as other aspects of Seattle culture, which Rieser completed by painting pastel swirls and lettering over the collage. One of the figures included in the montage was "The Tango." Rieser had scanned this image, cropped it and added to her final work. The Symphony then incorporated this work in a brochure that was mailed to approximately 150,000 people all over the United States.

After learning of Rieser's montage and the Symphony's distribution, Mackie sought damages, which included a hypothetical royalty payment, the loss of future employment opportunities, and the recoupment of profits that the Symphony generated during the 1996–1997 season. Mackie also demanded profits for future seasons, arguing that people who subscribed to the Pops renewed their subscriptions in part because of the infringing collage. Despite

Mackie's passionate convictions and bruised ego, the court could not offer much more than sympathy. The appellate court affirmed the decision of the trial court limiting the artist's damages to one thousand dollars in actual damages and denying any award of indirect profits. In the court's opinion, section 504(b) of the Copyright Act (the section that provides for actual damages and profits as a result of an infringement), precludes the court from awarding any monetary remedies to a plaintiff, like Mackie who failed to register his copyright before infringement, unless a causal nexus between the infringing work and the profits can be proven. Unfortunately for Mackie, the proof he offered was purely speculative. The court commented that it would be impossible to tell what moved the public to purchase tickets and therefore, how much of the profits were due to Mackie's "The Tango" and how much were based on Rieser's design, the Symphony's reputation, the music, a particular conductor, etc. Furthermore, on cross-examination, Mackie conceded that his loss of further earnings was speculative at best. Furthermore, in the past he had given permission to others to use "The Tango" without payment of a royalty.

Although profits are a measure of damages under copyright law, it is very difficult for a plaintiff to establish the right to the defendant's profits when the infringement is based on the reproduction of either artwork or photographs used in an advertisement or brochure. An example of an appropriate claim for profits would be if an infringer were selling pirated copies of a CD-ROM or other product, where the link between the infringement and profits is clear. Typically, where an image is incorporated into advertising material, damages are limited to a license fee or royalty unless the infringed work was registered before the infringement. In such a case, statutory damages and attorney's fees can be sought.

INDIRECT VERSUS DIRECT PROFITS

There is a bit more to calculating actual and wrongful profits than that. The Timex case we discussed to demonstrate the effect of the statute of limitations gives us a bit more detail on the matters of actual damages and wrongful profits, at least as to how the Ninth Circuit sees it. In the Timex case, unfortunately for Polar Bear, *PaddleQuest* had not been registered with the Copyright Office prior to filing its suit, so Polar Bear's recovery was limited to what it could prove in non-statutory damages under §504(b) of the Copyright Act. This includes actual damages and the recovery of wrongful profits. In determining the evidentiary bases for each, the Ninth Circuit requires a showing of a causal link between the infringement and the monetary remedy sought.

The District Court initially awarded Polar Bear $315,000 in actual damages for the lost license and renewal fees and lost profits. The Ninth Circuit had no problem accepting Polar Bear's expert witness, an accountant, who came up with a fair market value of the licensing and renewal fees ($37,500). Timex argued that Polar Bear cannot recover that amount because Polar Bear never charged that rate. The Ninth Circuit found nothing improper about the estimate, since it was the price tag quoted to Timex before the infringing conduct occurred. Also, it reasoned that "[h]aving taken the copyrighted material, Timex is in no better position to haggle over the license fee than an ordinary thief and must accept the jury's valuation unless it exceeds the range of the reasonable market value," which is exactly what most artists want to say to infringers the world over as copyright holders.

However, the Ninth Circuit found no causal connection between the remaining actual damages ($277,500) and the infringement, because they were based on Polar Bear's speculation of what it could have done had it been initially paid by Timex for use of the footage. The Ninth Circuit stated that "[t]his theory of liability is too 'pie-in-the-sky,'" especially since Polar Bear had no knowledge of the infringement and therefore no expectation of receiving this money. The Ninth Circuit stated, "Polar Bear's financial losses were not of Timex's making, and mere speculation does not suffice to link the losses to the infringement."

The jury had awarded Polar Bear $2.1 million in indirect profits in addition to the direct profits above. Section 504(b) of the Copyright Act provides recovery for "any profits of the infringer that are attributable to the infringement." From this language, the Ninth Circuit reasoned that there is no legal difference between "direct" and "indirect" profits, and that both require the establishment of a causal link for recovery. In order to do this, the plaintiff has to do more than show that the defendant made money during the time of the infringement—plaintiff must show that the profits made by the defendant that plaintiff seeks to recover were a result (direct or indirect) of the infringement.

In this case, the Ninth Circuit agreed that the money Timex made during the trade shows that played the infringing promotional video was subject to recovery. It also found a causal connection where Timex used images from Polar Bear's film in a promotional campaign with Mountain Dew. However, the Ninth Circuit found no such connection with Timex's revenue from its sale of the Expedition line of watches which Polar Bear argued was at least partially derived from the enhanced prestige resulting from use of the material from *PaddleQuest*. The Ninth Circuit found Polar Bear's argument based on "brand premium analysis" that its footage attributed to "brand enhancement"

as insufficient to establish such a link, because there was no evidence showing that the promotional efforts of Timex that used the infringing material actually resulted in increased profits—profits that would not have been made without the infringing material.

The Ninth Circuit noted that in general, courts have rejected the theory of indirect profits resulting from enhanced good will. This is in contrast to cases where plaintiffs offered testimony from consumers who stated that the infringement may have actually influenced their purchasing decisions. In this case, the video was shown at a trade show and not at retailer establishments where consumers would make buying decisions. The indirect portion of the award was vacated.

The Ninth Circuit held that prejudgment interest was available under the Copyright Act, and that its application rests on whether such an award would further the statute's purpose. The court has discretion to award interest if necessary to make the legislative intent to "avoid unjust enrichment by defendants, who would otherwise benefit from this component of profit through their unlawful use of another's work." Awarding interest is appropriate whenever it is necessary to "discourage needless delay and compensate the copyright holder for the time it is deprived of lost profits or license fees." Therefore, the Ninth Circuit held that the District Court erred when it concluded that prejudgment interest was unavailable under the current Copyright Act.

High damage awards will always get heavy scrutiny under appellate review. It is difficult, as this court noted, to prove a relationship between an infringement and the infringer's indirect profits. The court in its analysis did think that if the jury had broken down the portion of the indirect profits attributable to the trade booth sales and the Mountain Dew promotion, the evidence would have supported it but as this was only approximately $333,000 of the $2 million award, it vacated the entire indirect profit award.

There are a few points to take from this case in negotiating damages after an infringement. First, in this district the copyright holder is not limited to three years of damages if it could not discover the infringement. The more years of potential damages, the greater the settlement figure you can demand when negotiating. Second, the amount of actual damages based on lost license fees is the amount the copyright holder demands, and the infringer does not get to "haggle" over the fee, unless it exceeds the range of reasonable market value. In other words, it is not entitled to the lowest fee as if it had the benefit of bargaining power. In addition, some of the infringer's profits may be attributable to the infringement. The use of the images in the trade show and the Mountain Dew promotion were sufficiently related to profits for the court to state that

these profits were supportable. Unfortunately, the jury lumped all the indirect profit claims together in this matter, causing all of them to be vacated. The court's allowance of pre-judgment interest is also a good argument to use when negotiating a settlement fee with an infringer. Finally, the plaintiff also had a trademark claim and the court found that Polar Bear's state trademark claims were separate from the copyright claims and did not dismiss them. Having an extra claim increases the chance of a settlement beyond the actual license value of the image infringement claim.

USING "MULTIPLIERS" IN NEGOTIATING A RETROACTIVE LICENSING FEE

One strategy a plaintiff may use in negotiating a retroactive fee from the infringer is to employ a multiplier. It is reasonable to argue that an infringer should not receive the benefit of a more favorable rate that it might have received if the request to use came before the infringing use. In 2002, a federal court in Massachusetts accepted a "five times" multiplier in determining the amount of damages a photographer is entitled to recover in *Bruce v. Weekly World News Inc.*

In March 1992, freelance photographer Douglas Bruce took a photograph of President Bill Clinton shaking hands with an unidentified secret service agent. A *Weekly World News* photo editor contacted The Picture Group, Bruce's stock photo agency, and obtained the photograph. *Weekly World News* intended to alter the photo by superimposing its own image of a "Space Alien" over the person shaking Clinton's hand. Before obtaining permission *Weekly World News* began manipulating the photograph. The Picture Group and *Weekly World News* were not able to reach an agreement on an appropriate license fee. Nonetheless, *Weekly World News* published the retouched photograph together with the banner "Alien Backs Clinton" on the cover of its August 11, 1992 issue.

The Picture Group billed *Weekly World News* five hundred dollars for use of the photo. Thereafter, the Picture Group billed *Weekly World News* for each occasion that the photo appeared in its publication until 1993 when the Picture Group went out of business. Bruce's share of the license fee for the billed uses was $1,775. In 1994, Bruce came across a *Weekly World News* T-Shirt advertisement displaying his retouched photograph. Bruce sent the publication a cease and desist letter claiming copyright infringement. In response, *Weekly World News* offered to pay Bruce five hundred dollars for a general release of copyright, which he refused. The photograph continued to be utilized in other advertisements including a different T-Shirt featuring twelve Senators under

the banner "12 U.S. Senators Are Space Aliens!" as well as numerous times on the *Weekly World News* Internet site. In total, the *Weekly World News* T-Shirt advertisements appeared 188 times in its publication and over 10,000 T-shirts were printed. Additionally, Bruce's retouched photo appeared forty-eight times in the publication's subscription advertisements. A district court awarded Bruce $20,142.45 in damages plus interest at a bench trial during which *Weekly World News* acknowledged its infringements. In reaching its decision, the court calculated the actual damages by using a multiplier of five for unauthorized use.

Bruce, however, felt that the court miscalculated the damages and appealed, arguing that he was entitled to at least $359,000. He argued that the court erred by awarding only one half of the $2,200 in licensing fees. Originally, Bruce had agreed to split the licensing fees with The Picture Group, but since the stock photo agency had gone out of business, *Weekly World News* only paid the half owed to Bruce. This resulted in *Weekly World News* being unjustly enriched by not having to pay the full licensing fee for their infringing use. The court agreed with Bruce and awarded him an additional $5,500 ($1,100 license fee times a multiplier of five).

Bruce made other assertions that the district court erred in calculating appropriate damages, but the court found his arguments unconvincing. Bruce asserted that the district court incorrectly ruled that he was only entitled to licensing fees for *Weekly World News'* first unauthorized editorial uses of his photograph in 1992 but not for each subsequent unauthorized use, including T-shirt and subscription ads and reprints of *Weekly World News* covers. The court disagreed with Bruce and concluded that he would not have been able to negotiate with *Weekly World News* for anything other than a single lump sum, up-front licensing fee, as distinguished from a per-use fee, even if the use had been authorized. Further, Bruce argued that although he received revenues realized from T-shirt sales, he should have received royalties on the number of T-shirts produced rather than just the ones that were actually sold. The court ruled that without evidence of such a continuing royalty contract existing in the industry, they could not find in his favor.

Finally, Bruce maintained that the lower court's apportionment of a 50–50 split between himself and *Weekly World News* of the profits generated from T-shirt sales was incorrect. He asserted that the repetitive use by *Weekly World News* of the retouched photo turned it into a sort of icon, resulting in a valuation exceeding the sum of its two components. Here, the court reasoned that in light of decisions in other cases where copyrighted material was later enhanced by so-called "star-power" and an award of far less than 50 percent of the profits was given, Bruce's share in profits was arguably generous.

Other than its importance because of the use of a multiplier to come up with actual damages, this case shows the importance of industry practice in presenting evidence of licensing in a copyright case. The court accepted the practice of the multiplier, but also agreed that the plaintiff could only obtain a one-time fee for the other infringing uses, absent other evidence of industry licensing. Bruce was not entitled to statutory damages or attorney's fees because the photograph was not registered before the infringement.

While *Bruce. v. Weekly World News* saw a court bless the five-times multiplier, in *Stehrenberger v. R. J. Reynolds Tobacco Holdings, Inc. et al,* Judge Stanton ruled that the practice within the photo licensing community of utilizing multipliers in the amount of ten times the usual fee in infringement cases was not the method by which damages were to be calculated under the copyright law. This court precluded the plaintiff from offering evidence in support of her claim that a multiplier of ten times should be used in calculating her actual damages. He summarized his point by stating "in litigated cases, infringement does not make a copyright more valuable."

The case involved a copyright infringement action brought by a photographer against the tobacco company for alleged infringement of her photograph in a newspaper advertisement. The facts surrounding the infringement were not described fully as the decision was based on defendant's motion for summary judgment. The sole issue was whether the photographer could seek actual damages based on a multiplier of ten times an amount that would otherwise be charged if the image was not infringed. The photographer hired an expert on damages who wrote an expert report that described the industry practice of granting a "retroactive license" to a user who has made a mistake and infringed. The report stated:

. .

> A user who discovers that it has made an unauthorized use can resolve the problem by paying a reasonable license fee of two to three times the normal fee . . . thus avoiding the costly and protracted business of a federal copyright case. The multiplier applies when the infringer recognizes the mistake and moves quickly to correct it. However, where a copyright owner must go to court to resolve the infringement, the fee guideline is that the price should be further enhanced up to *ten times* what the pre-infringement price would have been.
> (Emphasis added).

. .

The expert opined that the fair market value of the infringement was $60,000, that the infringement was unauthorized and therefore willful making the value of the retroactive license $600,000. The photograph had not been registered, so the photographer was limited to actual damages and could not elect statutory damages. The tobacco company argued that the measure of actual damages under the Copyright Act is limited to fair market value and the law does not permit any "enhancement" of damages if you go to court to enforce your rights. Any enhancement, it argued, was punitive and could only be awarded if you were entitled to statutory damages and could establish that the infringement was willful. In other words, there is no place for any deterrence factor in calculating actual damages.

Photography organizations have included language in their standard agreements available to members, which include a multiplier of a license fee to clients who have infringed and wish to resolve the matter without litigation. The fees range from three to ten times the normal fee. This multiplier has been significant in deterring infringements and encouraging clients to license images rather than "steal" them. The multiplier is also critical in negotiating a settlement where the images are not registered. If the infringing client can receive the same terms as the "good" client that licenses properly, then there can be no recovery of the extra costs of tracking down the infringement.

Despite the fact that the industry has relied on this multiplier for so many years, there have been almost no reported cases on this issue. Cases that settle are not reported and do not become part of case law. *Bruce v. Weekly World News Inc.*, relied on a multiplier of five to compute actual damages from an unauthorized use. Nonetheless, the court in *Stehrenberger* declined to follow this decision stating that the court in *Bruce* did not analyze the issue, because both sides' experts adopted the multiplier concept.

Rather, Judge Stanton looked to Judge Fox's opinion in *Barrera and Burgos v. Brooklyn Music, Ltd. et al.* for the standard of damage calculation. The court examined the language of the Copyright Act which states, in pertinent part: "an infringer of copyright is liable for either (1) the copyright owner's actual damages and any additional profits of the infringer, as provided by [§504(b)]; or (2) statutory damages, as provided by subsection [17 U.S.C. §504(c)]." The court went on to state that:

Actual damages are primarily measured by the extent to which the market value of the copyrighted work at the time of the infringement has been injured or destroyed by the infringement. In appropriate

circumstances, actual damages may be taken to be a reasonable license fee—that is, the fair market value of a license authorizing defendants' use of the copyrighted work.

. .

Judge Fox's standard of damages calculation would allow the victim of infringement to collect only "fair market value" of their work—a far cry from using a multiplier of up to ten times the amount, which, prior to this decision, had been the industry norm. According to Justice Stanton, "Both facially and substantively, this increase of that figure by a factor of ten does not define a fair and reasonable license fee, but represents concepts of punishment for infringement, deterrence of similar behavior in the future, and recompense for the costs and effort of litigation."

As a result, the photographer was not permitted to offer evidence supporting her claim that a multiplier of ten times the amount should be used in calculating her damages. The court most likely focused on the "penalty" issue because the damages sought for the infringing newspaper use was so high. A multiplier of two to three times the license fee was *not* struck down by this court and may still be a reasonable measure of a retroactive license fee as within the range of a fair market value. Importantly, the multiplier, as supported by *Bruce*, was an important tool in negotiating favorable retroactive fees. Ultimately, without the deterrence of a higher fee for an infringing use, there is little incentive to properly license. The costs of tracking down and enforcing an infringing use may often outweigh the value of an actual license fee.

The case is another lesson in the importance of registering copyright in your photographs. The photographer was restricted to seeking actual damages because the photograph was not registered before infringement. An infringer of a registered work can face statutory damages of $30,000 and up to $150,000 if the infringement is willful as well as attorney's fees.

STATUTORY DAMAGES

At the time of trial, the plaintiff can elect statutory damages if the work is registered. We can see how they are awarded in the Miami District Court jury verdict, which awarded photographer Jerry Greenberg $400,000 in his case against National Geographic Society for the unauthorized use of his images in the CD-ROM entitled *108 Years of National Geographic on CD-ROM.* The jury

also found that the infringement was "willful," which permits the prevailing party to seek the recovery of its attorney's fees and costs. Greenberg had registered his photographs prior to the infringement entitling him to seek statutory damages and attorney's fees.

The award was based on statutory damages in which the copyright holder can seek (at the time) up to maximum of $100,000 per infringement if the infringement is willful. Since the commencement of the action, the Copyright Act has been amended and the maximum amount has increased to $150,000. Although sixty-four of his images were republished in the CD-ROM, the court found that there were only four infringements for purposes of statutory damages because the photographs were published in four separate articles, viewing each article as one work. He was awarded $100,000 for each of the four infringements.

In a more recent case, in mid-2005, Judge Gorton of the U.S. District Court of Massachusetts found that a jury award of $665,000 infringement damages to photographer Joel Cipes was not excessive. The dispute arose out of a long-standing, routine relationship between the photographer and defendant Mikasa Inc. That relationship hit the skids when Mikasa continued to use the photographs beyond the scope of the license, in spite of the photographer's objections. Out of this unordinary row between a photographer and a client came a healthy verdict that could have been even larger. Since there was some question as to the validity of some of Cipes' copyright registrations, the judge instructed his jury that they were not permitted to award damages for any infringement claim not supported by valid registration. But because copyright infringement damages may include the portion of the infringer's profits attributable to the infringement, the jury was able to consider that aspect in calculating damages for those remaining images that carried valid registration. It appears there were some hundreds of such images at issue, and it appears there was evidence that the infringements were widespread–including Internet uses. Judge Gorton accepted the jury's apparent finding that this meant Mikasa's sales owed much to the plaintiff's images, and he let the verdict stand. One thing is certain, the case illustrates the importance of registering photographs. Further, as it ascribes a portion of a major corporation's profits to the photographer, the court implicitly acknowledges the currency of the image in today's commerce. While not all courts will permit a jury to consider profits when an image is used in an advertisement, there are some appropriate circumstances where the relationship is strong enough that a jury is permitted to consider them.

MORE ON STATUTORY DAMAGES WILLFUL INFRINGEMENT

Although largely analyzing the fair use defense in the context of karaoke bars, the case *Morganactive Songs v. K&M Fox Inc.* also examines the issue of statutory damages for copyright infringement. In this analysis, the Morganactive court's holding should bring some readers joy, especially those whose efforts to resolve infringement matters with retroactive license fees are either ignored, treated as a nuisance, or met with lowball offers.

Some readers are familiar with the copyright infringer who tries to settle for lower than what would have been paid had they simply obtained the proper license in the first place. Certainly, some are familiar with the infringer who flatly refuses to play ball, crying "extortion!" when you or your lawyer sends them a letter seeking retroactive license fees. Judge Godich characterized these defendants as "sneering in the face of copyright owners and copyright laws." The *Morganactive* court met these sneering faces with statutory damages backhand in hopes that they can put an infringer "on notice that it costs less to obey the copyright laws than to violate them."

Granting hefty statutory damages in those cases where infringement is willful substantially furthers the policies of copyright law. Willful infringement is when "the infringer knows that its conduct is an infringement or if the infringer has acted in reckless disregard of the copyright owner's right." So when those "sneering" infringers ignore a copyright holder's notice of copyright protection, refuse to seek the advice of an attorney when contacted by the copyright owner, or pass the matter off as a nuisance, they may be willful infringers and the copyright holder may be entitled to substantial monetary awards should they succeed.

The defendant in *Morganactive* clearly ignored the plaintiff's offers to obtain a blanket license for the infringed works. According to the defendant, he only bothered reading one such letter from the plaintiff, dismissing it as a mere extortion tactic. His files, on the other hand, included nine different letters notifying him of the infringement and offering to settle. The initial offer of $7,543.44 rejected by the defendant ended up much better than the round number that the court came up with: $19,500. Although this case doesn't deal with images, its result is good news to anyone who depends on license fees for survival. This plaintiff also had the option to seek statutory damages and enhanced damages for willful infringement because the music was registered before the infringement.

ATTORNEY'S FEES

While monetary damages and recouping wrongful profits are all wonderful, they may be completely swallowed by the attorney's fees in a copyright claim. When deciding whether to commence a copyright action or not, a decision is often made based on the expense of litigation rather than the nature of the infringement or the likelihood of success. Lawsuits can be expensive and attorney's fees are commonly part of the relief that one seeks under the Copyright Act. But attorney's fees are not automatic in most districts and whether a plaintiff is entitled to recover attorney's fees is up to the discretion of the judge hearing the matter. This makes the decision difficult where there is a great likelihood of success in winning a copyright infringement case, but the statutory damages may not cover the cost of litigation. As for the rationale behind compensating prevailing parties, its roots lie in what is known as the "primary objective" of the Copyright Act—which is "to promote the Progress of Science and useful Arts." While statutory damages further this general goal through deterring freeloading infringers, attorney's fees further the objective of the Act by ensuring all litigants have equal access to the courts to vindicate their statutory rights. In addition, the possibility of fee awards theoretically prevents infringements from going unchallenged where the fruits of litigation would be swallowed by the expense. This is not only good for compensating small plaintiffs, but good for copyright law in general. Since this area of law is defined by litigation outcomes, it is best that a good number of diverse claims and defenses see their day in court so that we can define the boundaries of copyright law as clearly as possible.

In *Gonzales v. Kid Zone, Ltd.*, a court was faced with the dilemma of what standard to apply in deciding whether attorney's fees should be awarded to a plaintiff who won a copyright infringement suit. David Gonzales owned several copyrights in designs he intended to imprint on T-shirts. Transfer Technologies, a company that produced temporary tattoos, took Gonzales' designs and turned them into temporary tattoos without obtaining a license. Gonzales sued and won. In its decision, the court noted that Transfer's infringement was voluntary and willful, but surprisingly awarded Gonzales the minimum amount allowable for statutory damages at $750 per infringed copyright. The judge also decided that in this case attorney's fees should not be awarded, stating "Transfer's actions, though willful, are not the kind of flagrant behavior that would justify an award of attorney's fees."

Gonzales appealed and won. The court reviewed past cases to determine what standard to use since the Copyright Act does not provide any standard

but merely authorizes that such awards can be given at the discretion of the judge presiding over the case. The leading case in this area did not create a standard as to how to decide when attorney's fees are appropriate, but made note of certain factors that should be considered. Among those listed were frivolousness, motivation, and the need in particular circumstances to advance consideration of compensation and deterrence.

The Appeals Court decided that in Gonzales' case, there was little deterrent in the amount of damages that the infringer was ordered to pay. The fact that Transfer stopped infringing after it was sued, although a point in Transfer's favor, was simply not enough of a deterrent. It was effectively patting a criminal on the back for not continuing with its criminal behavior. The court pointed out that "no one can prosecute a copyright suit for $3,000." The court took a big step forward and opined that the earlier *Gonzales* decision would, in effect, allow minor willful infringements to be committed with impunity. The court went as far as saying that the prevailing party in a copyright infringement case where the monetary stakes are small should have a presumptive entitlement to an award of attorney's fees. However, the entitlement to statutory damages and attorney's fees is predicated on obtaining registration of the work prior to the infringement.

HOW ATTORNEY'S FEES ARE MEASURED

In *Schiffer Publishing v. Chronicle Books*, the plaintiff was successful in an infringement action against another publisher who had cut up photographs from the plaintiff's books and used them in another publication. Schiffer received $150,000 in damages and obtained a permanent injunction against further sales of the offending book. Schiffer (or more accurately, Schiffer's legal team) sought fees in the amount of $828,055 and costs totaling $63,069.94. At close to $1 million, these costs and fees are high, the result of a drawn-out legal battle. Ultimately, the court brought the total down drastically, and in doing so provided some useful input regarding how the Copyright Act imparts fees to prevailing plaintiffs.

As for how a court determines how large a fee award changes hands, this is not so simple. The court has a broad margin of discretion in this area. At the outset, the court will have to determine if anyone is even entitled to fees. This involves an analysis of who the prevailing party is, generally defined as one who has "succeeded on any significant issue in litigation which achieves some of the benefit sought in bringing suit." The cases above demonstrate how this

works out. A finding of infringement will put the plaintiff within the bounds of prevailing party while a successful fair use defense could put the defendant within the definition.

A court will then decide if the parties were frivolous or improperly motivated in bringing their claims or defenses. In addition, the court will establish whether or not either party was unreasonable in advancing any legal theory or factual claims. If the losing party bogged down the case with frivolous and unreasonable defenses or claims, the prevailing party's petition for fees becomes a very handsome proposition to the court, which typically has a low tolerance for those parties who hope to frustrate the process. While adding reasonable claims to a complaint may enhance the settlement process, it does not help to add claims preempted by copyright.

Once the court finds an award of fees is an appropriate means of compensation or deterrence, the court moves on to assess the proper amount of the award. In doing so, the court begins by calculating a "lodestar" or the number of hours reasonably expended on the case multiplied by a reasonable hourly rate. And when a legal definition employs the word "reasonable," it means no monkey business allowed. Here, the burden lies squarely on the party seeking fees, and the court will go over the bill with a fine-toothed comb. The first things struck will be any hours not adequately documented. Then the court begins to trim any hours or charges that seem excessive for the work done. Finally, any billing that appears redundant or duplicative (for instance, two high-paid attorneys doing the work of one) comes off the bill.

After the court excludes inadequately documented, excessive, and redundant charges, the lodestar still has to undergo some further adjustment. In copyright actions, factors such as the degree of success obtained by the prevailing party, the complexity of the litigation, and the relative financial strength of the parties will influence the calculation. Prevailing parties in cases of relatively low complexity who barely win over a broke defendant will see a court bring their lodestar down, while a defendant in financial straits who on all counts soundly beats a plaintiff who dragged out a complex and lengthy litigation will see little downward adjustment in their lodestar.

After the court reviewed the attorney's fees, Schiffer's attorneys were left with $256,148.88–about a third of what they sought. Although the court found some of the Schiffer legal team charges unreasonable, even redundant or excessive, the court's point here was not to paint the attorneys as dishonest, but to determine just what is reasonable in terms of fees for this particular case. In other words, when bringing an action, remember that although the Copyright Act permits the prevailing party to seek attorney's fees, it is not automatic that

even if you win, the court will make the defendant pay the entire costs of your legal battle. However, the prospect of reasonable attorney's fees in addition to statutory damages will encourage meritorious cases where there is no possibility of a fair settlement.

THE DEFENDANT AS PREVAILING PARTY

The United States District Court in Texas granted attorney's fees to the prevailing accused copyright *infringer* in *Compaq Computer Corporation v. Ergonome, Inc.* Ergonome, a publisher of computer handbooks, learned an expensive lesson when taking on Compaq in a copyright dispute concerning the publication of computer guides covering the ergonomics of healthy computer use. Ergonome published general audience works on computer ergonomics beginning in 1993. When a potential licensing deal between Ergonome and Compaq was abandoned, Compaq created its own ergonomic guides.

As a consequence, Compaq sought a court determination that its publication did not infringe on Ergonome's handbook. At the same time, Ergonome brought suit against Compaq in the Southern District of New York for copyright infringement; however, this suit was transferred and consolidated into the suit already pending in the Southern District of Texas. The Texas District court found that Ergonome's works were "original" based on Ergonome's arrangement of the ideas through words and pictures and rejected Compaq's argument that Ergonome's words and phrases were too short to be copyrightable. Once the court found that the works were sufficiently original, it had to determine whether Compaq's copying qualified as substantially similar to Ergonome's handbooks or whether it was merely *de minimis* and therefore not infringing. At the outcome of the trial, the jury concluded that while there were some substantial similarities between the handbooks, on the whole they related to unoriginal material that was not protected and that the original portions copied were so minimal that the copying was not infringing.

Since Compaq succeeded in defending the copyright claim, under section 505 of the Copyright Act the court had discretion to allow the recovery of full costs as well as reasonable attorney's fees. Based on the Supreme Court decision of *Fogarty v. Fantasy Inc.*, an accused infringer who prevails in a copyright lawsuit is to be treated the same as a winning copyright owner under the Copyright Act. Additionally, the award of attorney's fees in copyright cases, while within the discretion of the court, is generally the rule rather than the exception in the Texas court's jurisdiction.

The court awarded Compaq more than $2.7 million in attorney's fees. In its determination that Compaq be awarded attorney's fees, the court considered several factors, mostly relating to the frivolous nature of Ergonome's claims. First, Ergonome's alleged damages were more than $800 million, a figure considered unreasonably excessive and without substantiation. Second, Ergonome's complaint listed an array of claims that were preempted by the Copyright Act as they "flowed out of and were based on" the copyright infringement claim. Third, Ergonome was delinquent in responding to discovery requests from the outset of the litigation, leading to numerous fines and holdings of contempt. Next, Ergonome filed a number of claims that were completely without merit, and the testimony of Ergonome's principals was found to be not credible by the court in several instances. Finally, Ergonome rejected an early settlement offer for $200,000, and the attorney's fees Ergonome would have requested if its case had succeeded would have been more than 120 times the fees requested by Compaq.

The obvious lesson here is that one should consider the merits of any copyright action and possible defenses before bringing an action. Bring carefully crafted and narrowly defined claims, understand that once in litigation you must cooperate with the other side and provide documents, do not be blinded by emotions as to the true value of your claim, and finally, always consider reasonable settlement demands, especially when you are in your adversary's home state.

In *Video-Cinema Films, Inc. v. CNN, Inc.* (discussed in chapter 6), the defendant network recovered attorney's fees from the plaintiff. The plaintiff, Video-Cinema Films, asserted a claim for copyright infringement and for common law unfair competition against television networks CNN, ABC, and CBS for their nationwide broadcasts of excerpted footage from the motion picture *Story of G.I. Joe* after the death of actor Robert Mitchum who had appeared in that film. Plaintiff claimed that the defendants violated the Copyright Act when broadcasting this footage as part of an obituary for the actor. The Court found in favor of networks and granted their summary judgment motion. The Court found that the networks produced news reports that served the public interest in accordance with the Copyright Act's fair use provision. The Court specifically noted that the public would be hindered by denying Defendants' fair use defense and that the obituaries in question contained information which, if the general public did not find interesting, movie aficionados would find informative.

After receiving a favorable decision, the networks filed a motion to recover attorney's fees as the prevailing party in the copyright suit. As

stated, section 505 of the Copyright Act allows the court to award reasonable attorney's fees to the prevailing party as part of their costs, and that some of the factors the court may consider are frivolousness, motivation, objective unreasonableness, and the need in some cases to advance considerations of compensation and deterrence. Of these factors, objective unreasonableness is a significant factor and should be given substantial weight in determining whether fees are warranted. Thus the court may award attorney's fees solely upon a showing that plaintiff's position is objectively unreasonable.

The court found that throughout the litigation, plaintiff made objectively unreasonable factual and legal arguments. As a result, the networks' motion for attorney's fees was granted. The networks had used only small portions of the film clips and not movie stills to illustrate significant movies Mitchum had performed in during his career. Furthermore, Larry Stern, the sole president and shareholder of Video-Cinema, prior to buying rights in the film and in anticipation that the networks would show clips from *G.I. Joe*, spent ten hours watching television on the day of Mitchum's death trying to find as many potential litigation targets in the event he was able to buy the copyright to the film. Stern then sent letters demanding $5,000 to $10,000 from each broadcaster for their use of the film clips.

Just recently a court ordered photographer Kent Baker to pay $388,424.54 and his attorney to pay $65,760.65 in legal costs to clothing retailer Urban Outfitters after Baker's copyright infringement claim was dismissed in 2005. Baker's photograph of a man in a cowboy hat leaping from a boxcar was sold as a picture frame insert at Urban Outfitters stores. Urban Outfitters revealed that it only sold 862 pictures frames with a gross profit of $3,896 and offered Baker's representatives more than twice its profits to settle the matter. When the plaintiff demanded what Urban Outfitters considered an excessive sum, negotiations failed. The store then removed the frames from their shelves and replaced Baker's insert with a different image.

As a result, Baker registered his photograph and filed a copyright infringement claim against Urban Outfitters in the Southern District of New York in June of 2001. The complaint demanded $260,000 in damages. As the photograph was not registered with the Library of Congress before the infringement, his claims for statutory damages and attorney's fees were dismissed. Baker was left with a claim for actual damages, which he was required to prove in a process known as "discovery" in which the federal rules require each side to produce documents that are relevant to the prosecution or defense of a claim.

Baker and his attorney did not make the discovery process easy. His attorney objected to Urban Outfitters' request for any prior licensing documents claiming that such documents were irrelevant. When the court ordered the attorney to produce the documents, he told the court that no documents existed and that Baker did not license his work. However, at a later deposition, Baker stated that he had licensed his photographs, including the photograph in question. On the last day of discovery, Baker produced the documents to Urban Outfitters. The attorneys for Urban Outfitters made an "offer of judgment" for $9,096–twice the profits. The offer was rejected and Baker continued to demand more than a quarter million dollars.

In March 2003, Urban Outfitters was awarded $19,270 after Baker's motion for sanctions against Urban Outfitters was determined to be without merit. The copyright infringement claim was dismissed in February 2005 after Baker and his attorney failed to post a bond in that amount. Once the case was dismissed against the photographer, Urban Outfitters sought reimbursement of their legal expenses under Section 505 of the Act. Given that the court had already sanctioned the plaintiff earlier in the case, it should have been no surprise that the judge was not going to hesitate to award the defendant full costs. The judge based her decision in part on Baker's improper motivation and bad faith as he continually insisted on receiving actual damages of $260,000 despite Urban Outfitters' gross profits being less than $4,000. Baker's complaint also included false allegations, such as claiming that the man in the photograph was an "internationally known professional model." The complaint included improper claims for statutory damages and, finally, Baker's agent, Peter B. Kaplan, wrote in a letter to his lawyer that the case was great because it involved "a lot of STUPID, obstinate, deep pocketed, WILLFUL INFRINGERS" and would generate publicity for both of them.

The Court also required Baker's attorney to pay for fees caused by his unreasonable and vexatious conduct. The attorney's inclusion of statutory damage claims that he knew were improper, the inclusion of a claim based on tortious misappropriation of goodwill, the continued insistance on $260,000 in actual damages, the withholding of evidence, and the bringing of a frivolous motion for sanctions against the defendant caused the court to assess damages against the attorney in the amount of $65,760.50. Both the attorney and the photographer were ordered to pay within ten days.

And we just have to mention once again, attorney's fees are only available to a prevailing plaintiff if the infringed work was registered before the infringement or if the work was registered within ninety days of first publication and the infringement occurred in that time period.

An overzealous pursuit of infringement in a copyright case that is contrary to well confirmed principles of copyright law can result not only in a denial of infringement, but subject you to significant costs in terms of your adversary's attorney's fees. In other words, pick your battles wisely (and don't look so greedy to the court).

PART II

Basic Trademark Law

13 WHAT PHOTOGRAPHERS NEED

TO KNOW ABOUT TRADEMARK

This Trademark Section is not intended to be "How to Register" trademarks, but rather to touch on issues of trademark that affect the licensing of images, such as the use of objects in images that might be subject to trademark, domain name issues, and meta-tags.

One of the purposes of stock photography is to depict ordinary objects and people at work and play engaging in typical activities: people attend the theater carrying *Playbill* magazine, kids play basketball using recognizable brand products, doctors examine patients with sophisticated equipment, and lawyers work in offices lined with bookshelves filled with casebooks.

Increasingly, photographers and photo libraries are complaining that their clients are receiving cease and desist letters from manufacturers of the objects depicted in photographs. A manufacturer will object to the end-user or publisher's use of the photograph of the object it manufactured. The manufacturer typically alleges in its letter a violation of "trademark" and may assert "trade dress infringement" or make a vague reference that the use of the photograph "violates intellectual property rights" because it recognizes its object in the photograph. Whether or not the claim has any merit, it certainly causes a problem with the client, who expects to license a photograph without any claims. In most cases, the use of a photograph of an object will not violate any state or federal law. Nonetheless, the claim can damage the client relationship.

A photographic depiction of an object rarely infringes a trademark associated with the object, even if the design is registered. Trademarks are difficult to discuss with black and white rules as the nature of a trademark is not in the protection of the design or the art, but in the use of the object as the identifier of the source of goods. Even if goods depicted in a photograph are recognized by the manufacturer, recognition alone is not sufficient for trademark violation. The use of the photograph of the object has to be in a way that causes confusion as to the source of the goods, or implies endorsement or association.

Consequently, a stock photograph as it is displayed in a catalog of images, whether online or in a print catalog, can never violate a trademark as it only serves as a representation of the object in a neutral manner. It is only if a client uses the photograph in a trademark manner that the use of the photograph could potentially give rise to a trademark claim.

Trademark law encompasses both state and federal laws involving trademark registration, protection for unregistered marks under the federal Lanham Act, state and federal unfair competition claims, and new anti-dilution trademark laws. In sum, it is difficult to summarize trademark law and it is outside the scope of this publication to do anything other than identify and define the basic issues.

A trademark is defined as a word, phrase, symbol, or design, or a combination of words, phrases, symbols, or designs, that identifies and distinguishes the source of the goods of one party from those of others. A service mark is the same as a trademark, except that it identifies and distinguishes the source of a service rather than a product. Trademarks deal with a mark, not the design of an object. For example, the SWOOSH design on a Nike baseball cap is the trademark while the baseball cap is just the "good." The SWOOSH mark indicates that the cap is licensed by Nike and is subject to Nike's manufacturing standards.

A photographic depiction of an object, other than a pure "product shot," is not a trademark use under the Lanham Act as it does not serve as an indicator of a source of goods. When a photograph serves purely as a factual representation of a common object, it is not a trademark use. For example, if you want to illustrate the concept of a child at play riding a bicycle, you need to photograph a child on a bike that is manufactured by a bike company. While the bike may be manufactured by Schwinn, the trademark is in the mark SCHWINN, and not the design of the bike (unless it has obtained trade dress protection described later). If this photograph is licensed to a health insurance company for an advertisement of its insurance program, there is little likelihood that a consumer will believe that SCHWINN sponsored or endorsed the product. The photograph serves to illustrate the action of bike riding and the concept of healthy activities.

The very nature of a photograph, as a depiction of an object or activity, rather than as a design to indicate a source of goods, tends to negate trademark use. It is a misuse of terms and a misunderstanding of trademark law for an owner of a mark to recognize its product as part of the composition of the photograph and assert a trademark violation.

WHAT IS TRADEMARK INFRINGEMENT?

To determine trademark infringement, a court asks two questions. First, is the object photographed a trademark? In other words, is it used by the trademark owner as an indicator of goods and services? Second, is the user of the photograph using the photograph as a trademark? That second question will rarely be answered affirmatively. As described above, stock photographs are often used to illustrate actions and concepts such as "deal making" or "excitement," and do not serve as a trademark. In order for a photograph to serve as a trademark, the same photograph of the object would have to be used repeatedly in the same consistent manner by the party claiming trademark rights.

The test for ordinary trademark infringement is the likelihood of confusion that a consumer would believe that any licensee's use of the photograph of the object is produced, endorsed, or sponsored by the manufacturer. In *Medic Alert Found. v. Corel Corp.*, the court held that a mere reproduction of trademark does not constitute trademark infringement. The defendant had included the plaintiff's logo as part of clip-art in its computer program for possible reproduction by end users. The court found no likelihood of confusion that the owners of this mark approved of this brand of software. Similarly, the display of one logo among thousands on a Web site or CD-ROM would not cause confusion as to sponsorship.

Some vehicles have been held to have trademark protection in actions against competitors such as Yellow taxicab and Checker cab. This prevents other cab companies from driving confusingly similar cars. This does not mean that a photograph of a yellow cab is a violation of trademark. Good luck depicting a street scene in New York City without yellow cabs. A photograph of a cab in a street is not a trademark use of a yellow cab and, if used in a travel brochure, consumers would not believe that a particular cab company endorsed the advertised product or service.

A good example of when a photograph could cause confusion is *Volkswagenwerk Aktiengesellschaft v. Wheeler* where a local Volkswagen repair shop unaffiliated with the automobile manufacturer used a silhouette of the distinctive VW in its advertising. Volkswagen believed that the use of the VW shape could give the impression that the repair shop was authorized. This use was enjoined in a prior case.

Because a trademark must be a symbol for a source of goods and services, it is rare that artwork, even if the artist is readily recognizable, will serve as a trademark. In *Leigh v. Warner Brothers, Inc.*, a court found that Jack Leigh's

well-known photograph of the bird girl sculpture from the cover of the book *Midnight in the Garden of Good and Evil* was not a trademark because he used it as a sample of his art, and not as a trademark.

Because it is impossible to anticipate the intended use of stock photographs for commercial use, logos and other unique features or buttons on an object should be removed from the photographs. In addition with readily identifiable manufactured objects such as electronics, the photographs should not be shot head on but on an angle. This will avoid a claim where an actual competitor of the object depicted uses the photograph, as in the VW case.

CAN BUILDINGS SERVE AS TRADEMARKS?

The design of a building also does not serve as an effective trademark. The Rock & Roll Hall of Fame and Museum in Cleveland failed to prove that it used its building design as its trademark in *Rock & Roll Hall of Fame & Museum v. Gentile Prod.* against photographer Chuck Gentile who sold a poster of the building. The museum had never used any particular photograph or consistent view of the building in a consistent manner to identify a source of goods. The photographer did not use the image in such a way as to indicate that the poster was authorized by the museum. The building was not a trademark, and the use by the photographer was not a trademark use. Therefore, there was no consumer confusion.

The Rock & Roll Hall of Fame initially sought a preliminary injunction from the District Court preventing Gentile from selling the poster, claiming that the sale of the poster violated the museum's trademark rights in the building and its name. On appeal, the decision was reversed by the Sixth Circuit, which threw out the injunction. The court's decision was strongly worded to suggest that the Rock & Roll Hall of Fame was unlikely to prevail after a trial on its claim that its building was used as a trademark and that the poster violated any trademarks rights.

Since a preliminary injunction is a request for a court to take action *prior* to a trial on the theory that the complaining party will be irreparably harmed by the other party's conduct during the course of a trial, the Rock & Roll Hall of Fame was entitled to go back to the lower court and attempt to prove that Gentile's poster did in fact violate its trademark rights in the building. Despite the decision from the appeals court, the Rock & Roll Hall of Fame proceeded with its action against Gentile in the district court. This ruling in favor of Gentile relied on the reasoning of the appeals court and stated that the Rock & Roll Hall of Fame's building design was not used as a trademark so the

poster could not infringe its trademark rights. Also, Gentile did not use the poster as a trademark, so he would not have infringed any alleged trademark rights. Additionally, the use of the identifying words "Rock & Roll Hall of Fame" under the photographer's name did not infringe any trademark rights and being descriptive, the use was fair use.

While this decision does not mean that a photograph of a building could never violate a trademark, it would seem very difficult after this decision for the owner of a building to convince a court that a photograph of a building infringed any trademark rights. This decision supports the position that in most situations, a photograph of a building does not violate the building owner's trademark, and additional permission is not required by law. Since most trademark infringement cases turn on issues of confusion as to the origin of goods and services, it is still advisable to analyze each use on a case-by-case basis.

A three dimensional building will *rarely* serve as a trademark. An owner of a mark needs consistency to create a trademark. The building must be shown in the same angle on all brochures, advertising, marketing material, etc. Other museums or entities learning a lesson from *Rock & Roll Hall of Fame* may begin using the same image of their building consistently and over time build trademark rights. An example of the consistent use of a building as a trademark is the stylized illustration of the Transamerica pyramid as a logo for the insurance company. Use of the logo would constitute trademark infringement by a competitor, but showing the building in a skyline photo of San Francisco would not.

In recent years, there was a big trend in claiming trademark in buildings. Many companies have registered marks in illustrations of their buildings. Taking a closer look at this phenomenon gives us a good lesson in trademark law. One question is whether there is a distinction to be made between representing a property in a descriptive way (i.e., editorial) and representing a property in a commercial way.

The answer is that there is a difference. Trademark law recognizes the right to use a trademark in a descriptive manner. The term, as with copyright law, is the defense of fair use. For example, in *Rock & Roll Hall Of Fame*, the court, which reversed the earlier ruling that the photographer's sale of a poster of the building infringed the museum's trademark, found that the title under the poster "Rock & Roll Hall of Fame, Cleveland" to be descriptive and permissible. An article describing the historic buildings in the Wall Street area of New York City could publish photographs of the landmark buildings, including the New York or American Stock Exchange. The magazine would not be in violation of any alleged trademark rights in the buildings. However, if a financial services company wanted to use a photograph of the American or New York

Stock Exchange in an advertisement, it would be advisable to seek permission from the company. In the commercial use, there is risk of confusion in showing a recognizable image of the Stock Exchange. The viewer could interpret the use of the Stock Exchange image as endorsing the financial service company, when in fact it had not. Again, the underlying question is "Does the building represent a trademark?" Is it so connected to a particular business or service that if it is used in an advertisement an assumption of support or endorsement is made? Most buildings do not represent a particular business or industry, but some do.

Another frequent question is whether there is a distinction between the use of a photograph of the exterior of a home as opposed to the use of a recognized landmark. The answer here again is yes, there is a difference. In most instances, no laws prevent the reproduction of an image of a person's home taken from a public space. The laws that protect an individual's right of privacy relate to the use of the person's name or likeness for commercial purposes. Even though an owner might recognize his or her own home, the home itself does not conjure up the image of the owner to the viewing public. Some homes may be so identified to the owner that an association would be obvious. Most farm houses, suburban homes, and common buildings would not have any association with a particular owner and no additional permissions would be necessary to use them commercially.

Advertising agencies often require releases for commercial use. In light of the above, why are photographers encouraged to obtain property releases? Obtaining the release is a preemptive measure to prevent clients from being hassled by annoying homeowners who watch a lot of legal dramas on television and who think that you need everything in writing and notarized in triplicate. Everyone has the idea that you need permission for everything these days, including a photograph of their home, stray cat, and pet frog. And if they have a lawyer send your client a letter, it becomes your problem, even if they are wrong. A property release prevents the question from being raised, and allows for smooth transactions. It is more for preventative measures than a legal necessity.

PHOTOGRAPHS OF PEOPLE ARE NOT TRADEMARKS

To be certain, one can correctly assert that there is a big difference between merely recognizing a pictured product, building, or person, and the use of the photograph as a trademark use. The fact that there are so few cases that deal

with whether a photograph of a product infringes trademark rights is an indicator that the manufacturer or trademark owner's claims are weak.

Some years ago, the Unites States Patent and Trademark Office Trial and Appeal Board affirmed the final rejection for trademark registration of the likeness and image of Elvis Presley as a trademark for cotton fabric. The applicant tried to register the likeness of Elvis in all possible manners or presentation without regard to age, manner of dress, or pose.

As each application for a trademark must contain one drawing of the mark, the applicant failed to comply with the requirement that the applicant submit an acceptable drawing of its mark. The Lanham Act does not permit the registration of a concept or idea. The Trademark Appeals Board noted that if every likeness of Elvis from birth to death were covered by the application, the applicant would be in the position to prevent others from using or registering the specific images of other individuals (real or fictional) that resemble one of the thousands, if not millions, of vastly different photographs, film frames, or video frames depicting Elvis Presley (i.e., young beach party Elvis or Las Vegas Elvis).

The court cited the New York case *Pirone v. MacMillan* brought by baseball legend Babe Ruth's daughters to prevent MacMillan from publishing a calendar with photographs of Babe Ruth. The daughters asserted that the calendar violated trademark rights in Babe Ruth's name and likeness. The court noted that an individual's likeness is not consistently represented in a fixed image. In order to serve as a trademark, a particular photograph must consistently be used on specific goods. In this situation, no one pose of Babe Ruth had been used as a source to identify goods. Since the use of the name Babe Ruth was intended only to identify a great baseball player, it was not a trademark use. The court concluded that the photographs were merely descriptive of the calendar's subject matter and that consumers would not reasonably believe that Babe Ruth sponsored the calendar. The photographs of Babe Ruth did not serve as a source indicator.

Tiger Woods lost a trademark claim for the use of his name and likeness in multiple print art in a case from 2003, *ETW Corporation v. Jireh Publishing, Inc.* Jireh Publishing published artwork by Rick Rush, an artist who specializes in painting sports figures. In 1998, he created a painting entitled "The Masters of Augusta," which commemorated Woods' historic victory at the Masters Tournament in Augusta in 1997. Jireh published and marketed a limited edition of five thousand lithographs of "The Masters of Augusta." Tiger's name is used in the narrative description of the work.

The painting consisted of three views of Woods in different poses. Behind the figures is the Augusta National Clubhouse. In the background behind the

clubhouse are likenesses of famous golfers of the past looking down on Woods. The limited edition prints distributed by Jireh consisted of an image of Rush's painting, which includes Rush's signature at the bottom right hand corner. Beneath the image of the painting, in block letters, is its title, "The Masters of Augusta." Beneath the title, in block letters of equal height, is the artist's name, "Rick Rush," and beneath the artist's name, in smaller upper and lower case letters, is the legend "Painting America Through Sports."

ETW, the licensing agent of Tiger Woods, filed suit against Jireh, alleging trademark infringement in violation of the Lanham Act, dilution of the mark under the Lanham Act, unfair competition and false advertising under the Lanham Act, unfair competition and deceptive trade practices under Ohio Revised Code, unfair competition and trademark infringement under Ohio common law, and violation of Woods' right of publicity under Ohio common law. ETW owns a trademark registration for the mark TIGER WOODS for use in connection with art prints, calendars, mounted photographs, notebooks, and the like. Jireh counterclaimed, seeking a declaratory judgment that Rush's art prints are protected by the First Amendment and did not violate the Lanham Act. Both parties moved for summary judgment and the district court granted Jireh's motion and dismissed the case in 2000. ETW appealed.

The U.S. Court of Appeals for the Sixth Circuit decided that the district court properly granted summary judgment on ETW's claim for violation of its registered mark, TIGER WOODS, on the grounds that the claim was barred by the fair use defense. The court held that, as a general rule, a person's image and likeness cannot function as a trademark.

Their reasoning is simple. ETW registered Woods' name as a trademark but it did not register any image or likeness of Woods. The essence of a trademark is a designation in the form of a distinguishing name, symbol, or device which is used to identify a person's goods and distinguish them from the goods of another. ETW claimed protection under the Lanham Act for any and all images of Tiger Woods. In effect, they asked the court to constitute Woods himself as a walking, talking trademark. Images and likenesses of Woods are not protectable as a trademark because they do not perform the trademark function of designation. They do not distinguish and identify the source of goods. They cannot function as a trademark because there are thousands of images and likenesses of Woods taken by countless photographers, which have been published in many forms of media, and sold and distributed throughout the world.

The gist of ETW's false endorsement claim was that the presence of Woods' image in Jireh's print implies that he has endorsed Jireh's product. False endorsement occurs when a celebrity's identity is connected with a product or

service in such a way that consumers are likely to be misled about the celebrity's sponsorship or approval of the product or service.

In an ordinary false endorsement claim, the controlling issue is likelihood of confusion. However, both the Second Circuit and the Ninth Circuit have held that in Lanham Act false endorsement cases involving artistic expression, the likelihood of confusion test does not give sufficient weight to the public interest in free expression. The courts agreed that the public interest in free expression should prevail if the use of the celebrity's image has artistic relevance, unless it is used in such a way that it explicitly misleads as to the source of the work.

The photography industry *eagerly* anticipated this decision for nearly two years. Artists' groups filed briefs in support of the position that an artist/ photographer should be allowed to sell prints of his or her works without consent of the celebrity. Briefs supporting Woods were filed by sports licensing companies and companies that license celebrity rights. There has always been tension when selling prints of celebrities between what is art and protected as free expression and what is commercial merchandising, requiring permission. Few cases have been decided in this area. It was assumed that permission was needed for posters, but no one knew how many prints could be sold by an artist before the number of prints could be construed as commercial merchandise. It appears after this decision that if a work of art is sold as a print itself, the First Amendment will prevail and multiples in the thousands will be permitted by the courts.

DESIGN PATENT

Design patents protect ornamental features that are not intended to be functional. A design patent is given only to new and non-obvious ornamental features. A design patent is appropriate only for "industrial" design and not for works that are aesthetic such as photographs, sculpture, or painting. Examples of design patents are some of the Michael Graves kitchen products, teapots, toasters, and ovens. These design patents prevent competitors from creating "knock-off designs." It does not prevent a photograph of the design.

COLORS OF OBJECTS GRANTED TRADEMARK PROTECTION

If a color has become so associated with a certain product or brand it is sometimes protected by trademark law. An example of this would be Tiffany & Co.'s famous "blue," which is exhibited on the company's packaging. This same line

of reasoning also allows the color of pills to be trademarked. In the past when drug companies have applied for trademark registration for the color of their pill products, competitors have argued against the application making the case that the colors are unprotected as merely functional aspects. This argument has been rejected by the courts on the ground that color has nothing to do with the utilitarian performance of the drug. Thus both federal and a state trademark law protect the color of some pills. Another reason that the color of pills is protected by trademark lies in the area of unfair competition. Often pharmaceutical companies will register their pills' color so that the public will not be confused over the origin of the drug.

Although the color of a pill may be protected, whether a photograph that includes various pills violates a drug company's protected trademark is a more difficult question. There are no cases that address this issue. The purpose of trademark law is to prevent consumer confusion by identifying the source of the goods and services. A photograph of a product is not the product itself. In other words, in creating a photograph, no one is creating a competing drug. The use of the image would have to infer that a particular company was either endorsing or affiliated with the company using the photograph. It is possible that some photographs will contain pills that are clearly identified with a pharmaceutical company and should not be used to advertise competitors' products or used to illustrate an article that disparages the product. The user should be advised to seek additional permissions from the manufacturer of the drug. It would be helpful in seeking this permission if the caption information on the photograph stated 1) the type of pill and the manufacturer, or 2) that the pill is a generic brand medicine. There is little risk in photographing generic drugs since the idea of "generic" is that the period of protection of the drug has expired and anyone can manufacture the drug. In addition, the use of a disclaimer may be used with the publication of the photograph to decrease any likelihood of consumer confusion as to the type or source of the medicine.

TRADE DRESS

Trade dress originally referred to the packaging of a product but the definition of trade dress has expanded over the years to encompass the shape and design of a product itself. Like trademark law, the product design must be used to denote the source of the goods. If a product feature is decorative and aesthetic with no source identifying role, it cannot be given exclusive rights

under trade dress. Like a trademark, it is a symbol or device that carries a meaning. Trade dress can be registered as a mark or protected as unregistered trade dress under the Lanham Act. Examples of registered trade dress that function as a trade mark is the red LEVI tab affixed to the vertical seam of the back pocket of jeans, the shape of LIFESAVERS candy and its hole, and the three stripes on ADIDAS athletic shoes, the FERRARI DAYTONA SPYDER classic sports car, Black & Decker Snake Light flashlight, and the Rubik's cube puzzle. Similar to copyright law, trade dress does not protect generic ideas or concepts. The court in *Jeffrey Milstein, Inc. v. Gregor, Lawlor, Roth, Inc.*, refused to grant trade dress protection to a photographer who created cards based on the concept of making greeting cards of color photographs of animals, plants or people cut to the shape of the image. His works would include a card in the shape of a sitting golden retriever, for instance. The concept was held not to be protectable as trade dress because such a concept was a generic idea or concept.

For a product design to be granted protection as unregistered trade dress, the design must be "distinctive." The cases describe distinctiveness as "inherently distinctive" where the mark is so arbitrary, fanciful, or suggestive that it is considered distinctive. (In trademark law, Camel cigarettes are considered a distinctive mark because there is no natural association between a camel and a cigarette.)

Marks that are not inherently distinctive can acquire distinctiveness if they obtain "secondary meaning," another term of art used in trademark law. Simply put, secondary meaning is where in the mind of the consumer, the primary significance of the mark is to identify the source of the product rather than the product itself.

The Supreme Court in 2000, in the *Wal-Mart Stores, Inc. v. Samara Bros.* decision, laid down a rule: product design trade dress can never be classified as inherently distinctive. A party asserting infringement of unregistered product design trade dress must establish secondary meaning. In order for an advertiser to establish secondary meaning in its product, it must advertise the feature in a "look for" manner to distinguish its product from competitors. As a result, it is very difficult for a product design to claim trade dress. Consequently, a photograph of a product will rarely violate the product's trade dress rights.

Mere association with a particular product is not enough to acquire secondary meaning. Customers must care that a product comes from a particular company. Just because you recognize the product and know who manufactured it is not sufficient to acquire secondary meaning and trade dress protection.

FEDERAL TRADEMARK DILUTION ACT—WILL RECENT REVISIONS AFFECT THE LICENSING OF PHOTOGRAPHS?

In 2006, Congress passed a bill that expands the power of a famous trademark over new trademarks. The Trademark Dilution Revision Act of 2006 is an amendment to the Federal Trademark Dilution Act (FTDA) in response to the Supreme Court's ruling in 2003 that went against the owners of the Victoria's Secret trademark. Victoria's Secret had sued a small "adult novelty" store named "Victor's Little Secret." In that case the court held that the then-version of the trademark dilution statute required proof of actual dilution of a trademark, such as a loss in sales by the famous mark owner. This is a hard burden for a trademark owner to meet and as a result, Victoria's Secret lost the case against the novelty store.

Dilution of a trademark can occur in two ways, by either blurring or tarnishment. Blurring is when the newer mark impairs the distinctiveness of the famous mark. Tarnishment happens when the similarities of the marks harms the reputation of the famous one. Under the amendment, the burden of proving dilution on the famous mark was made easier. The owner of the famous mark would only have to establish that dilution is likely regardless of any actual loss of sales. This is a much easier test than actual dilution, required under the old act as interpreted by the Supreme Court.

Importantly, the amendment still leaves intact the exceptions that govern fair use of a trademark: parody, criticism, commentary, news reporting/commentary, advertising to compare goods, and any non-commercial reasons.

Having a stronger anti-dilution statute may make owners of famous marks more persistent in arguing that a photograph of their trademark goods violates trademark law. There is no bright line to determine whether a mark is sufficiently famous for this statute to apply. Regardless of this revised language, I would maintain that in most instances, a photograph of a product, unlike the selling of a competing product, is not a trademark use and would not tarnish or blur the famous mark, whether the owner of the famous mark is required to establish only likelihood of dilution rather than actual dilution.

14 FAIR USE OF TRADEMARKS

L ike copyright, trademark law has a statute governing the area of fair use, and courts have decided cases explaining the doctrine's parameters. It is valuable to understand what is permitted, especially in the area of advertising.

An example of fair use of trademarks in advertising is a commercial that references and displays the trademarked name and logo of another company without obtaining prior permission. The Lanham Act, which governs trademark law, permits a fair use defense where the trademark identified is not to be used as a mark, but to merely describe the good or service, and there is a fair use defense to using the trademark without obtaining prior permission. For example, in the Rock & Roll Hall of Fame case, even the though the phrase "Rock & Roll Hall of Fame" was registered as a trademark, the photographer could title the photograph as "Rock & Roll Hall of Fame, Cleveland" because it was an accurate description of the building.

The best description of why a trademark does not give an owner exclusive control over the mark was stated by one of the most respected American jurists, Justice Oliver Wendell Holmes: "[A trademark] does not confer the right to prohibit the use of the word or words. It is not a copyright. A trademark only gives the right to prohibit the use of it so far as to protect the owner's good will against the sale of another's product as his."

The case *New Kids On The Block v. News America Pub., Inc.* concerned the pop group the New Kids on the Block and dealt with an unauthorized telephone poll regarding the group using the name "New Kids on the Block." The New Kids claimed that the use of the name violated their rights under the trademark. The defendant argued that the use in connection with the poll was fair use. The court set forth three requirements for fair use: 1) the product or service in question must be one not readily identifiable without use of the trademark; 2) only so much of the mark or marks may be used as is reasonably necessary to identify the product or service; and 3) the user must do nothing that would, in conjunction with the mark, suggest sponsorship or endorsement by the trademark holder. In addition, the court said that where "the use of a

trademark does not imply sponsorship or endorsement, the fact that it is carried on for profit and in competition with the trademark holder's business is beside the point."

In the recent fair use trademark case *Mattel Inc. v. Walking Mt. Prods*, toy maker Mattel sued photographer Thomas Forsythe for copyright, trademark, and trade dress infringement for using the iconic Barbie doll as his subject for social and political commentary. The photographs depicted a nude Barbie in danger of being attacked by vintage household appliances. The series was entitled "Food Chain Barbie." Titles include "Barbie on a Half Shell" (doll on oyster server), "Blended Mermaids" (dolls in blenders), "Blue Ice" (doll reclining in martini glass), and "Barbie Enchiladas" (four dolls wrapped in tortillas, covered with salsa in a casserole dish in a lit oven).

Forsythe described his artistic message as an attempt to critique the objectification of woman associated with Barbie, and that he selected Barbie as the product because it best embodied the conventional beauty myth and the perfection-obsessed consumer culture. Mattel was not amused, despite the fact that the photographer's artistic success was limited primarily to a small town in Utah, used in slides by a feminist scholar and depicted in low resolution on his Web site. In all, he earned $3,659 from the sale of postcards (half of which were purchased by Mattel investigators). Some of the photographs were also displayed in various museums.

The court noted that when marks "transcend their identifying purpose" and enter the "public discourse," they "assume a role outside of trademark law." When a mark achieves cultural significance, it gains First Amendment

© *Thomas Forsythe*

protection. It noted that Mattel had lost a similar case in New York against the manufacturer of a line of dolls called "Dungeon Dolls" (essentially Barbie dolls dressed in sadomasochistic attire). Here, as in that prior case, the public interest in free and artistic expression greatly outweighed any potential consumer confusion about Mattel's sponsorship of the photographer's work.

Mattel claimed trade dress in the Barbie head and overall appearance. The court found that the photographer's use of the Barbie trade dress to be "nominative" fair use (for the purpose of comparison, criticism, or point of reference). The court found it highly unlikely that any reasonable consumer would have believed that Mattel sponsored the work.

Lastly, Mattel argued that the photographer's use of Mattel's trademark and trade dress violated the federal anti-dilution statute because it tarnished its mark with negative association. The court dismissed this claim as well, stating that the statute did not pertain to non-commercial speech and the work was protected by the First Amendment.

Although commercial photo licensing is not the same as licensing photographs for the purpose of social commentary, this case aptly illustrates that trademark and trade dress laws are not absolutes. There are certain words, products, and images that become part of the fabric of our society. Laws protecting intellectual property and trademarks cannot be used to stifle speech, even if we find the speech offensive or unflattering.

The Restatement of Unfair Competition, a reference book for lawyers, points out that one is not subject to liability when one uses another's protected designation to refer to the other or the other's goods, services, or business, since such use does not create a likelihood of confusion. For example, use of another's trademark in comparative advertising, even if the comparison is unfavorable to the other, does not subject the user to trademark liability. And, if the use merely causes prospective purchasers to recognize the mark as a reference to the trademark owner, the use is not an infringement.

Furthermore, *Restatement* helps clarify the distinction between the use of another's mark as a trademark for the manufacturer's own goods or services and a non-trademark use of the mark. In both contexts the perception of prospective purchasers and not the intent of the user is controlling. For example, if prospective purchasers interpret the use of the mark as an indication of the source or sponsorship of the manufacturer's goods or services, the use is within the scope of provisions of the Lanham Act. On the other hand, if the use is interpreted merely as a reference to or a comment on the goods, services, business, or mark of the trademark owner, the Lanham Act should not be applicable.

In conclusion, a general rule of thumb for trademark fair use is that, so long as the trademark is not being used to confuse a customer and is merely identifying a product or service that already exists, the unauthorized use may be permissible.

TRADEMARK AND PUBLIC DOMAIN

Like copyright, the rights of a trademark owner are not absolute and cannot be effectively used to prevent the use of a work out of copyright. The Ninth Circuit U.S. Court of Appeals, which hears appeals over federal district court cases in California, unanimously ruled in *Comedy III Productions v. New Line Cinema* that a thirty-second film clip of the Three Stooges' *Disorder in the Court* played in the background of a scene in a 1996 movie *The Long Kiss Goodnight* did not violate trademark laws. New Line Cinema did not have to seek permission from Comedy III Productions, holders of the rights to use the clip.

Disorder in the Court was no longer protected by copyright and in the public domain. Without the armament of copyright law, Comedy III Productions filed a trademark claim in order to protect their rights in the Three Stooges image. The court rejected the Lanham Act argument, finding that the short clip was not an "enforceable trademark." To succeed under a Lanham Act claim, the plaintiff needs to demonstrate likelihood of confusion over ownership of a trademark, as the purpose of a trademark is to identify the source and origin of goods. Also noted was the fact that just because other film producers chose to pay Comedy III Productions a fee that they did not have to, New Line Cinema was not legally obligated to follow suit.

This case demonstrates the difficulty in relying on trademark law rather than copyright law when trying to control the use of film or still images that have fallen into the public domain. It is not surprising that rights holders will try to use trademark law when copyright law is unavailable to continue to control rights. Disney has been registering trademarks in illustrations of Mickey Mouse, knowing that early films will soon enter the public domain. This decision supports the long-standing practice of film and still archive houses of renting images of public domain publicity stills and movie clips that are not protected by copyright. Of course, some uses may still fall under a Lanham Act claim, and each situation should be analyzed as to whether the image or clip is serving as an enforceable trademark.

In a significant decision, the United States Supreme Court ruled unanimously in *Dastar Corp. v. 20th Century Fox Film Corp.* that Federal Trademark

Law permits the copying of Public Domain works. The court was asked by Fox to decide whether Section 43(a) of the Lanham Act prevents the unaccredited copying of a work and if so, whether a court may double a profit award under Section 1117(a) of the Lanham Act in order to deter future infringing conduct.

The facts of this case are complicated. The story actually begins in 1948, when General Dwight D. Eisenhower completed *Crusade in Europe*, his written account of the allied campaign in Europe during WWII. Doubleday published the book, registered it with the Copyright Office in 1948, and granted exclusive television rights to an affiliate of Twentieth Century Fox Film Corporation. Fox arranged for Time, Inc., to produce a television series, also called *Crusade in Europe*, based on the book, and Time assigned its copyright in the series to Fox.

The television series, first broadcast in 1949, combined a soundtrack based on a narration of the book with film footage from the United States Army, Navy, and Coast Guard, the British Ministry of Information and War Office, the National Film Board of Canada, and unidentified "Newsreel Pool Cameramen." In 1975 Doubleday renewed the copyright on the book as the proprietor of copyright in a work made for hire. Fox did not renew the Copyright on the *Crusade* television series, which expired in 1977, leaving the television series in the public domain.

In 1988, Fox reacquired the television rights in General Eisenhower's book, including the exclusive right to distribute the *Crusade* television series on video and to sublicense others to do so. SFM Entertainment and New Line Home Video, Inc., in turn, acquired from Fox the exclusive rights to distribute *Crusade* on video. SFM obtained the negatives of the original television series, restored them, and repackaged the series on videotape; New Line distributed the videotapes.

Enter Dastar Corporation. In 1995 Dastar decided to expand its product line from music compact discs to videos. Anticipating renewed interest in WWII on the fiftieth anniversary of the War's end, Dastar released a video set entitled *WWII Campaigns in Europe*. To make *Campaigns*, Dastar purchased eight beta cam tapes of the original version of the *Crusade* television series, which is in the public domain, copied them, and then edited the series. Their package included a new opening sequence and did not use all of the footage from the television series.

Dastar manufactured and sold the *Campaigns* video set as its own product. The advertising states: "Produced and Distributed by Entertainment Distributing" (which is owned by Dastar), and makes no reference to the *Crusade* television series. Similarly, the screen credits state "DASTAR CORP. presents" and "an ENTERTAINMENT DISTRIBUTING production" and list as executive

producer, producer, and associate producer, employees of Dastar. The *Campaigns* videos themselves also make no reference to the *Crusade* television series, New Line's *Crusade* videotapes, or the book. Dastar sells its *Campaigns* videos to Sam's Club, Costco, Best Buy, and other retailers and mail order companies for twenty-five dollars per set, substantially less than New Line's video set.

In 1998 Fox, SFM, and New Line brought this action alleging that Dastar's sale of its *Campaigns* video set infringes Doubleday's copyright in General Eisenhower's book and thus their exclusive television rights in the book. They later amended their complaint to add claims that Dastar's sale of *Campaigns* "without proper credit" to the *Crusade* television series constitutes reverse "passing off" in violation of Section 43 of the Lanham Act, and in violation of state unfair competition law. (The copyright claim was denied and remanded to a lower court for factual review.) "Passing off" occurs when a producer misrepresents his own goods or services as someone else's. "Reverse passing off," as the name implies, is the opposite: The producer misrepresents someone else's goods or services as his own.

Fox's main accusation against Dastar is that in marketing and selling *Campaigns* as its own product without acknowledging its nearly wholesale reliance on the *Crusade* television series, Dastar has made a "false designation of origin, false or misleading description of fact or false or misleading representation of fact which . . . is likely to cause confusion . . . as to the origin . . . of his or her goods." In other words, according to Fox, Dastar has violated Section 43 of the Lanham Act.

The court must determine if, by not crediting the other parties involved in creating the original television series, Dastar was misrepresenting the true origin of its production and infringing Doubleday's copyright and Fox's exclusive rights. The problem with according special treatment to communicative products such as books and videos is that it causes the Lanham Act to conflict with the law of copyright, which addresses that subject specifically.

According to the Supreme Court, reading "origin" in §43(a) to require attribution of uncopyrighted materials would pose serious practical problems. Without a copyrighted work as the base point, the word "origin" has no discernable limits. As the court noted, a video of the MGM film *Carmen Jones*, after its copyright has expired, would presumably require attribution not just to MGM, but to Oscar Hammerstein II (who wrote the musical on which the film was based), to Georges Bizet (who wrote the opera on which the musical was based), and to Prosper Merimee (who wrote the novel on which the opera was based). In many cases, figuring out who is in the line of "origin" would be no simple task. In the present case it is far from clear that respondents have that status.

Neither SFM nor New Line had anything to do with the production of the *Crusade* television series—they merely were licensed to distribute the video version. While Fox might have a claim to being in the line of origin, its involvement with the creation of the television series was limited at best. Time, Inc., was the principal if not the exclusive creator, albeit under arrangement with Fox. And of course it was neither Fox nor Time, Inc., that shot the film used in the *Crusade* television series. Rather, that footage came from the United States Army, Navy, and Coast Guard, the British Ministry of Information and War Office, the National Film Board of Canada, and unidentified "Newsreel Pool Cameramen." If anyone has a claim to being the *original* creator of the material used in both the *Crusade* television series and the *Campaigns* videotapes, it would be those groups, rather than Fox. As Scalia noted, "We do not think the Lanham Act requires this search for the source of the Nile and all its tributaries."

Another practical difficulty of adopting a special definition of "origin" for communicative products is that it places the manufacturers of those products in a difficult position. On the one hand, they would face Lanham Act liability for *failing* to credit the creator of a work on which their lawful copies are based; and on the other hand they could face Lanham Act liability for *crediting* the creator if that should be regarded as implying the creator's "sponsorship or approval" of the copy.

Had Fox *renewed* the copyright in the *Crusade* television series, it would have had an easy claim of copyright infringement. Fox's contention that *Campaigns* infringes Doubleday's copyright in General Eisenhower's book was not decided at the time of this decision. (Subsequently, *Campaigns* was found to be an infringing derivative work of the Eisenhower book.) If, moreover, the producer of a video that substantially copied the *Crusade* series were, in advertising or promotion, to give purchasers the impression that the video was quite different from that series, then one or more of the respondents might have a cause of action—not for reverse passing off under the "confusion . . . as to the origin" provision of the Lanham Act, but for misrepresentation under the "misrepresents the nature, characteristics [or] qualities" provision. For merely saying it is the producer of the video, however, no Lanham Act liability attaches to Dastar.

Fox lost this one. The Court said that the law allows the copying of public domain material without giving credit to its source. Justice Scalia said it would be impractical to require publishers to give credit to all the originators of their products. This decision is particularly useful for archives that deal in public domain movie stills. As long as the material is not protected by copyright, the studios do not have a secondary Lanham Act claim against the archives for failing to properly credit the studio.

15 TRADEMARKS AND THE WEB

Another way trademark law can impact a photographer, besides what is in the picture, is when the photographer builds a Web site and chooses a domain name. The conflict between trademark law and domain name reservation continues to be a major issue, as many traditional businesses have adopted Web sites and entered in to the world of e-commerce. Trademark law has always permitted unrelated businesses to share the same name. You could be Ford, the car manufacturer, or Ford, the modeling agency. But there is only one Web address, or URL, that can reside at www.ford.com. As you may have guessed, it is owned by the motor company.

When Network Solutions was the company that reserved domain names, it reluctantly handled disputes when one company had a trademark that was identical to the domain name in dispute. Essentially, it had a hands-off policy. If you had a dispute, the company would put the name on hold for a period of time and you needed to bring a court action to resolve the dispute. Since Network Solutions has turned the reins over to the Internet Corporation for Assigned Names and Numbers (ICANN), it is no longer placing names on hold. Now, ICANN is the organization responsible for domain name reservation. In the last days of 1999, ICANN officially adopted a different dispute resolution policy. Under the policy, agreement, court action, or arbitration must resolve most types of trademark-based domain-name disputes before a registrar will cancel, suspend, or transfer a domain name.

Cybersquatting is a practice where someone reserves several possible permutations of a company's domain name in hopes of holding it for ransom when the company decides to go digital. This practice may be addressed by expedited administrative proceedings that the holder of trademark rights initiates by filing a complaint with an approved dispute-resolution service provider. Persons who believe that a domain name has been registered in bad faith now can force the domain name registrant into a mandatory administrative dispute resolution process with one of three approved dispute resolution "providers." Information regarding the Uniform Policy and Rules, as well as Providers,

current proceedings, and background are available at ICANN's Dispute Resolution Web site: *www.icann.org/udrp/udrp.htm.*

The administrative action is fairly inexpensive (as compared to a court action) and quick. The relief is the cancellation of the bad faith registration. Congress was active in legislating against cybersquatters as well. In 1999, Congress enacted the Anticybersquatting Consumer Protection Act, which was passed as part of the Intellectual Property and Communications Omnibus Reform Act of 1999. The legislation provides for both civil and criminal remedies against "cyberpiracy" in the domain name/trademark context, and amends Titles 15 and 28 of the U.S. Code (the trademark laws). While the civil remedies are retroactive, the criminal penalties are not.

Abusive registrations are those that register a name in bad faith with intent to profit. Abusive registration applies to marks that are distinctive, famous, or protected by statute. Trademark owners can seek an injunction, actual damages or statutory damages ranging from $1,000 to $100,000, costs, and attorney's fees. The action, being part of the federal Lanham Act, requires the complaint or proceeding to be filed in federal court. Trademark owners have wasted no time in using this new tool in the war against cybersquatting.

SEARCH TERMS AND TRADEMARK ABUSE

On the subject of Web sites, trademark law can also come into play regarding the search terms associated with a site. As the saying goes, "sticks and stones may break my bones, but names will never hurt me." This may be true for the playground, but not when it comes to the Internet. A federal District Court in California held in *J.K. Harris & Co. LLC v. Steven Kassell, et al.* that excessive mention of a competitor's registered trademark in a party's Web site architecture to unfairly garner "hits" in an Internet search is an invalid use of a competitor's trademark. J.K. Harris and Co., one of the largest tax representation and negotiation companies in the United States, filed suit against a competitor, Steven H. Kassel and First Tax Inc., for trademark infringement alleging that Kassel's Web site unnecessarily and excessively made mention of the Harris trade name, drawing away potential Harris clients. J.K. Harris also sought an injunction against negative statements published on the Kassel site.

The Lanham Act prohibits "initial interest confusion" which occurs when a consumer is lured to a product by its similarity to a known mark, even though the consumer realizes the true identity and origin of the second product before making a purchase. In this case, Kassel established a page on its Web site entitled

"J.K. Harris Employees Tell of Wrongdoing While Complaints Pile Up," dedicated to criticizing J.K. Harris. It included statements from unidentified disgruntled former employees and customers, as well as solicitations for critical information about J.K. Harris for publication on its Web site.

J.K. Harris alleged that Kassel strategically manipulated its Web site so that a customer typing in "J.K. Harris" in any search engine would find Kassel's site within the top ten hits, including the line "J.K. Harris Employees Tell of Wrongdoing While Complaints Pile Up." This was accomplished by creating keyword density using the J.K. Harris name, creating "header tags" and "underline tags" around sentences that used the J.K. Harris name, using the J.K. Harris name as keywords within the site and by using various hot links to Web sites with information about J.K. Harris.

Kassel argued that mentioning J.K. Harris was reasonable under a rule known as "nominative fair use" which allows a registered trademark to be used by a commercial user. The court applied the three-factor test from the *New Kids On The Block* case to determine if the use qualifies as "fair use."

Although the court agreed that Kassel satisfied the first and third factors, the court found that Kassel's use of the mark was more excessive than reasonably necessary. The court noted that Kassel's site made mention of the J.K. Harris trade name as a keyword over seventy-five times, that the Kassel site did not need to use the J.K. Harris name in "header tags and underline tags," or increase the font size, underline the sentences using the competitor's trade name, or place the name in sentences at the top of the Web page. The fair use argument was denied. J.K. Harris was successful in showing a likelihood of initial interest confusion and the court granted an injunction, preventing Kassel from further excessive use of the trade name but only from using it more than necessary, rather than completely.

Kassel argued that it had a First Amendment right to free speech and should be permitted to display content regarding J.K. Harris. However, the court pointed out that the Lanham Act specifically prohibits false statements made in a commercial advertisement that have a tendency to deceive a substantial segment of the audience. The court did not enjoin statements that were publicly available and factually correct, but required that Kassel remove third party statements from disgruntled employees and customers submitted to Kassel since they were factually unreliable and harmful to the business reputation and goodwill of J.K. Harris.

In this Internet world, where everyone fights over the most "eyeballs," being in the top ten list of any search engine is critical to generating traffic to your site. However, where unfair tactics are employed, parties are fighting back, using traditional trademark law to level the playing field.

As more image users turn to search engines to find image sources, the cost of keeping a Web site as one of the front runners in a search result or elevated to a premium listing is increasing. Google and Overture (a Yahoo! company) are two of the most prominent companies that allow companies to "buy" search terms and pay for advertising hits. Initially, Google prevented advertisers from purchasing keywords that contained the trademarks of others, but it recently changed its policy and stopped screening for trademarks. Now search words can include trademarks, whether the trademarks belong to the company or a competitor. This can result in a competitor outbidding the trademark owner and, by using its trademark, receive a premium position, driving targeted purchasers to the competitor's site. These search engines also sell space for advertising on the search engine pages so a competitor's advertising may appear alongside the company's listed search. Trademark owners have been complaining that the placement of the competitor's ads is an improper attempt to trade off the goodwill of their marks and is a form of unfair competition and trademark infringement.

Both Google and Overture were sued for violating federal trademark law for selling online advertising triggered by a trademark that belonged to the purchaser's competitor. The U.S. District Court for the Eastern District of Virginia ruled in *Government Employment Insurance Co. v. Google Inc.* that this allegation of selling trademarks as search words for online advertising was sufficient for a prima facie trademark infringement claim. The court also ruled that the search engines could be liable for trademark infringements committed by advertisers who use the plaintiff's mark in their online advertising.

Plaintiff Government Employment Insurance Co., popularly known as GEICO, alleged that Google and Overture Services Inc.'s Internet search engines used its mark GEICO in a manner constituting trademark infringement. In this case, GEICO alleged that its trademark was being sold as a keyword triggering the display of advertising for GEICO competitors and that such use amounted to trademark infringement. The search engines moved to have the case dismissed, arguing the facts did not support a trademark claim. The judge disagreed and let the case continue, finding that GEICO had alleged sufficient facts for an infringement claim.

Earlier decisions in prior cases involving trademarks and pop-up ads were inconsistent throughout the country, with some courts permitting trademarks in pop-up ads and other finding it a violation of trademark rights. The court did not follow the ruling that found that the use of trademark terms to trigger the ads were not an actionable "use" in commerce of the mark, a required element of a trademark infringement claim. The court believed that other court rulings

that found such use of trademarks to trigger advertising was a use in commerce to be better reasoned. The court said that the search engine's actions could falsely imply a relationship between the search engine and the owner of the mark, a use that "may imply that defendants have permission from the trademark holder to do so."

The court distinguished this case from others that allowed advertisers to purchase broad categories of terms that included trademarked terms. In this case, the trademarks were marketed as terms that could be purchased individually. The court went on to hold that the defendants could also be liable on contributory and vicarious liability theories for trademark infringements committed by advertisers who use the plaintiff's marks in the advertisements displayed on the defendants' web site.

This decision does not mean that the search engines are in fact liable for trademark infringement by selling the trademark terms—just that the facts are sufficient to permit the claim to go forward. Whether the search engine will ultimately be found liable depends on whether the use of the marks was a fair one in competition, and whether a likelihood of confusion existed.

16 FEDERAL STATUTES THAT

PROTECT MARKS

There are some Federal Statutes that protect specific symbols using Federal Civil and Criminal laws. One example is the "Red Cross" emblem. Other symbols that have statutory protection include Smokey the Bear, Woodsy Owl, the Olympic Rings, the 4-H Club emblem, and the presidential seal.

The Red Cross is known for vigorously protecting its famous red Greek cross emblem, even if depicted in a photograph. While the cross is technically no longer a registered trademark, a criminal statute protects misuse of the emblem. Persons found violating the statute face either a fine up to $250, up to six months in prison, or both. The emblem is thought to evoke ideas of humanitarian interest. Today, the Red Cross emblem is used to identify and protect medical and relief workers, military and civilian medical facilities in combat zones, mobile units, and hospital ships. It further identifies the programs and activities of Red Cross national societies throughout the world. To that effect, the Red Cross seems adamant in protecting its reputation, image, and emblem. The symbol was further incorporated into the Geneva Conventions, and since most nations have signed onto these treaties, almost every nation has undertaken the responsibility to establish a Red Cross organization to protect the emblem of the Greek red cross.

The first American criminal statute to protect the Greek red cross was enacted in 1905. Since then, however, many users have infringed the emblem despite the Red Cross' feverish attempts to police the market. While major companies like pharmaceutical giant Johnson & Johnson still use a very similar mark for some of their products, they are exempt from the federal statute because their original date of use for those marks is pre-1905. Because anyone trying to use the mark that did not use it prior to 1905 is prohibited from doing so, only twenty-one pre-1905 users remain active today. The Red Cross actively pursues misuse in both traditional arenas and on the Internet. Plus signs have become a popular design element, especially

among companies who advertise their products as improved, superior, or new. When thickened and colored red, these plus signs are indistinguishable from the Red Cross emblem.

There are few defenses in favor of an infringing use of the Greek red cross. Arguing that your use of the red cross is not infringing because there is no confusion between your use and the services of the Red Cross is of no avail. Trademark law and the Lanham Act, which permits similar marks on different classes of goods, affords infringers no protection because it is preempted by this federal criminal statute. The only test to establish infringement under this Red Cross statute is whether a mark is "a Greek red cross on a white background, or any sign or insignia colored in imitation thereof." Further, because the emblem is protected by federal statute, it will not revert back into the public domain, despite the fact that it has been abused for nearly a century. In selecting or creating images for stock use, care should be taken to avoid products that incorporate the Greek red cross.

Beware of restrictions to the licensing of photographs that contain images of military personnel wearing an official military uniform and/or insignia as the consumer might have the impression of endorsement by the military. Persons wearing Armed Forces uniform (any branch) and/or insignia may not be used to advertise a "product." This leaves open the question of whether they can be used to promote a service. An argument that if the service supports and promotes the best professional standards of armed forces of the nation might prevail, assuming model releases for the individuals are obtained.

Title 10 of the United States Code, Section 7881, restricts the use or imitation of the seal, emblem, name, or initials of the U.S. Marine Corps in connection with any promotion, goods, services, or commercial activity in a manner reasonably intended to suggest that such use is approved, endorsed, or authorized by the Marine Corps or any other component of the Department of Defense. The statute entitles the Attorney General of the United States to bring a civil proceeding to enjoin any person from engaging in an act that is prohibited. There is no mention of any monetary penalties or criminal liability.

A federal regulation (CFR Sec. 765) establishes procedures to determine whether to grant permission for certain commercial and non-commercial applications relating to the Marine Corps. Prior approval is only necessary if the use or imitation of the seal, emblem, names, or initials is used to suggest official approval, endorsement, or authorization in connection with a promotion of goods, services, or commercial activity. The proposed use will ordinarily be approved if it merely provides a Marine Corps accent or flavor to fungible goods. Disapproval would be expected when the use 1) implies a connection

with the Marine Corps, 2) implies a suggestion of financial or legal obligation of the user, 3) implies that the Marine Corps selectively benefits the particular commercial entity or user; or 4) tends to subject the Marine Corps to discredit. Examples listed are the use of the name or insignia on musical instruments, weapons, or in connection with advertising, naming, or describing products such as insurance, real estate, or financial services.

No request for permission is required if the use includes a prominent display of the following disclaimer: "Neither the United States Marine Corps nor any other component of the Department of Defense has approved, endorsed, or authorized this product (or promotion, or service, or activity)." Prominent display is defined as one located on the same page as the first use of the insignia, and printed in letters at least one half the size and density of the insignia.

If you believe permission is necessary, written permission can be requested from the "Director, Administration Resource Management" (ARDE).

It is recommended that anyone using an image from the other branches obtain a similar disclaimer of non-endorsement by that particular branch of the service.

For those creating new images, there is also a federal statute detailing when a person who is not on active duty may wear the uniform of the Armed Forces (Title 10A Part 11, Chapter 45, Section 772). Among the permitted uses are retired officers, those that have been honorably discharged, those that have served honorably, and actors if the portrayal does not discredit the Armed Forces, and Boy Scouts!

CONCLUSION

It can be very intimidating to receive a letter from an attorney, with its crisp letterhead and assertions of violation of a company's trademark, trade dress, and other intellectual property rights, listing numerous trademark registrations and claims of consumer confusion. The truth is that these allegations can rarely be backed up by case law or actual use. In trademark cases, the party must establish the likelihood of consumer confusion, usually through expensive survey evidence. In most instances, the claim has no merit.

An effective approach is to respond to the claim letter and demand the basis of the claim, asserting the non-trademark use of the photograph. While the owner of a trademark is required to protect its mark, trademark cases

are expensive and involved and are generally not brought if there is no claim. The hope by the manufacturer or trademark owner is that a threatening letter will be effective without bringing a claim. Lawyers and trademark owners will never admit in writing that the claim is without merit, but when pushed the letters will stop. Unfortunately, many clients do not like any risk and voluntarily discontinue the use of the photograph, making any further correspondence moot and accomplishing just what the claim letter requested.

PART III

The Law of Privacy and Publicity

17 THE VARIOUS TORTS THAT MAKE
UP THE PRIVACY RIGHT

Unlike the Federal Copyright Act and the Federal Lanham Act for trademark, there is no federal statute in the United States concerning rights of privacy or rights of publicity. The laws vary from state to state. In order to avoid liability, the laws of the most conservative states must be acknowledged. There have been many cases in the area of publicity arising out of right of privacy actions, so people tend to confuse one situation with another. It is necessary to examine the basis of a right of privacy action as it currently exists in the United States to understand how it gives rise to right of publicity action. This area is extremely important to photographers and image libraries as this is an area that can give rise to costly litigation when one licenses images that were not properly released.

Right of privacy initially meant the right of someone to be left alone. It developed thereafter through legislation and court interpretation into four areas: intrusion, disclosure, false light, and appropriation. The states, through court interpretation or statute, absorbed not only appropriation, but intrusion, disclosure, and false light.

INTRUSION

Invasion of privacy by intrusion is generally accepted to mean intrusion upon a party's seclusion or solitude or into his or her private affairs. Examples of intrusion are when police enter a home to search without a warrant. It could also include "peeping Toms" and those who open other people's mail or eavesdrop on a personal conversation. A very famous photography case involving intrusion is the suit Jacqueline Kennedy Onassis brought to prevent physical harassment by a persistent photographer.

Although not common, photographers have been sued for violating privacy based on intrusions. Most recently in December 2005, Judge Frank Seay, United States District Judge for the Eastern District of Oklahoma, dismissed a case brought against a photographer alleging invasion of privacy. Summary judgment was granted in favor of defendant photographer Peter Turnley and his publisher *Harper's Magazine* in a case regarded as pitting the photographer's First Amendment rights against a grieving family's alleged right to privacy. After photos of Sgt. Kyle Adam Brinlee Showler's body in an open casket appeared in *Harper's Magazine* as part of a larger photo essay entitled "The Bereaved," Robert Showler and Johnny Davidson, family members of the fallen Oklahoma National Guard Specialist, brought a claim against Turnley and his employer magazine alleging causes of action ranging from several species of invasion of privacy to intentional infliction of emotional distress to fraud.

Turnley did take the allegedly offending photos at the deceased's funeral. But as the opinion points out time and time again, this was no "ordinary" funeral. Brinlee's family held services in the local high school auditorium packed with 1,200 people—reportedly "friends, family, admirers, classmates . . . and strangers." Oklahoma Governor Brad Henry spoke at the ceremony concluding with an open casket viewing. As printed in a *Harper's* photo essay "The Bereaved," the photos depict a scene not unlike what any attendee would have seen at this point in the funeral: "a slain soldier lying on a white pillow, with white-gloved hands folded over his crisp uniform."

Yet when these photos appeared in the August 2004 edition of *Harper's*, the plaintiffs held them an invasion of their privacy, taken without permission for economic gain and published with no result but inflicting emotional distress on the family. The complaint alleged a myriad of torts that were violated and demanded substantial damages. Indeed, these were very moving images. Yes, they captured what can be a very intimate rite. However, in light of the facts and considering our free speech system, the court could not allow the case to go forward.

Judge Seay began by discussing a possible First Amendment defense. Seay asserts that the public had an interest in Brinlee's death, which trumped the family's privacy rights. Certainly a local Oklahoma newspaper agreed on the issue of public concern, as it regarded this death as the number one area news story of 2004. Brinlee was the first Oklahoma National Guard member to be killed in action since the Korean conflict. In his opinion, Judge Seay reminds the plaintiffs time and time again that they chose to make the funeral public themselves. In one line, Seay admonishes that "plaintiffs chose to open it to all comers . . . and to toss control of the event to the wind and even sought celebrity of politicians and the public." He goes on that "if plaintiffs wanted to

grieve in private, they should not have held a public funeral and had a section reserved for the press." In short, what we are dealing with here is a photographer who merely captured a public, newsworthy event accurately and exactly as it appeared to the twelve hundred people in attendance.

It is well established that our right to privacy does not prohibit any publication of a matter that is of public concern. The Supreme Court has described the First Amendment as creating a sort of "privilege of enlightening the public." This privilege is very broad, and goes beyond factual or historical data into what could be described as merely interesting human activity. Even when publications may at times run counter to ordinary sensibilities, principles of privacy will not prevent truthful publications that fall under matters of public interest. The First Amendment protection afforded the press, including photojournalists, is the foundation of the free press in the United States and is what distinguishes the United States from many other countries whose laws tip the balance more in favor of an individual's privacy concerns rather than the right to publish. With this in mind, Judge Seay deftly navigated the technical twists and turns through all of the torts claimed. For our interests, what primarily controls the outcome is the fact that Brinlee's funeral was a public event offering a newsworthy topic coupled with the fact that Turnley's photo was an accurate illustration of true information—in short, the First Amendment prevails over claims of privacy and other similar tort violations.

This decision was characterized as a victory for First Amendment rights. Indeed, if Seay had allowed the plaintiffs to move forward and had they eventually won, it would have a tremendously chilling effect on journalists and publishers, which would in turn ultimately erode our free speech principles. Fortunately for other news agencies, publishers, and photojournalists, *Harper's Magazine* and Turnley chose to fight this claim and to defend their principles rather than settling to avoid the costs of litigation. As of this writing, the plaintiffs have appealed the decision. PACA and other news organizations joined in an *amicus* brief supporting the photographer and magazine. It would indeed be a blow to photojournalism if publishers and photographers were inhibited from published truthful and accurate accounts of newsworthy events based on the sensibilities of a few.

PUBLIC DISCLOSURE OF PRIVATE FACTS

The second type of invasion of privacy action is public disclosure of private facts. This is the disclosure of embarrassing private facts about a party. Examples of this type of invasion of privacy are people who were once involved

in famous criminal prosecutions and in later years find themselves the subject of media attention. In these situations there is a collision between the freedom of the press under the First Amendment of the Constitution and an individual's right of privacy. Various states have treated these cases differently, some favoring the press, others the individual.

FALSE LIGHT

The third type of privacy action is called false light. An example of false light is where a periodical publicly and falsely attributes to someone an opinion or statement, which that person does not hold or has not made.

APPROPRIATION

The fourth invasion of privacy is privacy by appropriation. This is a prime area where image libraries or suppliers of photographs are subject to liability. This involves the unauthorized use of a person's photograph, name, likeness, or voice for commercial purposes, which damages the person's dignity, interests, and peace of mind.

18 THE RIGHT OF PUBLICITY

Invasion of privacy by appropriation gave rise to the right of publicity. The early cases were brought by celebrities or other non-private persons. Traditionally under the right of privacy, celebrities had no legal action to prevent the publication of their photographs. The conventional wisdom was that a celebrity who placed himself or herself before the public eye could not be heard to complain that his or her privacy was intruded upon. Indeed, what they were really complaining about is not getting paid for the use of their identity in selling the defendant's goods and services. What developed was a new area of privacy called right of publicity. Additionally, right of publicity claims developed so that it could be brought by the estate of a deceased celebrity as well as the celebrity during his or her lifetime. The traditional right of privacy claim only applied to living persons since it was a personal right.

For example, at the time of this writing, the family of the socialist revolutionary icon Che Guevara is reported to be launching a coup of its own and intend to enforce the right of publicity in the iconic revolutionary. Conspicuous consumers the world over flaunt Che's image on countless products, and the companies that produce them could face suit quite soon. This is an interesting case of pop irony. The revolutionary's family undoubtedly senses the twist in the Marxist martyr's capitalist appeal. They have reportedly enlisted the aid of several lawyers abroad to keep his stern visage off of merchandise. Whether the family has a valid right of publicity under relevant law is to be seen. T-shirts sporting Che's image are still prevalent and there have been no known claims after the initial report.

On the other end of the economic theory spectrum, Governor Terminator Arnold Schwarzenegger sued a small toymaker from Ohio that produces a line of bobbleheads featuring politicians. The Schwarzenegger bobblehead depicts Arnold in a "gray suit with a bandoleer brandishing an assault rifle." Arnold's lawyers claimed that his name and likeness was worth millions. The toy maker argued that this use is a parody and thus protected by the First Amendment. Besides–other politicians like Hillary Clinton, Jimmy Carter, and Rudy Guiliani

have not had a problem with the bobblehead maker. It is true, one can use a public figure's name voice or likeness for journalistic, artistic, or political statement as long as the artist "transforms" the image into an original work. Professor Volokh of the University of California thought Arnold had a good claim because the bobblehead has not transformed his image. However, Volokh also believes that these suits tend to make celebrities look bad and humorless. Other experts disagreed on the strength of his suit and explained that Arnold, now a politician as well as a celebrity, cannot be immune from satire. Nonetheless, as is the result of most cases, the parties came to a settlement.

The right of publicity is treated as a property right that can descend to one's heirs in many states. The law in this area varies greatly from state to state. Some of those laws are enacted by the legislature and some are judge-made. It is important for each image library or photographer in every area of the country to check their own area's laws concerning rights of publicity. Still, knowing the law of your state may not be sufficient in many instances. Most images licensed appear in many states with differing laws concerning the right of publicity, subjecting one to liability in other states.

People have claimed they are "identifiable" in commercial photographs even if their face is not recognizable. A professional auto racer has been recognized by the markings on his racecar, for example, an astronaut by his stance on the moon, and a ballplayer by his pose and uniform. All of these are examples of real court cases. This is often referred to as "persona." For example, a silhouette of a man with a bowler hat, baggy pants, and a cane would be recognized as Charlie Chaplin even if one could not see his face.

The astronaut Dr. Buzz Aldrin asserts a right of publicity in any commercial use of the NASA originated photograph of him as an astronaut standing on the moon. Although no identifying features of Dr. Aldrin are recognizable since he is encased in a space suit, he asserts that the photograph itself is so famous, including the composition and pose, that he is recognizable as the astronaut. The particular image is of an astronaut standing on the moon with the reflection of Neil Armstrong in the visor.

The Tiger Woods case *ETW v. Jireh*, discussed previously, demonstrates a typical rights of publicity claim by a celebrity. ETW, the licensing agent for Tiger Woods, sued an artist who created a poster, *Masters of Augusta*. In addition to the trademark claim, Woods claimed that the poster violated his rights under the Ohio right of publicity statute. The court dismissed the publicity claims as the trademark claims, and the appeal came out against Woods. The court analyzed the publicity claim, and as you'll remember, concluded that Rush's work had substantial informational and creative content which

outweighed any adverse effect on ETW's market, clearly not violating Woods's right of publicity.

As with the trademark claim it is important to the rights of publicity claim that the court saw Rush's work as expression entitled to the full protection of the First Amendment. The court concluded that effect of limiting Woods' right of publicity wouldn't stand in the face of society's interest in freedom of artistic expression.

19 RIGHTS OF PUBLICITY:
CALIFORNIA CASES

Claims relating to rights of publicity and privacy arise under state law. Most cases, but not all, deal with New York and California because these states have higher concentrations of publishers and celebrities. These states treat the right of privacy and publicity very differently, with New York favoring the publishing industry and California favoring their celebrities. New York law, as detailed later in the chapter, does not permit the right to descend upon death. On the other hand, California's statutes specifically permit the descendants the right.

In order to balance the First Amendment protection, California's statute regarding deceased celebrities' rights of publicity has always had an exception to permit the use of images for what is considered "editorial purposes." This exception came under attack by celebrities wishing to obtain greater control over the use of their images in magazines and other publications. Fortunately California's exceptions regarding the commercial exploitation of deceased celebrities remain intact, notwithstanding efforts by Robyn Astaire, the widow of actor Fred Astaire.

Under California law, the name, voice, or likeness of dead celebrities may not be used to advertise or sell products without the permission of the heirs. However, there are exceptions for political, newsworthy, and artistic works. Ms. Astaire contended that the exceptions should be applicable only for serious artistic and literary works. Opponents protested that removing the exceptions would grant heirs the right to block almost any use and placing the burden on an author to establish that their work was protected by the First Amendment.

In addition, sponsors of the bill initially sought to prohibit the use of digital technology to alter the names or images of deceased celebrities. Such an amendment would have prevented the use of historical characters with live actors in films as we saw in *Forrest Gump.* They had also proposed language that

would have given heirs of a deceased celebrity the right to sue newspapers, magazines, and film studios for falsely depicting the celebrity. Both efforts were abandoned before the bill was finalized.

The sale of photographs depicting deceased celebrities to magazines and other publications does not run afoul of California Law. As it stands, the state's right of publicity under California Civil Code section 3344–3344.1 extends the right of publicity to seventy years after the death of the personality.

In 2001, the Supreme Court of California formulated a balancing test to determine whether reproductions of celebrity artwork are entitled to First Amendment protection, or require the consent of the celebrity's estate under the California statute granting deceased celebrities a right of publicity.

The California statute (formerly section 990 of the California Civil Code, currently Section 3344.1) grants the right of publicity to successors in interest of deceased celebrities, prohibiting any other person from using a celebrity's name, voice, signature, photograph, or likeness for commercial purposes without the consent of such successors. The statute specifically exempts a use "in connection with any news, public affairs, or sports broadcast or account, or any political campaign." Further, use in a "commercial medium" does not require consent solely because the material is commercially sponsored or contains paid advertising; "Rather it shall be a question of fact whether or not the use . . . was so directly connected with" the sponsorship or advertising that it requires consent. Finally, the statute provides that "a play, book, magazine, newspaper, musical composition, film, radio, or television program"; work of "political or newsworthy value"; "[s]ingle and original works of fine art"; or "an advertisement or commercial announcement" for the above works are all exempt from the provisions of the statute.

DAMAGES FOR VIOLATION OF THE CALIFORNIA STATUTE

If a photograph of a person is used for advertising purposes in California, damages under the statute can be high. The statute permits damages to be calculated based on the defendant's profits and permits attorney's fees. Russell Christoff, a former model from northern California, posed for a two-hour Nestlé photo shoot in 1986 but figured it was a bust—until he stumbled across his likeness on a coffee jar while shopping at a drugstore in 2002. A legal dispute with Nestlé USA ensued, during which Christoff declined the company's $100,000 settlement offer, and Nestlé USA turned down his offer to settle for $8.5 million.

In 2005, a Los Angeles County Superior Court jury in *Christoff v. Nestlé USA* ordered Nestlé USA to pay Christoff $15.6 million for using his likeness without his permission and profiting from it. The award includes 5 percent of the Glendale-based company's profit from Taster's Choice sales from 1997 to 2003. During that time, Nestlé sold the freeze-dried coffee with labels featuring Christoff's face in the United States, Mexico, South Korea, Japan, Israel, and Kuwait. The company's Canadian arm started using his image in 1986.

Nestlé USA attorney Lawrence Heller said the company would appeal the verdict.

"The employee that pulled the photo thought they had consent to use the picture," Heller said. Eric Stockel, an attorney for Christoff, said he hadn't expected such a large verdict. Christoff, who while working as a model had appeared in corporate training videos and hosted his own public television show, is now a kindergarten teacher in the Bay Area community of Antioch. He first came across his picture while shopping for Bloody Mary mix and says there's a good reason he didn't spot it sooner. "I don't buy Taster's Choice," he said. "I do beans."

In another 2005 case, a California jury ruled that Vans, Inc., a company that makes sneakers for skateboarders, must pay bassist Nikki Sixx of the rock group Motley Crue $600,000 for using his photo without permission in an advertising campaign. The jury also awarded interest on the award and attorney's fees as permitted under the California statute. This could bring the total award to over $1 million. The photograph was taken of the bassist at an awards ceremony. Vans asserted that it had obtained permission to use the photograph in print, online, and retail ad displays.

These two cases are examples of damages under the California right of publicity statute and do not necessarily indicate how courts in other states would award damages. The Taster's Choice decision in particular appears excessive and should be reduced upon appeal. No decision is available at the time of this writing

CALIFORNIA'S RIGHTS OF PUBLICITY STATUTE: FACTORS CONSIDERED BY A COURT

The California statute was tested against the First Amendment in the case *Comedy III v. Saderup.* The defendant Saderup was a charcoal illustrator of celebrity portraiture. His drawings are used to create multiple reproductions in the form of lithographic prints and silk-screened images on T-shirts. Among the

celebrity drawings he sold were lithographs and T-shirts bearing a likeness of The Three Stooges. Comedy III Productions was the registered owner of all rights to the former comedy act known as The Three Stooges, all deceased personalities. Comedy III brought an action against the artist for violations of the California right of publicity statute, seeking damages and an injunction preventing further sales. The court trial judge found for Comedy III and entered judgment against Saderup awarding damages of $75,000 and attorney's fees of $150,000 plus costs. The court also issued a broad permanent injunction restraining Saderup from violating the statute by use of any likeness of The Three Stooges in lithographs, T-shirts, or any other medium by which the artwork may be sold or marketed. The sole exception to this broad prohibition was Saderup's original charcoal drawing from which the reproductions were made.

On appeal the court modified the award by striking the injunction. There was no evidence that the activity was continuing and the injunction was overbroad because it extended to conduct protected by the First Amendment. The artist appealed on two grounds, both of which were addressed by the Supreme Court: 1) the conduct did not violate the statute; and 2) the conduct was protected by the constitutional guarantee of freedom of speech.

On the first ground, the court determined that the statute applied because the lithographs and T-shirts were themselves products, and the artist was using the likeness of The Three Stooges on products. The more difficult issue for the court to address was the constitutional issue. The court noted the tension between the right of publicity and the First Amendment, concluding that depictions of celebrities amounting to little more than the appropriation of the celebrity economic value are not protected expression under the First Amendment. The court observed that the right of publicity is primarily an economic right, and formulated a balancing test between the First Amendment and the right of publicity based on whether the work in question adds significant creative elements so as to be "transformed" into something more than a mere celebrity likeness or imitation. This test was derived directly from the fair use doctrine in copyright law that employs a balancing of four factors to determine whether copying a work without permission is permitted.

In analyzing these factors, courts have considered whether the new work is "transformative." The court theorized that a work that contained significant transformative elements was less likely to interfere with the economic interest protected by the right of publicity. The court went on to say that the celebrity still has the "right to monopolize the production of conventional, more or less fungible, images of the celebrity." The question for this court was "whether a product containing a celebrity's likeness is so transformed that it has become primarily the defendant's own expression rather than the celebrity's likeness." The court

clarified the term expression as "something other than the likeness of the celebrity." In close cases, the court suggested that the question to be answered is "does the marketability and economic value of the challenged work derive primarily from the fame of the celebrity depicted? When the value of the work comes principally from some source other than the fame of the celebrity from the creativity, skill, and reputation of the artist it may be presumed that sufficient transformative elements are present to warrant First Amendment protection."

The court proposed that the right of publicity is aimed at preventing the illicit merchandising of celebrity images. Therefore, because single original works of fine art are not forms of merchandising, the First Amendment rights of the artist should prevail and permit any exhibition and sale. However, the court also concluded that a reproduction of a celebrity image that contains significant creative elements is entitled to as much First Amendment protection as an original work of art. It found that the trial court and the Court of Appeals erred in denying all protection to reproductions.

An example the court gave of reproductions that demonstrated significant creative elements was Andy Warhol's silk screens of celebrities such as Marilyn Monroe, Elvis Presley, and Elizabeth Taylor. In applying the test the court found that in the case of Saderup, his skill was subordinated to the overall goal of creating literal, conventional depictions of The Three Stooges so as to exploit their fame and therefore not protected by the First Amendment. Further, the court determined that the marketability and economic value of Saderup's work derives primarily from the fame of the celebrities depicted. The court perceived no transformative elements in Saderup's works that would require First Amendment protection.

The art addressed in this case was a charcoal drawing made into lithographs and T-shirts. A photographic depiction of a celebrity was not a medium of art before this court. However, how a subsequent court in California may handle the sale of photographs or limited edition photographic works after this case is unclear. While photographs by their nature are literal, there are many creative decisions made by a photographer in making a portrait, which should continue to protect photographic portraiture as a work of art under the California Statute.

PROBLEMS WITH THE TRANSFORMATIVE TEST

The balancing test evoked by the *Comedy III* court only makes sense for artistic likeness and not photographs. Determining whether a work is transformative has no place in photography as it relates to rights of publicity. A photograph by its nature could very well be quite a literal depiction of the celebrity. In this

case, the expression of the photographer and the celebrity cannot be separated. A photograph does not always necessarily add something new nor parody the subject. Unfortunately the word "transformative" is one of the more difficult terms for courts to understand in a copyright context. Now it has been adapted to publicity rights.

Still, a photograph is clearly a work of art, protected by copyright and the freedom of expression under the First Amendment. The California statute exempts "single and original works of art." It can be argued that each photographic print is unique and can be construed as a single and original work of art.

The problem with this case is that the artist must use the First Amendment as a defense. That means each case requires a fact finder (judge or jury) to determine if a limited edition photograph is worthy of First Amendment protection or is a conventional image restricted by the right of publicity. A case-by-case analysis necessarily means that you must defend yourself in court, an expensive proposition. Further, determining the primary motivation of the purchaser of the art reproduction seems unreasonable. Whether a purchaser chooses a photographic print because of the reputation of the photographer or a desire for the subject may not be readily ascertainable. Even with the Warhol example, are we interested in it only because it is a Warhol or because we are interested in Monroe, Taylor, and Elvis?

This balancing test appears to favor artists with an established reputation over emerging artists that choose celebrities or other personalities as their subjects. How do you describe the style of a photographer as recognizably his or her own? What factors will a court use? It is likely that all artists will face more pressure from representatives of estates of deceased celebrities in the future until these questions are resolved. While photography as an art form should be granted full First Amendment protection and additional permission should not be needed, assignment photographers in California who take portraits of celebrity personalities may want to obtain permission to use the photographs in self-promotional material, Web sites, books, limited edition prints, or other reproductions (such as digital prints) to avoid disputes with celebrities.

In selling any reproductions, the name of the artist and his or her reputation should be included. Describing the prints as "limited editions" also creates the impression that the work is protected artistic expression and not merchandise. What the court will consider "a conventional likeness of a celebrity" is unknown. What is certain is that issues involving rights of publicity will be an increasing area of legal concern. California is often the leader in states that view the right of publicity as an economic right that survives death to benefit the heirs, rather than a personal right.

Even with living celebrities, the courts in California are very protective. In 2001, the Ninth Circuit reversed a California District Court decision that had awarded Dustin Hoffman $1.5 million plus attorney's fees for the use of an altered photograph of a film still from the movie *Tootsie* in *LA Magazine*. The article entitled "Grand Illusions" featured famous film stills that were altered using computer technology to create the appearance that the actors were wearing 1997 spring fashions. One of the images was a famous still from *Tootsie* with Dustin Hoffman. The American flag and the head remained as in the original still, but Hoffman's body in his long red sequined dress was replaced by a male body in a similar pose, wearing a cream colored silk evening gown.

No permission was obtained from the actor. Obviously lacking a sense of humor about this subject, Hoffman alleged violations of California's common law right of publicity, California statutory right of publicity, unfair competition, and the federal Lanham Act covering trademarks. The court dismissed the magazine's First Amendment defense and found it liable on all claims. The federal appellate court reversed and found that the article was editorial opinion and not commercial speech. Therefore, Hoffman, being a public figure, must prove that the publication acted with actual malice, or with knowledge or reckless disregard that the photograph was false. In other words, Hoffman had to show that the magazine intended the readers to believe that when they saw the altered photograph, they were seeing Hoffman's real body.

In addition to showing the unaltered photograph, the magazine described the fact that they had digitally altered famous images using computers. According to the court, it was clear to the readers that the actors did not pose for these pictures wearing the 1997 fashions. This case confirms that photographs are protected as expression under the First Amendment, and if used in an editorial context that is not false, do not require permission from the subject.

The Estate of Diana Princess of Wales and the Diana Princess of Wales Memorial Fund brought an action in California federal court against the Franklin Mint seeking damages based on the use of her name and likeness on commemorative jewelry, plates, and dolls, and the advertisements for these products. The action was based both on California's Right of Publicity law and federal trademark law. The district court denied all claims and awarded the Franklin Mint attorney's fee. The Fund, not pleased with such a result, appealed to the Ninth Circuit.

The Franklin Mint had been selling unauthorized products years before Princess Diana's death in 1997, and continued thereafter. Shortly after her death, the Fund commenced a claim in California, which recognizes post-mortem

rights of publicity. However, in applying choice of law rules (the jurisdiction whose law should be applied in the case) the California court concluded that the law of the decedent's domicile controlled. Since British law does not recognize a right of publicity, there was no basis for a claim. The court also concluded that the Fund did not have a claim against Franklin Mint under the Lanham Act for false endorsement.

California amended its post-mortem right of publicity law and added language extending the statute to all cases in which the liability or damages arise from acts occurring within the state. Seizing an opportunity, the Fund reinstated its claim against the Franklin Mint, based on the revised publicity statute. Nonetheless, the Ninth Circuit maintained that the amendment was not a choice of law provision requiring the application of California law and continued to view British law as the appropriate choice of law and denied the claim. Because the California Right of Publicity Statute permitted the court to award attorney's fees to the prevailing party, the Franklin Mint was entitled to the award of attorney's fees.

This case is significant in that it resolves a dispute regarding the reach of the California post-mortem publicity statute, confirming that you must look at the law where the deceased person lived. This is particularly relevant if the deceased lived in New York prior to death or in the UK where post-mortem publicity rights are not recognized.

20 RIGHTS OF PUBLICITY AND PRIVACY:

NEW YORK CASES

New York has no common law right of privacy or publicity. The right of privacy is limited to section 50 and 51 of the New York Civil Rights Law. This statute has always been broadly interpreted in favor of publishers and is narrowly construed to uses of photographs without consent for purposes of advertising and trade. An example of this is the case of *Messenger v. Gruner & Jahr Printing and Publishing*, in which the New York State Court of Appeals (New York's highest court—the Supreme Court is the lowest court) interpreted New York's Right of Privacy Law, Sections 50 and 51 of the New York Civil Rights Law, with respect to use of photographers for a newsworthy purpose.

The plaintiff, a teenage girl and minor, consented to be photographed for the magazine *Young and Modern* (YM) published by Gruner & Jahr. No legal consent was obtained from her parent or legal guardian. The photographs were published as an illustration for a column entitled "Love Crisis" which began with a letter to the editor-in-chief from a fourteen-year-old girl identified as "Mortified." A pull-out quote in bold type above the column states "I got trashed and had sex with three guys." The letter details a teenager who got drunk at a party and had sex with her eighteen-year-old boyfriend and two of his friends. The editor-in-chief wisely responds and tells "Mortified" that she should avoid that situation in the future and should see a doctor for a pregnancy test and to be tested for sexually transmitted diseases. Three full-color photographs of the plaintiff illustrate the article.

The plaintiff brought an action in the District Court for the Southern District of New York, alleging that the magazine violated Sections 50 and 51 of New York Civil Rights law that prohibits the use of one's picture for purposes of advertisement or trade without written consent. The magazine moved to have the case summarily dismissed, arguing that it could not be liable as a matter of law because the photographs were used to illustrate a newsworthy column, and that the photographs had a real relationship to the article and it

was not an advertisement in disguise. The teenager argued that the newsworthy exception should not apply because the column and the photographs gave the false impression that the teenager in the photograph was the author of the letter. The district court agreed and the jury awarded $100,000.

Upon appeal, the Second Circuit certified the New York Court of Appeals to answer a question involving its New York State Civil Rights Law since it was a state statute and procedurally appropriate for the state and not the federal court to interpret it. "May a plaintiff recover under Sections 50 and 51 where the defendant used the plaintiff's likeness in a substantially fictionalized way without the plaintiff's consent, even if the use is in conjunction with a newsworthy column?" Fortunately for the photography industry, where the editorial use of images has relied on the newsworthy exception under New York Law, the answer was in the negative. As New York does not recognize any common law right of privacy, if a plaintiff cannot make a claim under Sections 50 and 51, they are out of luck.

The New York Statute has always been recognized as a limited right of privacy and has been very narrowly construed. In contrast, the newsworthy exception is broadly construed and includes actual events, political happenings, social trends, and any matter of public interest. The courts do not hold the public to a high standard when considering what is "of interest." If the picture is used to illustrate an article of public interest, there are only two conditions in which the publisher can be liable. One is if the picture bears no relationship to the article. The second is if the article is really an advertisement in disguise. For example, the prior New York case *Finger v. Omni Publishing* permitted the publication of photograph of a large family to illustrate and article about the effects of caffeine and in vitro fertilization even though none of the children were conceived through in vitro fertilization.

The plaintiff in the *Messenger* case argued that an action for violation of the right of privacy statute should still be permitted if the photograph and the article create a substantially fictionalized impression. The court rejected this argument and limited the analysis of whether the newsworthy exception applied to the two factors described above, specifically: 1) whether the photograph bears a real relationship to the newsworthy article; and 2) whether the article is an advertisement in disguise.

This case was followed closely by New York's large publishing community. Claims for violation of rights of privacy is an area of great vulnerability for photographers and stock agencies as well, even if they are careful and have "sensitive subject policies." The client may not always give enough information about the contents of the article that the photograph is intended to illustrate.

The photograph may be appropriate, but a caption such as "I got trashed and had sex with three guys" could make the use offensive to the person depicted.

While contract language can protect the image provider from liability for all claims arising out of the use of a photograph and require that the client may not use a photograph in any manner that is defamatory, if a model brings a lawsuit in this area typically all parties are included in the suit: the publisher, stock agency, and photographer. However, this decision greatly limits the ability of a model or person depicted a photograph to bring a successful claim for the use of a photograph that accompanies any article that is of public interest, no matter how offensive the use. Of course, this decision does not apply to the use of a photograph for purposes of advertising or trade. The importance of valid model releases when licensing photographs for commercial use is not changed by this decision.

When does the New York law apply? In the 2000 decision *Stewart v. Vista Point Verlag* brought by performance artist Jennifer Stewart, a federal New York Court refused to allow a right of publicity claim against two German publishers for publications that were primarily out of state. Ms. Stewart makes her living by "posing" as the Statute of Liberty in various public locations throughout New York City. After noticing Ms. Stewart while working, the German publishers sent a photographer to capture her image, and then used the photograph as the cover image of their German-language travel guidebook of New York. Ms. Stewart claimed this unauthorized was a violation of United States copyright law and of her right of publicity. She further claimed that, because the book was sold over the Internet and could be accessed by New York residents, the action could be properly bought in New York State. The court disagreed and dismissed her claim.

The court held that it did not have jurisdiction over the matter. The most important factors used by the court in making its determination were: (1) the fact that the book was marketed and sold primarily to German consumers; and (2) while the book was sold on the World Wide Web, the only book that had ever been purchased by a New York resident was purchased by the plaintiff herself for purposes of the litigation.

In *Cuccioli v. Jekyll & Hyde Metropol Bremen Theater Production Gmbh & Co.* in 2001, Judge Kaplan of the District Court in the Southern District of New York issued an opinion holding that in order to bring a claim for a violation of New York's right of privacy laws the alleged violation must have taken place in New York State. According to New York Civil Rights Law Section 51, New York's right of privacy laws only apply to violations existing "within [New York] state." Although the plaintiff established the court's jurisdiction over the

defendant, since the alleged violation was not sufficiently proven to have existed in the state of New York, the statute for violations of the right of privacy didn't apply and the case was dismissed for lack of a cause of action.

The plaintiff, Cuccioli, appeared in the Houston, Off-Broadway, and Broadway productions of the musical *Jekyll & Hyde* from 1995 to 1999. The defendant, a German company with its principal place of business in Bremen, Germany, was in the business of theatrical productions and related endeavors. In 1998, the defendant received a fax signing off on the use of the title treatment for *Jekyll & Hyde* and obtained the rights to produce the musical in Germany. In August 1998, the defendant's musical and art director wrote to the plaintiff enclosing samples of merchandise and stating "our logo is a combination of the tour logo and the Broadway logo. If you have a closer look at it, you will see that the face is yours!"

During the following month thereafter, the plaintiff's management firm demanded that the defendant cease and desist from using the plaintiff's image. In February 1999, the German production of *Jekyll & Hyde* premiered and in March 1999, the defendant signed an agreement with Polydor Records, GmbH, to release a compact disc of its German language cast recording of the musical. The logo, containing the plaintiff's image, appeared on the CD, on the back of the package liner, and on pages of the liner that offered other merchandise featuring the disputed image. The CD made its way to New York by the defendant's Web site and was also sold at stores. However, there was no evidence showing that the defendant was responsible for the CD reaching New York stores.

The plaintiff brought this action in March 2000 alleging that the defendant used the plaintiff's image in violation of New York Civil Rights Law Sections 50 and 51. The plaintiff requested damages and an injunction. Although the defendant asserted a lack of jurisdiction, Judge Kaplan found that the defendant satisfied the criteria for jurisdiction by transacting business in New York on a regular basis. In addition, the defendant asserted that the one-year time limit in which to bring a Section 51 claim had expired because it had been two years since 1998, the date when the use began. However, the Court held that the one-year period of Section 51 begins only at the date of first publication in New York. Thus, if Section 51 applied to this use, the one-year period began to accrue when it was first placed on sale in New York.

Although the Court found that it had jurisdiction over the defendant, the Court held that Section 51 did not apply to this use because there was no proof that the defendant was responsible for the sale of the CD in New York stores. Further, since the other way of obtaining the CD was through the Internet, violation of Section 51 could not apply to these sales because they did not

constitute an in-state use. Since no uses were found to have met the requirement of Section 51, there was no cause of action and the plaintiff could not receive damages for this claim.

This case notifies individuals that the one-year time limit begins on the date that the image is sold in New York. Further, a claimant in New York cannot collect damages on a use that constitutes a violation unless the use actually took place in New York. Sale of merchandise over the Internet has raised many questions about where a party can be sued and which jurisdiction's laws apply. This case demonstrates, in terms of the privacy law, a party cannot be liable in New York if it did not cause the unauthorized use to be made in New York. This case is important for all photographers and agencies who deal with commercial and stock photographs.

NEW YORK PRIVACY LAW AND STATUTES REGARDING THE SALE OF PHOTOGRAPHIC PRINTS

Photographers might wonder whether individuals they capture in their photographs without consent have any rights to that photo. Additionally, one might wonder if they had plans to use these photographs in one of their shows or exhibitions whether these non-consenting individuals have any rights to stop an artist from displaying the pictures. Can these photographs be licensed for editorial use without a release? What does a plaintiff need to prove to enjoin you from displaying your art? The 2006 case of *Nussenzweig v. DiCorcia* answered these questions.

Erno Nussenzweig, a Hasidic Jew from New York, claimed that the use of his likeness in a photograph displayed in defendant Pace Gallery and taken by DiCorcia violated his rights to privacy under Civil Rights Laws Sections 50 and 51. DiCorcia has been a professional photographer for over twenty-five years. Between 1999 and 2001, DiCorcia took a series of photographs on the streets in New York's Times Square in a particular location. After developing various photographs, he selected seventeen that would appear in his "HEADS" project. He did not seek or obtain consent to photograph any of the people whose likenesses were included in this collection. A photograph of Nussenzweig was chosen for this project, and was readily identifiable to others as the plaintiff.

The HEADS collection was exhibited at the Pace Gallery from September 6, 2001 to October 13, 2001. In addition to the exhibition itself, a catalog was published and distributed to the public to advertise the exhibition, and contained

reproductions of all the photographs in the HEADS collection, including that of Nussenzweig. In addition, the exhibition was open to the public and advertised and reviewed in local and national newspapers and magazines such as the *New York Times, Time Out New York,* and the *Village Voice. W Magazine's* September 2001 issue and *Art Forum International's* summer 2001 edition both published the photograph of the Nussenzweig from the HEADS collection. Pace Gallery sold all ten edition prints of the photograph, which went for between $20,000 and $30,000 each. Both Pace Gallery and DiCorcia claimed that the last print was sold in March 2003. However, Nussenzweig claimed, according to the opinion "shortly before he commenced this action, the photograph of him was still being offered for sale at the gallery."

Before determining whether the plaintiff had a valid claim against the defendant, the court had to settle a statute of limitations (SOL) issue. There is a one year SOL for actions brought under the Civil Rights Law Sections 50 and 51. This means that if a party brings a claim against another party after the one-year period has elapsed, that party is barred from bringing the claim and collecting damages. In this case, the court had trouble determining when exactly that one-year term should begin.

Defendant DiCorcia argued that the SOL begins to run from the first publication of the subject material, which was in 2001. If the SOL began in 2001 then the plaintiff Nussenzweig would be barred from continuing his quest for damages or get an injunction. Nussenzweig, however, contended that the SOL begins to run as of the date of the last publication, in which case he believed he was still able to assert his claim.

Depending on the jurisdiction, a court may use different rules in regards to the SOL. Nussenzweig relied on a New York case *Sporn v. MCA Records, Inc.,* and the "continuous wrong" doctrine which states that the SOL runs from the last wrong. Nussenzweig claimed that since there had been multiple republications of the photograph, each of which he considered to be a "wrong," he was within the one year SOL. In addition, he asserted that his attorney confirmed the availability of the photograph of himself for sale within the last year and therefore, he still had the right to bring this claim.

The court relied on other case law for the doctrine that the SOL on privacy claims begins to run from the first unauthorized use. This is commonly referred to as the "single publication rule." The court recognized, however, that *re*publication may set the SOL running anew, but then demonstrated how in this case the photographer's work had not been republished and therefore did not apply to the facts of his case. In order to be seen as a republication, the plaintiff had to establish that the gallery sells some alteration of the subject

matter or marketed to a different demographic or audience. Here, the minimal requirements were not present.

In the end, the court rejected all of the plaintiff's arguments, and his reference to the different SOL interpretations among the courts. The court also did not take into consideration the fact that the defendant was a Hasidic Jew, living in an Orthodox community, in which the print media that advertised defendant's exhibition were not generally circulated, demonstrating that the plaintiff would have had difficulty discovering the photograph within the one year statutory limit. The court did, however, go on to consider the merits of the case based on the fact that there was a split of authority among the departments in regards to the SOL.

In order to bring a privacy claim under the Civil Rights Laws, a plaintiff has to prove (1) use of plaintiff's name, portrait, picture, or voice, (2) for advertising purposes or for trade, (3) without consent, and (4) within the State of New York. Both parties agreed that elements 1, 3, and 4 are established in the case, but disagreed as to element 2, referring to the photographs used for advertising purposes or trade. The photographer claimed that the photograph was not used for "trade or advertising purposes," but that the photograph depicting the plaintiff was art which is not expressly within the privacy protections of the New York Civil Rights Laws. Additionally, DiCorcia believed that the photograph of the plaintiff could not run afoul of New York's privacy laws because it was constitutionally protected speech. Nussenzweig argued that the photographs were produced with the purpose to sell, and therefore constituted a commercial use actionable under the Privacy laws. The court went on to explain that the New York statutory right to privacy restricts the use of one's likeness ONLY against use for advertising and trade. The statute is interpreted strictly because it serves as a balance between a plaintiff's privacy protection and a defendant's right to free speech.

Consequently, if the photograph is considered art, then the plaintiff has no claim against the defendant for the use of a photograph with his likeness even though the defendant did not obtain plaintiff's consent. The court noted that in the past New York has been fairly liberal in its protection of what constitutes art. Nussenzweig's argument relying on the fact that the art was sold was previously decided in favor of the artist and not the subject depicted in *Hoeper v. Kruger*, where the court held that "art can be sold, at least in limited editions and still retain its artistic character." The fact that the photographer obtained profits from his photographs of Nussenzweig and other individuals did not cause the court to conclude that the photograph was used for trade purposes.

The court instead explained how the HEADS photographs were not used to advertise anything but the HEADS exhibition itself. In addition, only a limited number of the photographs were sold for a profit. The profit motive of the selling institution was not relevant to the court. Although Pace Gallery is not a not-for profit museum and has an objective for financial profitability, this factor alone does not convert the art sale into a trade use. Although the court expressed sympathy for the plaintiff and recognized his distress as to the fact that a photograph bearing his likeness was spiritually offensive, the court found that the photographs in defendant's exhibition were considered art and not subject to Sections 50 and 51 of the Civil Rights Laws.

This case confirms that a photographer has broad rights when it comes to creating art and whom they choose as a subject. As long as there is limited sale of art prints, an individual whose likeness is the subject of the photograph cannot prevent the photographer from displaying the picture is an exhibition, catalog, etc. In connection with the sale and exploitation of art prints, a photographer's First Amendment right to free speech outweighs the individual's right to privacy. A photographer is free to advertise his or her work in order to bring the public in to view his or her work and can not merely use the work for advertising purposes for other than the sale of the art without a release.

INCIDENTAL USE

If the photograph is used for what is considered editorial, for example, to illustrate an article, book, or documentary that is newsworthy or of public interest, the publication will not violate anyone's rights of privacy or publicity if it is published without a release. This is the case even though the person in the photograph is not the subject of the article. It is enough that there is some relationship between the article and the image. The image may be used to advertise the particular article, book, or documentary, without violation of the right of privacy or publicity as well. For example, if a book on the life of Marilyn Monroe had a photograph of her on the cover, the publisher could advertise the book by showing a copy of the book including the cover, without violating the rights of her estate. This advertising use is considered "incidental use." It is important that the subject on the cover relates to the subject matter of the book, and is not used decoratively just to sell the book. Under the same theory, photographers and image libraries can display in catalogs or on their Web site examples of the work in their collection if it is available for publication.

21 AVOIDING CLAIMS BASED

ON RIGHTS OF PUBLICITY

It is important to get clear comprehensive releases from living people and authorizations from estates before licensing images of people for commercial purposes. Photographers should be cautious when granting rights to images involving recognizable people or deceased celebrities for commercial purposes unless the proper release is provided.

This extends to non-celebrities as well. The New York case *Doe v. Merck* involving an advertising brochure illustrates this point. The brochure seemed straightforward, with a picture and some text. The text described the woman pictured, "Maria," as a nineteen-year-old mother of two small children, ages eighteen months and three years. It said she had been treated for AIDS for at least two years and was also diagnosed with recurring herpes. However, Merck, the pharmaceutical company, along with its advertising company, were not so straightforward. The model's name was not Maria, and the alleged nineteen-year-old mother was really in her thirties. She was a suburban housewife and mother who had contracted the HIV virus from her husband. She never had herpes and was never sexually promiscuous.

In order to promote the sale of its new drug, Crixivan, the company created and published a brochure titled "Sharing Stories," along with a flip chart called "Getting the Facts." Merck took it upon itself to use "Maria's" picture alongside a fictitious biography of her. The model, when recruited by the modeling agency hired by Merck, was told that her image would be used for "educational purposes" only. Merck claimed that its use was educational because the brochure compiled the information of a number of people who had used the drug. Upset by this use, the model sued Merck for defamation. The court found Merck liable for defamation because it had knowingly published her picture along with a fictitious biography and medical history. The model claimed that the ad, in its entire context, made her seem promiscuous.

Because New York libel law requires an offending statement to be viewed in its full context, the court agreed with her. Under New York Civil Rights Laws Sections 50 and 51, the model asserted a limited right to privacy, which makes it a misdemeanor to use a person's name or photo for advertising purposes without their written consent. In court, the judge agreed that the Merck brochure was clearly for advertising purposes. Merck had apparently forgotten to get releases from the models to portray them as real people. A release limited for educational purposes cannot be used for advertising, even if the advertisement imparts educational information. This case demonstrates the risks associated with licensing images without a release for broad purposes.

At trial, the jury awarded over $3 million in damages to the plaintiff. This sum included compensatory and punitive damages to be paid by both defendants, Merck and the advertising agency responsible for compiling the brochure. The defendants appealed, and the Court modified the damages. Generally, damages are left to the discretion of the jury, but may be modified when the plaintiff has failed to introduce sufficient evidence to authorize the jury verdict. Here, the Court agreed that the plaintiff was not entitled to punitive damages at all, and was entitled only to a reduced award for compensatory damages.

In order to justify an award of punitive damages in a New York right of publicity case, a plaintiff must show that the defendant acted maliciously or with an evil and reprehensible motive resulting in a conscious disregard of the rights of the plaintiff. Here, the defendants' actions, while careless or negligent, did not rise to the level of "hatred, ill will, [or] spite" to establish malice. Thus, punitive damages were not an appropriate remedy and the New York Court vacated the jury's $2 million award.

Next, the Court examined the extensive testimony given at trial regarding the effect defendants' actions had on the plaintiff in order to evaluate the jury award of $1 million for compensatory damages. Compensatory damages are awarded as a remedy for the plaintiff's pain and suffering. Here, there was ample evidence regarding the plaintiff's mental state and the effect the brochure had on her, but the evidence was not persuasive enough to support the jury's large award. Consequently, the Court reduced the award to $650,000.

Aside from demonstrating the need for full releases, this case exemplifies the tendency for juries to grant large awards based on passion or prejudice. Here, the Court applied a legal evaluation to arrive at a more reasonable verdict. However, this is not always the case, and a sympathetic plaintiff may be very successful at trial and win an appeal. This case was the result of the errors arising from a lack of centralized supervision of a project, where various

employees "passed the buck" and never received a signed, valid model release, and it is difficult to argue that the plaintiff did not really suffer from this type of publicity. Therefore, it is of the utmost importance to ensure that each and every model signs a release, because $650,000 is far too much to pay for carelessness.

However, New York courts will reduce jury awards that are excessive. In mid-2005, a district court judge dismissed 2004 French Open champion Anastasia Myskina's $8 million claim for damages against *GQ Magazine*, its publisher Condé Nast, and photographer Mark Seliger. The judge ruled that Myskina's rights were not violated after topless photographs of the tennis star were published in 2004. Myskina insisted that she did not understand the photo release form she signed and was not fluent in English at the time of a 2002 *GQ Magazine* photoshoot on female tennis players. She had agreed that topless photographs could be shot if they were not published. However, without allegations based on fraud, duress, or other wrongdoing, the judge ruled that not understanding the contract does not excuse Myskina from its terms.

Back in California, a jury convicted photographer John Rutter of felony charges of forgery, attempted grand theft, and perjury for a scheme involving the sale of topless photographs of the nineteen-year-old movie actress Cameron Diaz taken in 1992. The photographer admitted that in 2003 he asked Diaz for $3.5 million for the photos or he would sell them to other buyers. However, Rutter insisted he was offering Diaz the right of first refusal and not blackmailing her. Rutter also agreed that Diaz's signature appeared to be forged on a model release form, but he said he did not forge her signature. Characterizing the case as a "misunderstanding," Rutter stood for sentencing in Los Angeles Superior Court.

In a maneuver the judge said displayed "criminal sophistication," it turned out Rutter did attempt to sell the photos back to Ms. Diaz for $3.5 million on top of a forged release. While he claimed he "never intended to do any harm," Rutter conveniently waited for the budding starlet to hit the big time before approaching her. He then tried to defend himself with a bogus release signature he had lifted from an autographed publicity shot of Ms. Diaz. Rutter was sentenced to three years and eight months in prison.

RELEASES FOR ANIMALS

Many photographers ask if a model release is necessary for photographs of non-humans, such as a dog, cat, frog, etc. The answer is almost never. Model releases are required if using a photograph of a recognizable *person's* likeness for

commercial purposes, such as advertising or trade. It is either based on common law tort theory such invasion of privacy or misappropriation of one's likeness for commercial use, or based on various state statutes that recognize a right of publicity for living or, in some states, even a deceased person's likeness.

The common element is that these theories apply to a *person*–not any inanimate object, building, corporation, bird, reptile, or animal (no matter how cute). The underlying principle is only a person can be embarrassed by the publication of his or her image. The exception would be if the animal (dog or race horse, etc.) were a recognized character, such as a movie or TV character. (Think Lassie, the parrot from Baretta, Secretariat). Then there might be a trademark claim, based on the argument that the commercial use by an unlicensed entity might cause confusion as to sponsorship or interfere with an already licensed user. A person's common pet would not be a trademark.

ADVERTORIAL

Photographs are also used for "advertorial" purposes. This is not the same as "editorial," and requires a release. It is essentially an advertisement in disguise, intended to look like an article within a magazine to capture the reader's attention. But the purpose of the use is to promote the advertiser's product or service, and the client should expect to pay more than the usual editorial use rates.

"Advertorial" is a word made up by advertisers to fool readers into reading advertisements. Often, the user will wish to negotiate lower rates than standard advertising from copyright holders for these uses. Nonetheless, it is advertising use and not editorial no matter how you try to disguise it. Editorial use of an image is limited to the use of an image to illustrate something that is newsworthy or of public interest. No release is required and the First Amendment protection of free speech permits the truthful publication. If an article is really imbedded in a section that is paid for by one sponsor or entity, even if it is a not-for-profit, the article is there to promote the sponsor's business or service. In those situations, you do not have the presumption of a journalist's independent reporting. A case that illustrates this point well involved an historic photograph of surfers used in an article about surfing that taught us fame may not be nearly as fleeting as we had once thought it to be.

Legendary surfers George Downing, Paul Strauch, Rick Steere, Richard Buffalo Kealana, and Ben Aipa (the "surfers") know this, as the Ninth Circuit court found in *Downing v. Abercrombie & Fitch*, that pictures of the men, which clearly identify them, used without their permission in a catalog, violated their

right to publicity under California law. The court further rejected the idea that the state law claim of right to publicity or the federal Lanham Act claims were preempted by the federal Copyright Act, or that the use was protected as free expression under the First Amendment. The surfers found their picture in an Abercrombie & Fitch subscription catalog known as the *Abercrombie and Fitch Quarterly*. The Quarterly is Abercrombie's largest advertising vehicle, accounting for 80 percent of the company's overall advertising budget. Approximately one quarter of the publication was devoted to editorial pieces, while the balance featured models wearing the clothing retailer's garments.

When Abercrombie decided on a surfing theme for an issue of the *Quarterly*, they came across photographs in a book that surfing photographer LeRoy Grannis took at the 1965 Makaha International Surf Championship in Hawaii. Abercrombie purchased the photographs from Grannis for use in its catalog, and Grannis then hand-wrote the names of the surfers at the bottom of the photograph. Abercrombie did not seek permission from the surfers to publish the photographs. The pictures of the surfers made it into the Spring 1999 *Quarterly* in a section entitled "Surf Nekkid." This section contained several articles, one recounting the history of surfing and a story entitled "Your Beach Should Be This Cool." Following the articles were two pages of what Abercrombie labeled its "Final Heat Tees." These shirts were exact copies of the shirts the surfers wore in that picture. The surfers argued that the photograph violated their right to publicity under the California publicity statute (section 3344 of the California Civil Code) and common law. Abercrombie defended its use of the image by arguing that the photograph merely illustrates an article about surfing, a matter in the public interest. If a matter is found to be in the public interest, a cause of action for the right to publicity will be barred. The court, however, rejected Abercrombie's argument.

The court pointed out that the articles in the *Quarterly* made no mention of the surfers—that Abercrombie made no mention that the men were surfing legends, which makes it unlikely that the pictures were used in the public interest. Instead, the court found that the way Abercrombie used the surfers' picture does not contribute significantly to a matter of the public interest, and that Abercrombie violated the surfers' right to privacy by using their image as window dressing to advance the catalog's surf theme. Abercrombie then argued that this right to publicity claim should be preempted by the federal Copyright Act. In order for a state law claim to be pre-empted by federal copyright law, the content of the protected right must fall within the federal Copyright Act. Where a photograph is subject matter that may be protected by the Copyright Act, the publication of the photograph itself is not the basis for a right of publicity claim.

Rather, a right of publicity claim focuses on the use of the surfers' likeness and their names in the published photograph. While the photographer owns the copyright to the photograph, the individuals depicted in the photograph retain a right to their identity or "persona." Therefore, the individuals depicted in the photograph can maintain a claim outside of the Copyright Act.

Further, although five of the surfers resided in Hawaii, which has no comparable publicity statute, the court nevertheless applied California law, finding that Hawaii wouldn't wish to restrict its residents from recovery that others could obtain in California. Because the catalog was distributed in California, California could enforce its laws within its borders. The surfers had also brought a Lanham Act claim, which the lower court had dismissed. California courts recognize that celebrities may have a trademark type claim if the use of their identify causes confusion as to the endorsement of goods or services. The appellate court found that there was sufficient factual basis for the claim and that it should not have been dismissed prior to trial. This case illustrates the difficulty in licensing photographs for "editorial" use in a magazine that is predominantly an advertising vehicle.

Generally, if there is some relationship between a newsworthy article and the photographs, the use of the photographs will be considered editorial, even if the article is not directly about the subject of the photograph. However, in this case where the vehicle for the articles was an advertising publication for one product, rather than a magazine or newspaper that contains advertising pages for many products, the standard was much more stringent, requiring that the article directly relate to the photographs in order to contribute to a matter of public interest.

The producer of the catalog most likely believed that this was an editorial use before this decision. It is important to ask questions when a company not in the traditional news media requests a photograph for editorial use. It may be a better policy only to supply model-released images for such users to avoid having to make a judgment as to whether the photographs serve a public interest. Any license agreement should require that the user indemnify from any claims regarding the use of the photographs.

22 DEFAMATION

In some cases, the image may not be objectionable but the caption accompanying the photograph may be defamatory and give rise to a claim for defamation or invasion of privacy. A photographer or image library can limit its liability in this area by including language in its invoice that it is not responsible for any defamatory use of the images submitted. It is probably also good practice to request from the client the caption that will accompany the photograph and the nature of the article or book the photograph is to illustrate to avoid licensing images for uses that could be considered defamatory.

In *Amrak Productions, Inc. v. Morton,* Madonna's former bodyguard and ex-lover brought a defamation action against the author and publisher of a Madonna biography, based on an incorrect photo caption within the book that identified him in the photograph when in fact the person was a back-up dancer and outspoken homosexual.

Defamation is a reputational tort that is brought against anyone who publishes a false, defamatory statement of fact, concerning the plaintiff. If it is against the publisher, the publisher must be guilty of some level of fault and the plaintiff may have to demonstrate some harm. To succeed, the plaintiff must prove that the statement is false *and* suggests some moral opprobrium (a big word for disgrace). What is considered defamatory can vary from community to community and can change over time.

The plaintiff in this situation, *AmrakProductions, Inc.*, employed James Albright as a professional bodyguard for the popular singer Madonna from January to July 1992. During that period, Albright and Madonna became romantically involved and remained in a relationship until 1994. In December 2000, author Andrew Morton contracted with Albright for information on his relationship with the singer for use in new biography he was writing on Madonna. Morton's book *Madonna* was published in 2001 by St. Martin's Press in the United States and O'Mara Books in the United Kingdom. Chapter 11 of the book detailed Albright's relationship with Madonna.

Accompanying the text are forty-eight pages of photographs. In the photograph that resulted in the defamation claim, Madonna is with two men. The man to her left is wearing "black pants, a black and white shirt, a black leather jacket, tinted sunglasses, a necklace, and an earring." The caption goes on: "Madonna attends ex-lover Prince's concert with her secret lover and one-time bodyguard Jimmy Albright (*left*). Albright, who bears an uncanny resemblance to Carlos León, the father of Madonna's daughter, enjoyed a stormy three-year relationship with the star. They planned to marry, and had even chosen names for their children."

The photograph was subsequently reprinted in *People Magazine*, published by Time Inc, on November 12, 2001, and *News of the World*, published by News Group Newspapers, Ltd., on March 17, 2002.

However, the man in the photograph was in fact José Guitierez, a back-up dancer for Madonna, whom Albright identified as an "outspoken homosexual" who "often dressed as a woman" and took part in "homosexual, sexually graphic, lewd, lascivious, offensive, and possibly illegal" conduct. As a result of the miscaptioned photograph, Albright and Amrak brought a defamation suit against the author Morton, and all the publishers of the photographs including Michael O'Mara Books, Michael O'Mara, St. Martin's Press, Time Inc., and News Groups Newspapers, Ltd. The action was brought in the federal court located in the District of Massachusetts for defamation, invasion of privacy, negligence, negligent and intentional infliction of emotional distress, and violation of other Massachusetts statutes.

It is always a question for the court and not a jury whether a statement is capable of having defamatory meaning. The District Court dismissed all claims against the author and publishers. As is typical, the bodyguard and his employer appealed the decision. The lower court had dismissed all the claims for two reasons. First, the court held that no reasonable view of the photograph and text suggested that Albright was a homosexual. Second, the court continued, being labeled as a "homosexual" is not inherently defamatory. This view considered recent cases from 2003, such as *Lawrence v. Texas*, where the United States Supreme Court invalidated a Texas statute that criminalized same-sex sexual relations, and *Goodridge v. Department of Public Health*, where the Massachusetts Supreme Judicial Court extended marriage to same-sex couples. Accordingly, since Albright could not prove his defamation claim, all the derivative claims were dismissed.

The appeals court also dismissed the bodyguard's lawsuit but for different reasons. To succeed in his defamation suit, Albright had to establish both 1) that the defendants published the false statement; and 2) that the statement was

capable of damaging the plaintiff's reputation. As mentioned, the first question a court asks is if the statement in question can have a defamatory meaning. A defamatory meaning holds the plaintiff "up to scorn, hatred, ridicule, or contempt" in a "considerable and respectable segment in the community." In addition, Massachusetts requires that allegedly defamatory photographs or headlines must be considered with the entire publication. Or, in this case, the court must consider not only the photograph and caption as being capable of defamatory meaning, but the entire biography as well. The court will dismiss a defamation suit when the published statement cannot be construed as defamatory against the plaintiff.

The appeals court held that the miscaptioned photograph was not capable of defamatory meaning for two reasons. First, nothing in Guitierez's appearance in the photograph, and the caption mentioning Albright's relationship with Madonna, indicate that Albright is homosexual. Few, if any, average readers in the community would fall into the narrow category of disliking homosexuals and following Madonna's life closely enough to know that Guitierez is gay yet not closely enough to recognize Guitierez or Albright. Second, when considering the entire text, as required in Massachusetts, of the biography that contains an entire chapter on Albright's relationship with Madonna, no average reader would conclude that Albright is homosexual. Since the threshold question of defamatory meaning was not met, the appeals court did not rule on the district court's holding that labeling a person as "homosexual" is inherently defamatory in Massachusetts.

While photographers may be required by contract to represent that the photo captions are accurate, mistakes can happen, particularly in naming the lesser-known individuals that accompany celebrities. In most situations, a mistake will not harm the reputation of the individual. It is helpful to have a decision in writing that makes it more difficult to assert that one has been defamed merely by being misidentified as a homosexual. It is to defend these types of claims that error and omissions insurance is important for both photographers and photo libraries.

DISCLAIMERS

At one time, the conventional wisdom was that a disclaimer with a photo could save a publisher or photographer from a defamation claim. In *Stacey Stanton v. Metro Corporation*, Stacy Stanton, a student, claimed that publication of her photograph in connection with an article on teenage sexuality defamed her under Massachusetts law and constituted an invasion of privacy.

In May 2003, *Boston* magazine printed an article by Alexandra Hall on sexuality and promiscuity among Boston area teenagers. The headline of the article read "The Mating Habits of the Suburban High School Teenager." The basic premise of the article was that high school students over the last few years have become sexually active and promiscuous—shunning committed relationships in favor of "casual sex" and random hook-ups. The article stated that the author based her story on recent studies on teenage sexuality, statistics on teenage sexual activity and substance abuse, and months of interviews with students from high schools in the Boston area. A large photograph accompanied the article. The photograph shows five students at a prom, boys in tuxedos and girls in formal dresses. Three of the students are smoking cigarettes and one is drinking from a plastic cup. Plaintiff is looking at the direction of the camera with an apparently friendly expression. Her face and a portion of her body are clearly visible. She is wearing a black sleeveless dress and is neither drinking nor smoking. On the same page as the photograph, beneath the headlines and initial text, was the following caption and disclaimer:

The photos on these pages are from an award winning five-year project on teen sexuality by photojournalist Dan Habib. The individuals pictured are unrelated to the people or events described in this story. The names of the teenagers interviewed for the story have been changed.

The statements were italicized and printed in the smallest font on the page. Stacy Stanton was not named anywhere in the article. Stanton filed a complaint for defamation and invasion of privacy in state court against the publisher of the magazine. The case was subsequently removed to federal court. Stanton stated that she "was not the subject of," nor did she participate in "an award winning five-year project on teen sexuality by photojournalist Dan Habib" and that she "never authorized the use of her photograph in conjunction with that project."

The complaint further alleged that 1) she was defamed by defendant because the juxtaposition of her photograph and the article insinuated that she was a person engaged in the activity described in the article and the language of the caption falsely insinuated that plaintiff was part of an award winning five-year project on teen sexuality; and 2) that the publication of her

photograph in conjunction with the article amounted to an invasion of her privacy and portrayed her in a false light in violation of Mass. Gen. Laws ch. 214§1B. Stanton claims to have suffered damages in the form of harm to her reputation and sense of personal dignity, humiliation, and emotional pain and mental anguish.

In order to maintain an action for defamation under Massachusetts law, a non-public figure such as the plaintiff must allege facts to show four elements: 1) the defendant made a statement "of and concerning" the plaintiff to a third party; 2) the statement was defamatory, meaning it could damage the plaintiff's reputation in the community; 3) defendant was at fault in making the statement; and 4) the statement either caused the plaintiff economic loss or is actionable without proof of economic loss.

Stanton contended that the defendant made two separate defamatory statements. First, she claimed that by juxtaposing her picture and the article, the defendant improperly insinuated that she engaged in the conduct described in the article. Second, she claimed that the language of the italicized caption improperly suggested that she was part of an award winning project on teen sexuality.

The publisher disagreed and argued that the challenged publication was not "of and concerning the plaintiff" and is not reasonably capable of a defamatory meaning because the photograph does not portray plaintiff engaging in improper behavior; the accompanying article describes a variety of behavior, not all of which is misconduct and none of which is ascribed to the plaintiff; and the disclaimer expressly stated that the individuals photographed are unrelated to the events in the article.

The ultimate issue became "would a reasonable reader make a connection between the photograph and the statements." The Court began by considering the juxtaposition of the photograph and the text. The Court stated that while it was true that the article didn't ascribe any particular form of sexual misconduct to the plaintiff, it was difficult to avoid the inference that the person depicted in the photograph had engaged in some form of sexual misconduct, and the court agreed that *based on the juxtaposition alone*, a reasonable reader could conclude that the teenage girl depicted in the photograph is sexually active and engages in at least some form of sexual misconduct. However, this juxtaposition was tempered by an important factor—the presence of a disclaimer.

Although the court expressed sympathy for the plaintiff and noted that in general a disclaimer does not present an absolute barrier to a plaintiff's ability to state a defamation claim, they ultimately found the presence of this particular disclaimer to override any claim of defamation. The publication

included a disclaimer stating that the "*individuals pictured are unrelated to the people or events described in this story.*" According to this court, the presence of the disclaimer directly contradicted the otherwise defamatory connection between the photograph and the text. It stated that the individuals photographed are "unrelated" to people and events in the story. Although the disclaimer was inconspicuous, it was not unreadable or buried in fine print. It appeared on the first page of the article, not in the back pages and it was positioned near the attention-grabbing headlines and lead photograph. The court concluded that the disclaimer adequately negated the defamatory connotations about plaintiff otherwise arising from the article and photograph.

Then came the later decision on appeal. Judge DiClerico of the U.S. Court of Appeals for the First Circuit reversed the lower court's order and put Stanton's defamation claim back on its feet. Considering the rules of defamation require, among other things, that the statement be "of and concerning" the plaintiff, it seemed the disclaimer should have been enough to protect the defendant—or so the defendant publisher thought.

Judge DiClerico began by setting out the basic premise of a defamation suit. When examining a determination to dismiss a case, the standard requires that a court should dismiss if it is apparent beyond doubt that the plaintiff can prove no set of facts in support of his claim that would entitle him to relief. As it relates to this defamation claim, this means that the plaintiff must raise at least a question as to whether the defendant was at fault for the publication of a false statement of and concerning the plaintiff, which was capable of damaging his or her reputation in the community.

Below, the court held that because of the disclaimer, the article could not be held to be reasonably susceptible of a defamatory meaning. In examining whether the article and photo could subject Stanton to scorn or contempt, the District Court concluded that any reasonable person would have read and heeded the disclaimer as it was on the first page of the story.

Apparently, this disclaimer was not sufficient on appeal and Judge DiClerico mercilessly picked it apart. Pointing out the type was smaller than and sandwiched between the adjacent text of the byline and the story, the Court of Appeals found the disclaimer might be overlooked or not even read in its entirety by a reasonable reader. The question remained as to whether readers would remain under the impression that Ms. Stanton had some connection to the accompanying story. The publisher argued that the number of readers who would ignore the disclaimer would be few. In answer, the court thought that the same readers who may hold that mistaken impression may in fact amount to a "considerable and respectable class of people" who would

conclude the article discredited the plaintiff. The court correctly asserted that a plaintiff is not required to demonstrate damage to her reputation in the community at large or among all reasonable people since defamation is not a question of majority opinion.

The publisher countered that while this may be true, those who would arrive at the defamatory conclusion would be unreasonably misunderstanding the photograph's relationship to the article. In response, the court relied on a Supreme Court ruling that held "a writing is a libel if, in view of all relevant circumstances, it discredits the plaintiff in the minds, not of the court, nor of wise, thoughtful, and tolerant men, nor of ordinary reasonable men, but of any considerable and respectable class in the community." In other words, the standard is more akin to that of a typical magazine reader skimming headlines and scanning photos. In conclusion, with support from a study concerning the haphazard reading habits of magazine readers, the court found that enough people would have overlooked the disclaimer. Certainly, the court gave the disclaimer a rigorous treatment, but wouldn't go so far as to say that a disclaimer never saves an article or statement from being defamatory. However, the court is saying that a reasonable reader could overlook the one in question.

Moving on to the "of and concerning" factor, the Court of Appeals held that the photo adjacent to the article without a disclaimer could lead a reasonable reader to conclude that Ms. Stanton is sexually active and engages in at least some form of sexual misconduct. Going one step further, the court held that even with the disclaimer, one needn't necessarily come to the conclusion, as a matter of law, that the article is not "of and concerning" Stanton. As with the analysis concerning the defamatory meaning of the article, a defamatory comment is made of and concerning the person if the reader connects it to them correctly or even mistakenly but reasonably. Again, as with the previous analysis, the court holds that while the jury may ultimately find for the defendant, the disclaimer is not foolproof as a matter of law against the reasonable, albeit incorrect impression among a considerable number of readers that Ms. Stanton is the subject of the damaging statement. The court further held that while the article drew no literal connection between the article and Stanton, a jury may be able to find that the publisher was negligent in publishing the article, which could reasonably be interpreted to refer to the plaintiff.

The court refused to put much stock in the publisher's defense that even if readers could draw a connection between the story and Stanton, the article did relate some wholesome teen attitudes. The publisher argued that parts of the article couldn't possibly be read to be harmful to the reputation of the subjects as

they related innocent activities including "attending a school prom ... abstaining from sex ... vowing to avoid abusive relationships." Judge DiClerico thought this was an overly generous reading of the article and put this small portion of the article in perspective. Stating that the determination of defamatory meaning should consider the article as a whole, the court found the article clearly sensational and nearly exclusively concerned teenage sexual misconduct.

The publisher also unsuccessfully argued that the article made no "articulably false statement." Generally, unverifiable statements of opinion will not be actionable. For instance, calling someone "greedy, corrupt scum" will not be actionable because the meaning of the words is imprecise, hyperbolic, and open to interpretation. However, accusing someone of "accepting thousands in money bribes from convicted murderers" could be subject to verification and thereby defamatory if false. With this distinction in mind, the court found that it wasn't necessary that any of the specific instances of promiscuous behavior be ascribed to Stanton. Historically, general allegations of promiscuity are enough for a defamation claim, while statements of specific acts are not required.

These findings add up to the court's ultimate conclusion; if a reader understood Stanton was one of the teens engaging in the hi-jinx illustrated in the article, which the court thought a reasonable outcome, "it would tend to hold her up to scorn, hatred, ridicule, or contempt in the minds of a considerable and respectable segment in the community." The court acknowledged that other readers might not come to that conclusion, yet as long as the reasonable possibility a defamatory meaning imputed to Stanton existed, a jury would have to make the ultimate decision. As a result, dismissal would be improper at this point in the game. As with any case at this stage, the final determination as to liability remained open. The court closed by reiterating that the holding merely observes that the standard for dismissal has not been met, and that the questions should go before a jury. This means that an expensive jury trial is necessary and with it the risk of an unfavorable judgment, not what any defendant wants to hear. This makes it more likely for this type of case to settle as a result.

How should publishers or photographers protect themselves from defamation claims going forward? A broad model release would of course prevent a defamation action from going forward. However, many editorial articles are illustrated with images that do not have model releases. It may have been that the subject matter of teen sexuality was too sensitive for this court. It appears that disclaimers need to be addressed to the superficial reader who would misunderstand the connection between the article and

the photographs. A publisher who wants to illustrate a sensitive article with unreleased images should put a *prominent* disclaimer with *each* picture. I would not limit it to a line by the title in the event a reader only looks at the images and not the title. If you cannot avoid seeing the disclaimer, there could be no argument that it might be overlooked. In other words, be *obvious*.

CONCLUSION

Copyright, right of publicity, and trademark issues will continue to affect the image licensing industry in the future. Copyright laws in particular are under attack as Internet users have a greater expectation that content found online is available for use. Photographers will need to work with their trade associations to support protection of copyright and other measures. Trade associations can be instrumental in creating change at the legislative level.

Proposed legislation currently before Congress seeks to address issues of liability for users of works that may be subject to copyright, but because the owner may be unknown, permission is difficult to obtain. These works, commonly referred to as "orphan works," include a large number of images still within the copyright term of protection—the life of the author plus seventy years. Unfortunately, works of visual art, such as photographs, are the most prone to being thought of as "orphaned." This is because even living owners who continue to exploit the artwork may not be credited (a common malady associated with photography), and the number of photographs created and distributed by a photographer can be vast. Consequently, historians and scholars have difficulty locating the owners of many works when they attempt to seek permission before publishing.

It is likely that photographers and illustrators, whether required by the Copyright Act or not, will have to work with their respective trade associations and the Copyright Office to develop systems to make themselves easier to locate. While registration of works remains important, to date, deposits made at the Copyright Office are not searchable. However, emerging technologies (and funding) may make new works deposited with the Copyright Office searchable going forward. Other organizations and entities may develop registries of images in thumbnail form that would assist would-be users of orphaned works in finding the copyright owner or representative by matching the unknown work to a thumbnail version of the image.

Copyright enforcement is another important issue. Having copyright protection as a right under law is meaningless if the tools to enforce the right are prohibitively expensive. The cost of copyright litigation can easily exceed the amount of damages that may be awarded, particularly if attorney's fees cannot be recovered because the photograph was not registered prior to infringement. There has been some discussion by the Copyright Office of

looking into a system to enforce claims under a certain amount where the copyright owner is seeking a license fee.

Again, trade associations have been active participants in articulating these issues and shaping the strategies that will protect the copyright interests, as well as the other legal interests, of their members. The Picture Archive Council of America (PACA) mission is comprehensive, encompassing education to advocacy. This organization supplies a place for its members who are involved in image licensing to come together to share information about the licensing industry, keeping its members abreast of the issues that face them daily. PACA has been instrumental in copyright education for its community, making life easier (and more profitable) for contributing artists and libraries alike. Indeed, as developments such as the orphan works issue arise, PACA takes an active role in the discussion.

To make licensing easier for users and photographers, the non-profit, international coalition Picture Licensing Universal System (PLUS) has developed tools to untangle the common problems of the licensing industry by offering standards for the first time. PLUS's board is comprised of representatives from various photography and illustration associations as well as publishers and advertisers. PLUS offers a glossary of terms used in licensing, a "media matrix" which standardizes rights packages for users, and a universal license format, which ties the rights of the media matrix to the words of the glossary. It intends to offer a registry of artists' names to chip away at the orphan works issues.

With the issues facing creative individuals, it is important that the industry works together with a common goal to protect copyright and educate users. Education and advocacy are key tools for this industry, one that has so many talented individuals who are devoted to making lasting and impressive images. With that solid education and with sound advocacy, photo professionals can focus their efforts on the big picture: Pictures.

INDEX

Books from Allworth Press

Allworth Press is an imprint of Allworth Communications, Inc. Selected titles are listed below.

Licensing Photography
by Richard Weisgrau and Victor S. Perlman (paperback, 6 × 9, 208 pages, $19.95)

Business and Legal Forms for Photographers, Third Edition
by Tad Crawford (paperback, with CD-ROM, 8 $^1/_2$ × 11, 192 pages, $29.95)

The Photographer's Guide to Negotiating
by Richard Weisgrau (paperback, 6 × 9, 208 pages, $19.95)

ASMP Professional Business Practices in Photography, Sixth Edition
by the American Society of Media Photographers (paperback, 6 $^3/_4$ × 9 $^7/_8$, 432 pages, $29.95)

The Real Business of Photography
by Richard Weisgrau (paperback, 6 × 9, 224 pages, $19.95)

Legal Guide for the Visual Artist, Fourth Edition
by Tad Crawford (paperback, 8 $^1/_2$ × 11, 272 pages, $19.95)

The Law (in Plain English)® for Photographers, Revised Edition
by Leonard D. DuBoff (paperback, 6 × 9, 224 pages, $19.95)

Publishing Photography: Marketing Images, Making Money
by Richard Wesigrau (paperback, 6 × 9, 240 pages, $19.95)

Starting Your Career as a Freelance Photographer
by Tad Crawford (paperback, 6 × 9, 256 pages, $19.95)

Photography Your Way: A Guide to Career Satisfaction and Success, Second Edition
by Chuck DeLaney (paperback, 6 × 9, 336 pages, $22.95)

Profitable Photography in the Digital Age: Strategies for Success
by Dan Heller (paperback, 6 × 9, 240 pages, $24.95)

Photography: Focus on Profit
by Tom Zimberoff (paperback, with CD-ROM, 8 × 10, 432 pages, $35.00)

Pricing Photography: The Complete Guide to Assessment and Stock Prices, Third Edition
by Michal Heron and David MacTavish (paperback, 11 × 8, 160 pages, $24.95)